Early praise for **The L**

MW00830397

"Mary's book takes her career experiences and brings them to the present. Her recommendations are timeless and valuable."

— Tom Brillat, Mystic Seaport Museum
Director of Interpretation (ret.)

"Wonderfully constructed with great flow between chapters. I loved her selection of quotes. There is much good reference to leadership challenges of the pandemic throughout the book."

— Conrad Donahue, Captain, USN (ret.)

"This book dispels the perception [of those] who believe leadership is ... inherent in ... [and comes with] their title."

— Dorothy Mattiello,
Vice President of Human Resources

"[Minimizes] the scientific or psychological jargon that makes leadership material feel 'heavy.'
The examples are current and relevant. ...
[For] someone in a new leadership role ... technical skills are the 'easy' part ... [but they] struggle with the soft skills at times. [O'Sullivan provides] a good mix of thought-provoking questions for leaders to ask of themselves to get self-awareness confidence in order to influence their teams, peers, etc."

— Denise White, PHR, Human Resources
Director at Pine Tree Society

"*The Leader You Don't Want to Be* gives a different but actual perspective regarding leadership or navigating management minefields ... [W]orth the read!"

— William C. Kordis, Captain, USN (ret.)

"I had nightmares about my old bosses after I read this book."

— Mary Francey, RDH (ret.)

"I think the analogy between seat belts and face masks is powerful. It clearly shows the failure of leadership during the pandemic."

— Steven W. Smith, Author & Teacher, Former Naval Aviator

"It's very intriguing and ... realistic It's a really good read and transitions so effortlessly."

— Tracey McMillian-Booker, Manager of Human Resources at Norsk Hydro

"The mask/no mask controversy shows exactly what happens when the message is muddled at the top Executive levels."

— Mark Berger, Public and Media Relations Professional based in Rhode Island

"I dropped what I was doing and flew through this book!"

— Kate Rollins, Director, Florida Operations (Consultant) at Pugh Associates, LLC

THE LEADER
YOU DON'T
WANT TO BE

**Transform Your
Leadership Style from
'Command and Control'
to 'Transformative Visionary'**

MARY T. O'SULLIVAN

ENCORE EXECUTIVE
ASSOCIATES MEDIA

THE LEADER YOU DON'T WANT TO BE
Transform Your Leadership Style from
'Command and Control' to 'Transformative Visionary'

Copyright © 2021 Mary T. O'Sullivan

Published by: Encore Executive Associates Media
ISBN: 978-1-7362786-0-4

Editor: Yvonne DiVita
Cover and Interior Design: Tom Collins

Disclaimers:

While the author and publisher have used their best efforts in preparing this book, they make no representations or warranties regarding the accuracy or completeness of the contents of this book or any related, referenced, or linked materials. The author and publisher specifically disclaim any implied warranties of merchantability or fitness for a particular purpose, and make no guarantees whatsoever that you will achieve any particular result.

We believe all information, scientific research, and case studies and results presented herein are true and accurate, but we have not independently audited or confirmed the research methods, data collection, or results reported. Any advice or strategies contained in this book might not even be suitable for your situation and you should consult your own advisors as appropriate. Names used in this book are completely fictitious; examples from real situations have been modified, remixed, and bear no resemblance to any individual person, living or dead.

Dedication

This book is dedicated to
Michael P. O'Sullivan, Sr., and Daniel C. Stessen.

They give me strength.

Acknowledgments

Thanks to my husband, Michael, my biggest cheerleader throughout this process. He's my champion. Thanks to my son, Danny, whose entertainment, writing, and editing professions, helped with the book graphic design process. His talent is apparent in the incredible TV series, *Dream Corps LLC*, for which he's been the show runner, creative director, and executive producer.

Great thanks to all my reviewers, who took time out of their very busy schedules to make this book better than it ever could be without their insightful comments and recommendations. Thanks also to the professors at Quinnipiac University and University of Texas at Dallas who assigned tough leadership topics in legal, ethical, and cultural issues with which to wrangle. Those mind teasing topics produced the basis of the successful stories you'll read in this book.

A huge thanks to my devoted editors, Yvonne DiVita and Tom Collins, whose genius led me all the way through the jungle of book writing and publishing. Without them, I would have no idea what I was doing in putting this book together. Extra gratitude for Dave Seybert, one heck of a talented graphic designer who made my launch page and sales pages look stunning. My copywriter, Deb Goeschel created the most original and inspired promotional material for which I am most grateful. Without her incredible work, this book would not have come to fruition.

And many thanks to those real people whose stories are told in this book, some sympathetically, some not. You inspired me to write and wrap my head around the behaviors and actions I saw involving you and express them in terms of standard "B" school learning. May we all discover how to be better human beings by the lessons you taught me.

Contents

Foreword

I met Mary through a mutual business contact several years ago at a Central Rhode Island networking event. When you attend these gatherings, one never knows if there is a possible connection or chance both will work together.

Fast forward a year later, when my name appeared on Mary's desk as someone who could help promote her business. With hope and positive vibes, she called and we decided to meet at her Encore Leadership Meeting. Mary invited me to be the speaker for this event. After my presentation, a light went off in Mary's head as she figured out that her story could lead to more opportunities. We ended up working together and her vision was seen and heard throughout Southern New England. Mary also landed a project with one of Rhode Island's biggest employers, because someone read her story and quickly reacted.

That is one of many examples of how a story can positively impact your company. Mary saw a chance to demonstrate her experience and apply it to board rooms across Corporate America.

That's why her accounts here resonate. Mary has seen and heard many stories of executives performing with grace under pressure while others crashed and burned under the same circumstances. You can read how some companies chose the right path to resolving conflicts and how others made matters worse.

No matter what you think or do, Mary has first-hand accounts of what happens when business owners have a clear plan for success and the consequences when they either do not or change the parameters in midstream.

With numerous anecdotes and knowledge of Corporate America, Mary's lessons will help guide readers to what worked, what did not, and where to go from there.

You will be better prepared for what lies ahead after reading Mary's story!

Mark Berger, Principal
Berg's Eye Communications
Cumberland, RI

Introduction

The Leader You Don't Want to Be

WHAT DO YOU KNOW about being a leader? What were the qualities of the best leaders you've ever known in business, in the military, in politics? And if you are currently leading people, who is your role model?

These questions pose a number of problematic challenges. What is real leadership behavior and who actually practices it? In this book, you will find true stories about leaders. Some were awesome, but most of the characters you'll meet here are deficient and absent of any earmark of leadership. That's what makes them so fascinating and memorable. No one wants to be remembered for being a sorry example of their profession, but it happens. And I'm sure you don't want to be among them.

Here are some of the questions about bad leaders that sparked my interest in this topic. And while I've been careful to change any name in this book, the scenarios you'll read about here are all true. Sometimes I had a front row seat to the show, sometimes I was the main character, sometimes I witnessed the circuitous plot twists as a "groundling" on the floor of the theater. The stage seemed to be set every day. Usually I arrived in the office expecting some drama on a Shakespearean level, tragedy, comedy or even history; the tragedy

and treachery of Macbeth, the sexism of Taming of the Shrew, or the leadership lessons of Henry V.

Does your workplace erratically shift from one dramatic performance to another? Or do you have a cohesive narrative to tell, where everyone knows the words and is reading from the same script?

It made me wonder whatever in the world empowered these people to act like characters that were made up, fictional, or even worse, characters that no one could ever invent. Here are just a few examples you'll read about in this book.

Imagine your boss plotting against you behind your back. You'll learn the story about how someone's own boss announced that she was being displaced and gave her 90 days to find another job. She couldn't wrap her mind around this news because she had a rating of "exceeds."

Or the tale of a truly rude VP, who demanded water for himself, while ignoring the needs of others in the meeting room.

Surely, you're aware of the "big guys" who don't "walk the talk," who ignore your organization's mission statement, vision, and values. So why should anyone else follow them if their leaders don't? Ask yourself that queasy question about personnel decisions: are promotions and firings decided based on favoritism or nepotism, not the "quality of work? And who hasn't wondered how that rude guy or insincere gal ever got into the corner office?

The commonality all in these stories is that, apparently, once these people achieved that goal of being the person in charge, they lost the ability to act like a human or demonstrate respect for the humanness in others. Ignoring someone's humanity leads directly to the ability to deceive, mistreat, underrate, belittle, and disregard his/her human

value. Lacking respect for your workforce is one of the most egregious sins a boss can commit.

So, how do you learn to treat people the right way?

I've worked with hundreds of people in leadership roles over the years, and in general, my conclusions boil down to two missing pieces: In every case, they lack empathy and perspective. They don't understand how their behavior impacts people and can only view the situation from their own point of view.

You'll read the story of a talented leader who belittled people. He was rude, he didn't bother thanking people, greeting them, or calling them by name. He had no idea how threatened his employees felt. He could not understand why no one seemed to listen to him, and further, how anyone dare complain about him! After some hard introspection, about six months later, this leader experienced a "Pauline-like" epiphany, as St. Paul did on the road to Damascus.

Being a disbeliever, Paul was struck by light, knocked off his horse, and was blinded for three days. After a healing, the "scales" fell from his eyes. Similarly, for the first time, this leader was able to appreciate the impact of his behavior. He experienced a real awakening. He finally learned to thank his workers, he began to be less aloof, and even created small rewards for people. His perception of himself in relation to other people completely changed.

How about you? What's your office behavior like? Have you disremembered or unlearned that human assets, human capital, and human relations all begin with the word "human"? It's up to the boss to establish an atmosphere where people feel comfortable, and it goes beyond ergonomics. If you swear and raise your voice at work, imagine

what that would look like if you did that in your own home.

I'll tell you about a manager that deliberately sabotaged a person's work and his language always included every foul word imaginable. He lost his temper, shouted, and screamed at people, often. Filing complaints did nothing but bring trouble upon the person who complained. I doubt his behavior would be tolerated by his family. But everyone in the office laughed it off. Only, to some people, such a work environment isn't funny. It's highly stress-inducing.

> **It's up to the boss to establish an atmosphere where people feel comfortable**

Causing employee anxiety is not the way to manifest productivity.

In this book, you will discover how acting more human and authentic, and with kindness, encourages higher levels of employee engagement and improves the overall employee experience. Study after study has found that engaged employees help improve your bottom line.

As a leader, you may be shocked about such bad behavior, but don't be. Just pick up a book of employment law and flip through the cases. Those stories will astonish you even more than the outlandish antics I've already mentioned. It's true that these painful, and in many cases, illegal, incidents are perfect material for books, movies, and TV. In reality, though, they come with more serious consequences.

Based on one woman's experiences on the job, Lilly Ledbetter, a worker at Goodyear, documented her true story of pay inequity and blatant sexism. It's the story of how her workplace experiences triggered dramatic change in federal employment law. As a result of her lawsuit against her employer, Congress initiated and passed the Lilly Ledbetter Fair Pay Act in 2009, an addition to the Civil Rights Act of 1964.

What would it have been like if Lilly Ledbetter had different bosses, willing to show their more human side? Where was the fairness and caring? The behaviors of her bosses, bad judgment and inequitable treatment, caused Congress to act in her favor.

If you find yourself wondering about how these situations can happen, you're not alone. Thousands of workers everyday punch in because they need the money. They don't always expect to like the job. They have mortgages, car payments, college tuition. It's not that they don't care about which customs, rituals, and traditions are kept and which are broken, or how much their lunch hour's been cut, but they need to keep peace at home, so hostile work environment or not, they will show up, do the job and leave. This distant, disengaged approach to work is known as "Peace for Pay," and I've written a chapter on the psychology of this work survival technique, and what you, as a leader can do about it.

Just as frustrating is the leader who vacillates, who can't make a decision, or allows a lack of any decision to be the decision. Bosses who wait until the last minute to approve a conference or any travel which requires fees, flights, and hotels, fail to instill confidence in workers. People are held captive to the whims of how the boss chooses to spend his time.

When I heard this story, it almost seemed to me this boss was "waiting out" the person. Maybe he thought if he took his time and dragged it out long enough, the employee would become discouraged and forget about the conference or just give up on ever attending. People should not have to rely on their own wits to get permission to attend a professional event. As a leader, you are called to make a decision. Don't make people wait. Waiting is frustrating and makes people resent you.

Were you the boss who held up an important professional event for one of your direct reports? Did you put the request on the bottom of your inbox or lose it under stacks of other papers? In *The Leader You Don't Want To Be* you will read how your decision to firmly step up into your role makes you a more effective, credible leader.

How ingenious must your employees be?

Here, in this book, you'll find out how ingenious your employees can be, how they learn to work around you. How they figure things out on their own, even though you are getting paid to do so. I'll talk about how with the smallest amount of attention, you can be the hero of your employees just by being upfront and honest, and you do your best to demonstrate how human you are.

We've all heard of fiefdoms established inside a big company. There's a story in this book about how groups align against each other, even to the point of plotting to destroy one another, or steal each other's assets. This is yet another narrative that sounds phantasmagorical, but it's where organizations have many commonalities with great literature, like William Golding's *Lord of the Flies*. It's a great leadership lesson on organizational

cohesiveness, culture, and the importance of an integrated internal structure.

And what is the outcome when management tells us one thing, and then suddenly that "fact" is now "untrue"? For instance, when common sense tells us a process is a slow crawl, but now management identifies it as "speed"? No brave soul will openly admit that there's something wrong, it is too career endangering. No one wants to be the prairie dog who sticks his head up out of a hole, only to have it shot off.

Suddenly, memories of a "learning culture," "humbleness," or "respect for people," disappear. And, it's uncanny how fast everyone's memory fades, just like in the classic novel by George Orwell, *1984*. Orwell's novel presages the advent of organizational "doublethink," meaning the ability to believe two opposites things are true at the same time.

Leadership requires transparency and clear messaging. It's hard to be credible if you speak out of both sides of your mouth. People expect leaders to give them "straight talk," as the late Senator John McCain has said.

> **Leadership requires transparency and clear messaging**

With so much to discover on your leadership journey, you may wonder if you'll need help. It's hard to take on a big role without support, so you may turn to paid consultants for assistance. That's what most people new in leadership roles do, and it's a perfectly sane way to introduce an unfamiliar concept to the organization.

What you, as the leader, need to be wary of is relying too much on the consultant when you make changes. When the consultant thinks it's okay to

play 1970s music backwards in front of 100 high potentials, it's time to take a second look at the value of this consultant. You're obligated to ask yourself if you really need this person in your organization on a daily basis, or whether picking his brain for a few hours a week will help your people best.

Consultants can help you in specific areas, but it's up to you when and how to use them. They're expensive enough, so you don't want to pick the wrong one.

These areas are only a few examples of the subjects I cover in this book. I've chosen intriguing events to explore that have stood out over my 30 years in industry. The treatment of women, generational differences, following instincts, among other absorbing areas, are evidence of how leaders fail.

I offer you, the leader, some techniques and strategies to side-step the path to failure. The most critical lesson of all, however, is relatively simple: *just act like a human.*

Remember, people make the organization function, and the age of treating individuals like cogs in a wheel are over. People want respect and consideration. They want a leader who can show compassion, and still make tough decisions.

Becoming human is the way to avoid being the leader you don't want to be. Be that transformational visionary, leave the command and control in the 1980s, where it belongs.

Chapter 1

A Framework for Change: Support and Challenge Model

"Culture does not change because we desire to change it. Culture changes when the organization is transformed; the culture reflects the realities of people working together every day."

— Frances Hesselbein

FRANCES HESSELBEIN, former CEO of the Girl Scouts, USA, became one of the most renowned leaders of recent times. She believed that above all, people craved respect. And to show proper respect, a leader had to live her/his values.

One important element Hesselbein learned throughout her career as a leader was to ask the right questions to clarify people's thoughts and actions to ensure they were headed in the right direction. When she assumed leadership of the Girl Scouts, she relied heavily on the principles of Peter Drucker, a well-known management guru, called the Five Fundamental Questions:

- What is your mission?
- Who is your customer?
- What does the customer value?

- What are your results?

- What is your plan?

As a result, the Girl Scouts grew to 2.25 million people with a workforce of over 780,000. Hesselbein accomplished this at a time when the organization had struggled to attract volunteers and membership was on a steep decline.

But how do we develop leaders who understand basic skills well enough to "coach" people into making change? How do we ask the right questions? How do we use the power of three here?

For instance, these three "how do we" questions are often used in coaching situations: How can we move from where we are today to where we want to be? How might we use our strengths peering into in the future to create positive outcomes? How do we teach leaders to support others?

Through the years, I've established a coaching framework that transforms weak, ineffective leaders into change management agents. This technique is known as the Coaches Framework. The framework is a coaching modality aimed at leaders facing multiple challenges, crisis management, developing soft skills, and clarify decision making, to name a few, to help them guide their organizations through the process of change – changing organizations, changing attitudes and changing themselves.

> **How do we use the power of three here?**

The framework is based on the work of Dr. Robert Hicks, the Director, Organizational Behavior and Executive Coaching, at the University of Texas at Dallas. Dr. Hicks is the author of *Coaching as a*

Leadership Style (Routledge, 2014) and *The Process of Highly Effective Coaching* (Routledge, 2017). These two books dig deep into his Four-Square Framework philosophy, providing readers with a roadmap to the right questions to both support and challenge thoughts and actions.

In fact, many of these powerful questions are commonly used in after action reviews. In the ones I've led, common questions are:

1. What do we want to keep doing?
2. What do we want to stop doing?
3. What are we not doing now that we need to start doing?

Dr. Hicks mentions similar questions in his first book, *Coaching as a Leadership Style*. He calls them the "Three Magic Questions" because when people are asked these questions, they think of the many facets of solutions that can be tried or undertaken in order to make the change they want to happen.

The questions are a path forward, with all eyes on the future, not the past. And this approach is the critical difference between psychotherapy and professional coaching; while therapy focuses on the client's past, coaching is future focused, like the difference between studying history and planning for space travel.

Dr. Hicks' Four-Square Framework, which incorporates the work of many well-known psychologists and leadership theorists, in addition to Dr. Hicks' approach, promotes methods of self-inquiry, self-actualization, and self-awareness. These concepts are easily adapted by today's leadership development experts. Using simple, but powerful questions, changing organizational culture becomes less of a

struggle and more of an organizational revolution; a leader transforms his/her behavior from acting like an oligarch to modeling an organization's values; an individual gains the confidence and clarity needed to change careers or seek that ever elusive promotion.

So how do you get people to change and like it at the same time?

The idea is to develop people's confidence in the leader and get them to take action in the direction you need the organization to go. For instance, public health. If leaders are modeling behavior they wish people to follow, that spreads more confidence in the change that is needed. If we want people to stop smoking, role models such as athletes, TV personalities and other celebrities are shown not smoking. In fact, for many years, cigarette smoking was not shown on TV or in the movies. By banning smoking from being portrayed as acceptable behavior on TV and in the movies, the entertainment industry demonstrated their commitment to public health and alignment with science.

The moguls understood their millions of audience members were the prime targets that health officials needed to reach. Using on-screen stars from every demographic, the industry helped alter smoking behavior among great masses of people, by the millions. Cigarette advertising was and still is banned from TV commercials.

Seat belts are another good example. If we want people to wear seat belts, we gain credibility by role models who take the reins and exhibit the desired behavior. Wearing seat belts is another area where the entertainment industry has supported public health and safety. Even the bad guys are buckling

up on TV and in the movies. Additionally, if we want kids to use seatbelts, parents, babysitters, Grandma, and Grandpa need to buckle up as well.

Both of these instances clearly demonstrate how by building confidence among the public, radical change is possible.

The Four-Square framework has two major principles: *Support* and *Challenge.*

These address the two ways people are most likely to embrace change: Thought and Action. Leaders support, in many ways, the action they want others to take: effective communication, modeling, reinforcement, and reward. For instance – you'll get ticketed driving without a seat belt and will be banned from public places with a lit tobacco product. Leaders drive the change by helping people figure out the change being promoted is good and is necessary.

The tricky part is the challenge. For people to be challenged, their basic mindset must be put in question.

> **For people to be challenged, their basic mindset must be put in question**

In a pandemic crisis, mixed messages coming from the very top leaders seem counterproductive. If we want to slow down a virus, a behavioral change (such as wearing a mask) is needed, but some leaders appear in public without a mask. We wonder how it's possible to change that erroneous mindset.

We might ask ourselves, *"Where is the support for the idea or thought of making this needed change?"*

13

What we are left with is a very confused public, some making the changes, some not. Those people that feel supported by their state and local leaders will change their behavior and wear a mask.

But how do we deal with the challenge? What of those who defy the advice to take recommended safety precautions? What happens when we challenge the mindset of their right to emulate those in charge and not take the advice of medical and scientific experts?

Maybe these folks need a bigger incentive or reinforcement. Like cigarette smoking and seat belt wearing, there are consequences for not wearing a mask during a pandemic – people will get sick and die. Somehow that message failed to resonate with a large part of the population during the 2020 pandemic. The reason is there has been no challenge for thought. The mindset was not questioned. And the idea or thought of the need for masks was not supported in the usual ways.

What we saw, instead, was the people in charge not effectively promulgating widespread positive communication, modeling, reinforcement, and reward. Questions need to be asked in order for the public's behavior to change, from dangerous to safe. Journalists, concerned citizens, and influential legislators all have a responsibility to question unsafe behavior, regardless of the source, when it affects the public good, safety and health.

Without this framework of inquiry, change in the public's mindset and behavior is unlikely. Leaders in organizations dealing with similar issues around change and management deal with the same problems. The status quo is no longer working. We can't be comfortable doing things the same way we've done them for years. Change happens whether we want it to or not.

Think of the invention of the automobile. The transition from the horse and carriage impacted entire industries, including horse breeders, blacksmiths, and buggy whip makers. Now, buggy whips are not mass produced because there is not a high demand for them, and only "the horsey set" need blacksmiths, horse breeders, and crops.

Think of what stalls organizational change – inertia. If a change is introduced, like a "learning culture," and no infrastructure is provided, how does the "learning culture" materialize? How do employees embrace learning without access to courses, mentors, tuition reimbursement, and in-house training?

The same is true at any level for any kind of change.

The Negative Leader

A client of mine who was a senior leader from a major company is a good example of responding to challenge for thought and action. He presented as surly, disruptive, insulting, and harsh. His peers and direct reports avoided him. His performance review from HR was scathing because so many people had complained about his rudeness and abrupt manner. He knew he needed to make a change or he'd be looking for another job soon.

After several months of coaching, it became clear that he had no idea how to use his assumed power as a leader; he had to change this negative behavior to survive.

During one session, he described an uncomfortable meeting. As he walked through the details it became clear immediately that he was completely clueless about his poor leadership behavior. His body language, facial expressions, tone of voice and

language used were examples of bullying behavior, but he had no idea of the impact on others.

What he described as his own conduct clearly emerged as authoritarian and intimidating – standing up, hovering over the seated group, a boorish style of communication, demeaning in tone and word choice, the anger and disgust on his face as he told the story. It was clear to me that he needed a challenge to foster his awareness of his bad behavior.

I challenged how he used his power as a leader. *"What did you hope to accomplish with your employees?"* was the question.

It appeared that using the power he had as a leader in an adverse way gave him the mistaken impression that this behavior motivated people. The challenge question elicited shock and disbelief. He was incredulous.

We walked through the whole meeting once again, parsing out all his actions and words. I then gave him another challenge question: *"What would it be like for you if your boss used his power with you the same way?"*

The challenge question elicited shock and disbelief

That simple question became his Ah-Ha moment. He had never thought of his bad behavior from his employees viewpoint. He was quite unaware that he used his power negatively. That was the moment he knew he had to make a change.

Once this breakthrough happened, we shifted to support. The next question, *"What small behaviors could you start tomorrow to make a difference?"* supported his readiness for change and his ability

16

to make a commitment to change. And he was eager to learn what actions he needed to take to become a better leader.

Another support question was, *"Who do you know who is liked as a leader?"*

He admitted, a good leader has to have willing followers, and in order to have willing followers, he had to use his power as a leader in a positive manner. He made the list of positive actions for himself and began to follow his own plan back in the office. He learned to stay out of meetings where he had no key role. He began to reward co-workers and direct reports with gift cards for a job well done. He even learned to use common courtesy, good manners, and simple etiquette as in saying, "Good morning!" and showing gratitude by thanking people with handwritten notes. And he stopped stressing over work 24/7.

Just a few simple, yet powerful questions launched a major behavior change and salvaged a career as a leader.

The People Pleaser

Another client, the head of an IT department, sought relief from overwork and stress. He never said "no" – his personality as a people pleaser always overtook any good decision-making process he had. He was determined to keep everyone at his workplace and at home happy, so he regularly worked late into the night on numerous projects. He also took responsibility for grocery shopping, cooking, cleaning, and childcare as his wife often traveled.

Eventually, he could not stay abreast of everything and was becoming stressed to the

breaking point. After weeks of coaching, he continued to deny that there was any solution to his problem and even began to argue about it. Finally, his thoughts and actions had to be challenged.

I asked, *"What do you want in the endgame? What is your goal?"*

After some thought and further discussion, he finally admitted that all he wanted was to be happy. He experienced a glimmer of an "Ah-Ha" moment. Only then were we able to discuss achieving his goal through offering support for action.

The support question was: *"What do you do now that makes you happy?"*

He began to wistfully talk about some personal hobbies, like beekeeping and woodworking. Then I asked, *"How can you do more of these things?"*

He began to struggle as he placed himself into his imagined future, almost fearful to even think about his own happiness. He could not imagine a world where he was not taking care of every little detail. Instead, his need to please convinced him to take on more and more work, and his hobbies went neglected. His hives swarmed, and the bees all flew away, analogous to his idea of achieving his own happiness. It was challenging for him to realize that as a leader in the workplace or in the family, he could not spread himself so thinly.

He refused to give up any responsibilities. He worried about not getting things done perfectly. After three months of coaching, he admitted that he wanted to be happy, but he just could not reconcile his drive for perfection with his own self-care: relaxation, mental health, well-being, and happiness.

He knew what happiness looked like, he just could not put himself in that mindset, regardless of how it was framed. He could imagine happiness; he could not take the needed action to create it. He stayed in what I like to call "the default future." That is the future you get if you just do nothing differently. No decision to act *is* the decision.

> **"the default future" is the future you get if you just do nothing differently ... No decision *is* the decision**

The Four-Square Framework model developed by Dr. Hicks and accepted by many professional business coaches today, including myself, asks us to put ourselves through the proven process of change theory: Change your mind, change your actions.

As Charles Darwin said,

> *"It is not the strongest or most intelligent who will survive, but those who can best manage change."*

What Happens, then, When Senior Leaders Fail?

One of the most egregious examples of failure of leadership was painfully demonstrated by the Catholic leaders in Boston, with the whole child sex abuse scandal exposed during the late 1990s and early 2000s. Under Cardinal Bernard Law, abuse of children by priests was reported and documented, and the Church knew very well about these ongoing crimes against children.

However, Cardinal Law did not defrock these pedophile priests, instead, he rotated them throughout the Dioceses of Boston over and over again. Under Cardinal Law, predator priests kept their priestly status, and moved freely about the Dioceses, only to abuse more child victims to unknowing parishioners. This heinous practice of moving priests from parish to parish perpetuated the crimes of these priests, only to come to light once the Boston Globe launched an investigation. Through its Pulitzer Prize reporting, the public came to learn that the Cardinal's grievous practice had a long history, dating back many, many decades, and included his predecessors.

We'll never know Cardinal Law's reasoning for reassigning these predator priests, but we now know his actions are classic examples of a massive failure of leadership. According to Globe reports, complaints about many priests were reported to the Cardinal in the decades before the Globe's "Spotlight" investigation took place in the mid-1980s. Yet, rather than protect his flock from harm, he protected those that harmed the flock.

At the time of the Globe's exposé, predator priest cases were considered rare and isolated. The Globe's extensive reporting revealed the ongoing criminal offenses, both in Boston and other areas of the United States and the world.

Cardinal Law ignored the facts, ignored the truth, and like many other Church leaders, ignored his duty to the faithful. The actions of Cardinal Law, who was "recalled" to Rome by Pope John Paul II, demonstrate the oligarchy of the Church and the impenetrable walls around it. In this case, only the press rose up to challenge

the thoughts and actions of Cardinal Law and the Catholic clerical hierarchy.

After Cardinal Law's departure, no prelate was left in Boston to manage the profoundly needed change in leadership. In his wisdom, Pope John Paul II appointed Cardinal Archbishop Sean O'Malley who came onto the scene in 2003. These were challenging times for O'Malley since Cardinal Law's resignation was stoked by howls of protest from the victims and their families. Cardinal O'Malley's successful track record with swift action against abusers, brought a whole new sense of ethics to the Church's conduct in the Boston sexual abuse matter, supported the victims, and challenged the Boston Church's status quo in handling abuse cases.

During the 1990s and early 2000s, as Bishop of Fall River, Mass, and in Palm Beach, Florida, O'Malley dealt with huge sexual abuse scandals and quickly moved to rectify the matter both with victims and in punishing the abusers. O'Malley changed the tone in Boston immediately by inviting abuse victims to his installation ceremony, many of whom attended. He also moved to settle numerous lawsuits against the Church, rather than stonewall the victims.

In his installation speech, he acknowledged the pain of the victims and begged forgiveness, a stark contrast to Cardinal Law, who was forced to face the reality which cost him his prestigious position as a "Prince of the Church" in Boston.

> ... objectionable behavior that goes ignored by leadership ... is a strong signal that good leadership is imperiled

Yet it appears that the Church never really took Law's sins seriously, as he was reassigned to a high-ranking prelate's position in Rome which he held until his death.

The lesson here is that any objectionable behavior that goes ignored by leadership – those at the top who know better – is a strong signal that good leadership is imperiled. Those "leaders" are in world of denial and delusion.

Let's move on and talk about what simple lessons there are for women who aspire to leadership roles.

One theme that repeats itself over and over again involves women's aversion to networking with new people. Men play golf, and all are welcome, but what activity do women have in common? After yoga, do you socialize, or roll up your mat and rush off?

Men go to the 19th hole. But most women won't even gather for a post workout cup of coffee. Time to take our cue from the boys and help each other move up, maybe even learn golf.

Chapter 2

The Paradox of Women
in Leadership

"To be accepted as leaders, women often must walk a fine line between two opposing sets of expectations."

— Dr. Shawn Andrews
(Training Industry, Summer 2016)

FEELING LIKE NO MATTER WHAT you do, as a woman, leadership opportunities pass you by?

It's not your imagination. Conventional Wisdom says that in general, women struggle more than men do when aiming for the major leadership roles in an organization.

Yes, we've made some strides. But in my experience professional, aspiring women don't like networking with men, are still ignored in meetings, and feel overwhelmed – as if they have no time, because they haven't figured out that delegation is good for the soul, not a dirty word.

Are women leaders invisible?

Has this ever happened to you? Say you're a newly promoted female executive, a Vice President, and at your first executive staff meeting a question is posed to the mostly male group about how to solve a talent retention problem. Answers come from around the room, but none are sticking with the CEO. Since you've had a similar challenge in your last assignment, you offer your suggestion, too. Crickets. No one responds. You think they maybe they didn't hear you, because they keep talking about the problem without even looking your way or asking you to comment further on your input.

You know your answer is sound, it is logical, it is based on firsthand experience, and all said, it's a good answer. So, you stand up and repeat it. That's when you realize you're effectively invisible. It's as if you're not even there.

Looking around the room, the only other women you see are the CEO's administrative assistant and the woman attending the coffee bar. They look at you. They heard you. But the men at the table aren't even giving you the courtesy of even nodding in response to your suggestion.

No, you're are not daydreaming, and you are not having a neurological episode; in that meeting, with those men gathered around the table, you are invisible. Your voice is not being heard. Your colleagues are openly neglecting to acknowledge your opinion. The sad truth is, they don't mean to be rude, they're just oblivious.

And for the men reading this section, you have to admit you've been there when this sort of behavior takes place. I assume that you were not one of those men ignoring the woman's voice. But

if you were, take heed, reading this chapter might help you "get" why women are upset about your conduct. I will definitely show you how you can support your female colleagues and not just sit there, unaware of the talent you could be wasting.

This imaginary scenario reminds me of a similar instance where I felt invisible also, in my management career. While on a conference call with a program manager and a supplier, an issue with the supplier's product came up. There was a big problem with those parts. The conversation focused on the development of "cadmium bloom," a dangerous carcinogenic substance found growing on the supplier's equipment. This equipment was important to our company. It was the mechanism that opened the hatch on a missile silo.

> **The sad truth is, they don't mean to be rude, they're just oblivious**

However, when workers opened the box and saw the cadmium bloom, they threw down their tools and walked off the job, afraid to be contaminated. Production of the missile silo had to be halted immediately, and the project was already behind schedule.

During the call, the supplier was agitated and took no responsibility for the contaminated parts. Our team tossed around ideas to prevent this from happening again, and I decided to add my two cents. I had experience with other suppliers who were packaging experts and I suggested that maybe these parts should be wrapped in a package to shield them from the substance causing the

carcinogenic material, to keep it from forming. I even suggested that the pine box they packaged the parts in was the cause since the box is treated with chemicals. At that point, the supplier lost his temper and screamed, "Don't tell me how to ship parts. I've been in this business for 30 years!"

The male program manager said nothing about this outburst, he just let it go, but I was fuming. Later, I called the program manager and announced that if that supplier ever spoke to me like that again, I did not plan to answer him politely.

This incident released a strong emotional reaction. I became furious. It was bad enough that my idea was belittled, but his discourteousness and churlish tone of voice, stunned me. As the day progressed, the fury made me think; this ill-mannered behavior was rooted in sexism. Would a man receive the same impolite brush off? Probably not. Thankfully, I never did interact with that man again.

However, you might say "what comes around, goes around," because in this case, my opinion happened to be correct. An investigation into the original cause of the carcinogenic material was performed and guess what the cause was! The pine boxes had indeed leached a chemical onto the parts which caused the toxic material to develop!

The solution? Ship all new parts in special shielded bags that would protect any material from the pine boxes.

If only that supplier hadn't allowed sexism to seep into his judgment, he could have saved himself some trouble and embarrassment. Instead, he took his anger and frustration out on a woman he didn't consider his equal.

Being ignored is just one of the obstacles smart, qualified, professional women face when they attempt to move up the career ladder into leadership roles. One that strikes me as important to mention here is the fact that women don't accept the significance of mixing with the right people in the right setting – in other words, joining men in their networking events. This aversion to making good connections is a real barrier so many ambitious, aspiring women create for themselves. I am surprised so many of them often neglect these readily available opportunities.

Career experts and multiple publications validate that men build relationships mostly through stereotypical men's activities: golf, after work drinks, communicating with fraternity brothers, and joining male-only social and religious groups. These events are where deals are made, important conversations take place, and critical introductions happen.

> **This aversion to making good connections is a real barrier**

Men seem more comfortable with making important connections. They realize that if you're in line for a leadership role, and you never socialize with the next level of management, how are they going to know who you are or what you're capable of?

Join the club

As women, we need to ask ourselves, how do women gain entrance to this all male club? The answer is within us. We women need to find those opportunities and power our way into them.

For example, at women's conference I attended in 2019, I noticed a lonely female golf instructor prominently displaying her learn-to-golf program for women. A testimonial on her brochure stated, "I learned to play golf, and was promoted two years early." Despite her excellent messaging, there was not one woman at her table to find out more about how to learn the game. I saw women of all stripes walking by, completely ignoring her display, but busily chatting among themselves.

While I have my own up front and personal experience observing this attitude, having been a woman in a leadership role more than once, the truth is that study after study indicates women haven't accepted the intrinsic value of mingling with men.

It's not that we are anti-social, it's that our friendships are often with other women, our own assistants, peers, or direct reports. We're not managing up socially, the way the men do. Sometimes it's due to childcare, sometimes, we're just not comfortable, and other times, we limit ourselves to networking or meeting with others who make us feel more at ease. Other people just like us. What woman says "No" to a "Girl's Night Out" or a trip to the outlet stores? You can bet, however, our male executives are not roaming the malls for social interaction.

> **Networking is also about what you can give back**

Women with their eyes on the corner office need to understand how critical it is to build relationships in a social setting, with all of management, both men and women. A *Forbes* article reports that the

discomfort women feel at networking events is one of the most harmful barriers to our upward movement. Many women feel it's exploitative and even immoral to attend a social/networking event for the sole purpose of furthering our own careers. If that is your mindset and approach to career growth, I'm here to tell you that's just upside-down thinking!

Each of us, as professional women aspiring to leadership roles have enormous value in the networking world. Networking to advance your career isn't based on what you are taking away from others attending the event, networking is also about what you can give back.

Believe that your unique and special training, grasp of your discipline, and your existing connections in the industry, are highly valued, and others will appreciate and be grateful if only you would share with them. Be an agent for yourself. Leverage networking events to support as many people as you can by introducing yourself, asking the other person about him/herself, and contributing actively to the general discourse. Often, that's the start of a beautiful relationship.

Finding the time

Delegating is also a challenge for many women. There we are, buried at our desks all day, because we think we can "do it" better than anyone else. You'll see me talk about this again, in other chapters, but women have a tendency to work hard at being perfect. We women harbor a core belief that if we delegate anything to someone else, it will not be as good as our own efforts. Furthermore, women continue to expect themselves to have

immaculate homes and respond to every family need, regardless of whether someone else could do it just as well. And the truth is, men just don't care as much about domestic issues. Having an immaculate home, neatly folded laundry, worry about toys scattered on the floor are low priorities for men. They're comfortable with clothes draped over the furniture, dirty dishes in the sink, and piles of junk in the basement and garage. They don't spend a lot of psychic energy worrying about details they don't consider important. If you ask a man for help, he'll give it to you, but he's not going to think about it until you do.

We just have to learn to ask.

The number one complaint I hear from upwardly mobile women is that they never have enough time. Let's think about time in terms of control and delegating.

Often when I'm working with a stressed-out woman leader, the conversation shifts to control. We all need to learn exactly what is under our control and what is not. I encourage the women I work with to ask themselves, "What, exactly, do I have in my direct control?" Because we can't change what we can't control.

Recently, while coaching at a conference, a successful production manager came to me. She felt overwhelmed and complained that there was never enough time to get everything done. Who hasn't said that at least once this month? As we talked, I helped her uncover some areas of her responsibilities that were contenders for elimination. One thing that truly surprised me was to learn that this busy executive home-baked gluten-free items for her son. A very motherly task, no doubt.

Then I asked her what alternatives she could think of instead of home baking, since it took up hours of her time every week. Flabbergasted, she stuttered out an answer, "Well, then it wouldn't taste as good." I could not disagree, and we continued our brainstorming, only to have her reject every idea that we came up with. I heard a lot of "Yes, buts."

In the end, I had to conclude this woman did not want to relinquish any responsibilities or tasks, even though many of her own suggestions were good ones. I surmised it was her fear of failure and her desire for control that produced her stubborn dismissal of any practical solution to her time problem. Maybe she expected me to have a magic formula or wave a magic wand to make her troubles go away. But, regrettably for a lot of us women, Merlin retired a long time ago with King Arthur.

The role of women in leadership has been profusely studied and written about. For this book, my purpose in sharing this chapter is to present some alternatives dealing with the unique challenges women face, both in our lives and careers, where so often the two worlds collide.

Statistics show that women get promoted less often, that there are fewer women on major boards of directors, and less women CEOs of major companies. Refusing to delegate is a big reason women are held back and it is reflected in the literature. We shouldn't be sabotaging our careers by eschewing delegation. We should learn to consider it a strength, not a weakness.

There is a copious amount of written material and studies on the importance of delegation: all of which say it is one of the hallmarks of good

leadership. According to *Due.com* the number one reason for delegating is to save time. How much more time would the woman I coached at the conference have saved if she had been able to wrap her head around the concept of delegation? Imagine, gaining more time in your day by giving up control over something that's not a top priority.

> **The number one reason for delegating is to save time**

Delegation can take many forms, but first, we have to admit and recognize that it's okay to let go of some low priority tasks. In fact, *Harvard Business Review* advises that to be an effective leader, we have to drop the "doers' mindset," a belief system women cling to more than men. By saying yes to almost everything, women tend to spread themselves so thin they create frustration within their teams, who waste too much of their own time waiting to get a slice of their boss' precious moments.

Learn to say no

By consistently saying "yes" and refusing to delegate, we become the bottleneck; we slow everything down and lose sleep worrying about a detail that you may have forgotten.

Why do we say "yes," when we should say "no"? Guilt, worry about being liked, desire to please others, don't want to hurt someone else's feelings. All of the above?

Girls are socialized early in life to play nice and be likeable. Boys, on the other hand are socialized to win. We carry that early socialization into

adulthood, and that creates women's aversion to saying "No."

Saying "No" doesn't make us aggressive or unladylike, as so many assume. Saying "No" is code for assertiveness. Men understand this code. If you're like so many women, feeling guilty when you say no, and frequently, encountering a backlash when you do; if "no" doesn't easily come out of your mouth, look into some other ways women have devised to eliminate overload. After all, you won't get access to the big jobs if you're stuck with a whole bunch of chickenshit on your plate.

There is much else to say about women's use of language besides the inability to choke out the "N" word, "No". Companies know that they need talented women in key areas for a whole constellation of reasons, but if we don't adjust our way of responding, people will continue to have a hard time taking us seriously. Think about this, how often do you apologize? How often do you use self-defeating phrases like, "You probably already know this," or inserting phrases into conversations like "just," "actually," "sorry, "but," "I'm not sure," "I'm no expert," and "Does that make sense?"

Tara Mohr brings these self-deprecating words to our attention. According to Mohr, "Most women are unconsciously using these speech habits to soften our communications, to try to ensure we don't get labeled – as women so often do – as bitchy, aggressive, or abrasive." Because generally women would rather be considered "nice" and "likeable," than be perceived as "bitchy."

Don't we all know a woman who's been called the "B" word when she spoke out, or when she was simply speaking the truth? Maybe you are

personally more familiar with it than others. Hillary Clinton, a talented, brilliant woman lived with this moniker for years. Pop star Taylor Swift was called a "bitch" due to her disagreement with another celebrity and it caused a public brouhaha.

Julianna Margulies, the star of *The Good Wife*, was widely criticized for refusing to a guest appearance on the spin-off, *The Good Fight*, because she demanded the same pay as in her starring role. Her reasoning? She said, "... if Jon Hamm came back for a *Mad Men* spinoff or Kiefer Sutherland wanted to do a *24* spinoff, they would be paid [their asking fee]."

There are plenty of similar examples in some classic biopics. Consider two famous women with movies that tell their stories. Erin Brockovich (a female legal clerk who proved cancer causing groundwater contamination by a major energy company) and The Iron Lady (Margaret Thatcher, Former Prime Minister of the UK biopic). When we see these movies, we learn that neither of these women worried about what they said or how they said it.

> **Their boldness and surety of action changed the world**

And due to their boldness and surety of action they changed the world as we knew it in back the 1980s and 1990s. These women were not concerned with being "nice" or "likeable." They are true role models for women today.

There are so many references in the research about how we also denigrate strong women with disparaging names. "Ice Princess" and "Dragon Lady" and even "Queen Bee" immediately come to mind. How can women be effectual leaders with

these insulting names attached? And who are the worst offenders?

According to a 2014 Gallup poll, women!

We might think that with such difficult situations facing women, fighting for our seat at the table, we'd be totally behind one another. Believe it or not, that is simply not true.

Cases of women bosses belittling their female direct reports persist. Behaviors such as assigning menial or administrative work, demotions, referring to them with demeaning, condescending language, and deliberately leaving them out of important meetings have all been reported as female to female negative behavior.

Study after study clearly prove that women are more uncivil to other women. And a Center for Creative Leadership white paper reveals ways women often pay a price when they do promote other women. Such articles are eye opening, but nothing I bet you haven't already seen with your own eyes! The question begging an answer is why?

Some believe the reason lies in perception: assertive women are viewed as less "warm and nurturing," less "motherly," due to their attitude of strength and appearance of dominance. Some women view their more dominant female colleagues as "ruthless." Either way, we too often don't see women supporting each other or reaching out to meet the person behind the façade.

Isn't it time to drop the perfectionism and learn to accept each other as we are if we really want to grow as professionals and as people? Being a "bad" leader, one who doesn't take time to learn the lessons shared in this book, harms all of us,

not just you. In fact, your voice won't be heard any better, you won't have more time, and you won't get paid any more for bad behavior. As stated earlier, don't confuse assertiveness with aggressiveness.

To grow in your role, to be a true leader, you need to behave with civility. You don't have to be Nurse Ratchet (*One Flew Over the Cuckoo's Nest*, 1975) or Miranda Priestly (*The Devil Wears Prada*, 2006) to leave a lasting impression.

We have to believe that we can be the woman who's comfortable with in-person networking where we mix and mingle, sharing and learning from both men and women alike. Be the woman who resists the impulse to criticize or negate other women's achievements and talent.

Be the woman who instead, works to encourage and mentor other women around her. "Screw up your courage" (as Lady MacBeth would say) to assert your ideas in meetings and embrace the art of delegation.

Your career will thank you for it.

Next, we examine how all leaders can contribute to the creativity and problem solving capacities of their organizations.

Chapter 3

The Role of Leadership in Creative Strategy and Problem Solving

"The chief enemy of creativity is 'good' sense."

— Pablo Picasso

THERE'S MUCH TO BE SAID about how leaders encourage creativity and problem solving in organizations. It's no secret that the role of "task forces" or teams with specific assignments become successful when collocated and with few physical barriers in place. This concept is proven out in how institutions organize themselves for success.

Teams working within the same departments work best when they are in physical proximity to each other. When ideas can be shared, expertise is sought, and work critical conversations take place, creativity flourishes, and organizational problems are more easily solved. When team synergy is destroyed, individual creativity, motivation, and group problem solving disappear.

Teresa Amabile's article entitled "How to Kill Creativity" offered several antidotes to the lack of creativity in today's corporate cultures. We learn of studies which demonstrate theories of the three components of creativity: expertise, creative thinking

skills, and the importance of motivation, especially intrinsic motivation. The article seems to promote the concept that leadership is once again a key component of employee performance. The many examples cited, in particular, the story of Proctor & Gamble's transformation, demonstrate that when managers provide employees proper latitude, good things happen.

The most outstanding example in the P&G saga is the creation of their Corporate New Venture (CNV) group which brought forth a product that was "designed to provide portable heat for several hours' for relief of minor pain." When the article was published, the product was still under test; however, we now recognize that product as "Therma Care Heat Wraps," sold by another major pharmaceutical corporation.

The CNV product development team would not have been possible without the support of management, the self-motivated (all volunteer) workforce, as well as the freedom around "how, when, and where they approached their work." This example reinforces Amabile's theories of providing "challenge, freedom, resources, work-group features, supervisory encouragement, and organizational support." These teams are often known as *skunk works*, a term developed during World War II for its innovative and seamless solutions to complex problems.

The care and feeding of skunk works

Lockheed Martin created the Skunk Works® in the 1940s to create top secret products for the war effort. A group of engineers and scientists were gathered in "small, empowered teams, [with] streamlined processes and [a] culture that values attempting to do things that haven't been done before."

Many managers are fearful of such skunk works organizations, and we know these groups, aside from the original, are often created only to have Profit and Loss obligations imposed upon them. Of course, this action leads directly to a total lack of creativity, but it does serve to give management the warm fuzzies that those "crazy scientists in the back room" are actually being productive.

The lack of adequate goal setting or challenge as defined in Amabile's *Harvard Business Review* article is the primary reason that other organizations loosely modeled after the original Skunk Works, fail.

Other missteps that kill creativity include taking a well-functioning team and breaking it up to serve the desires of other departments, rather than serving the creative synergy of the team. In my last career role, one team I worked with was a large group of "mutually supportive," experienced professionals who all worked very well together. We were all in the same department, and with varying levels of expertise it was easy to find support on any particular subject when needed. Our group was diverse, including several well qualified women, as well as diverse age groups and experience levels. People all helped each other find answers and get work done. They naturally fell into the categories explained by Amabile: Expertise, Creative Thinking Skills, Motivation.

People all helped each other find answers and get work done

There were people with years of experience, as well as new people with lots of creative ideas and solutions that served to invigorate the team. This

team worked well together despite poor resources; use of email for archiving and as a main communication tool with suppliers and management, an extremely slow and ill-functioning, as well as frustrating, email platform. The team also dealt with cramped office areas; slow and byzantine electronic order placement and contract creation systems; continuously malfunctioning printers and copy machines; a faulty lock on the supply cabinets (you needed to be a magician to open them), and more obstacles that would have derailed any other team.

Each team members' expertise, however, offset another's deficit; someone could always answer a question or help another team member work through the archaic email system and other technical and departmental issues. There were experts in international contracting, specialists in the electronic systems, proposal experts, experts in all the deadly details in order placement, and people who just knew how to get things done in a crippling bureaucracy. Since the office space was open, people could often shout a question or an answer without even having to leave their seats. This space arrangement, although not private, supports the theory of the importance of "physical space" to enhance creative thought. People need to be near each other to develop the sense of synergy which engenders creativity. The combined psychic energy was almost *Avatar*-like, where minds and spirits unite, as physical barriers are removed.

Since the other leaders outside of the department exerted much power, with weak or zero support for the team from its own "leadership", the team was dispersed, to serve the needs of other, more powerful managers, members of the team were moved to the far flung corners of the huge building and even to other sites, hundreds of miles away. The once bustling corridors became empty and dark as the

team was broken apart. The team members left behind didn't have time to help each other, as they became too busy with their own work. The spirit of the group suffered, and people felt the pain of losing so many minds to help solve problems.

People were still messaging each other but it was not quite the same as popping in each other's offices or yelling across the aisle. In one case, a problematic software platform refused to cooperate. Deadlines were approaching, and one employee was panicking. She called the "help line" (casually called the "helpless line") and explained the problem, but there wasn't a ready solution. Her call was then transferred to another "help" desk, and after several hours of trying, the problem was finally resolved. Because there was no one else in the office that could help right then, when needed, as they had previously, the employee worked almost all night to meet the looming deadline. Had she had the support of her team to rely on, little time would have been wasted, she wouldn't have arrived home after midnight, and her attitude toward her job would not have deteriorated.

There were other negatives associated with breaking up the team. Those who were left retreated into their cubicles in isolation, many feeling lonely and anxious about the thought of operating without colleagues to confirm decisions, find a critical document, or learn about a policy change. The overwhelming impact was on morale and efficiency. Along with the dip in engagement, the feeling of empowerment, independence and creativity took a dive. But strings had been pulled to satisfy other departments, and the decision was irreversible.

Additionally, once the group dispersed, the people left behind felt an intense sense of loss; not only did they miss their co-workers, but they missed the

expertise, and spirit of cooperation they shared. They became less productive and certainly didn't feel as if they were learning more or creating more. If someone was relatively new to the group, and heavily relied on the other members for support in many aspects of her job, that person was lost.

In so many cases, the person who may have had an answer was so overwhelmed with their own work, that the normal anticipated, enthusiastic willingness to help had vanished. Those of us left had to face it, we were on our own.

After the move, some team members were forever pestering the boss, who projected indifference, and usually offloaded them to another co-worker for assistance. The boss eschewed becoming the "go to" person. He didn't want needy people lining up outside his door.

With fewer voices heard over the open cubicle walls, and fewer colleagues left for collaboration, it didn't take long for creative thought, innovation, and feelings of empowerment to dwindle.

Had the leadership risen to the occasion instead of caving to the pressure of other departments, the workflow would have continued to improve. Stymying bureaucratic obstacles could have been solved easily, and optimism and creative thought might have improved.

But that was not the case. The boss was weak, he avoided tough conversations, he didn't stand up for his people, he was a milquetoast, a pushover for other managers who could easily bully him into agreement. He didn't want to be a decision maker, he liked the pay grade, but not the responsibility it took to actually lead.

This failure of leadership led many department
members to retire, change jobs, or quit the company.
And one too many bad decisions actually led to
this boss being demoted. In his new position he
thankfully no longer had charge of people. Instead,
he functioned by himself, without passively
stifling people's creativity, morale and feelings
of empowerment.

How, you might ask, would W. L. Gore do it?

Chapter 4

At W. L. Gore It's All About Making Money and Having Fun

"It starts with that word, 'Associate.'
We're more than employees; we're trusted
stewards of our business."

— Bill Gore

AT W.L. GORE, the chemical company most famous for Gore-Tex, there are no management layers and there is no organizational chart. Few people have titles, and no one has a boss.

The core operating units are small, self-managing teams, all of which share two common goals: "to make money and have fun." The organization is compared to a lattice, with all Associates being more or less equal, and with the ability to freely communicate across disciplines and roles to anyone in the company. It's a human approach, dealing with people directly rather than following an artificial chain of command.

Imagine a workplace where employees can talk to everyone and anyone, and there is no barrier or Gatekeeper to the VPs office, because there is no VP or Gatekeeper. There are no bosses, no supervisors, no managers, in fact, there is no hierarchy whatsoever. It's a place where creativity can flourish and is encouraged!

Leaders from within

Leaders are distinguished by their behavior, as judged by their teams, and these leaders must prove their worth daily.

This approach is confusing to visitors because it's not immediately apparent who the leaders are, contrary to more conventionally structured organizations where leaders are surrounded by a contingent of yes-men or women, and where highly paid assistants guard the boss's elegant window office, identified by the fancy brass signs on the office door. (One company I worked for called the executive suite "Rug Row").

According to former CEO Terri Kelly, W. L. Gore designed this non-hierarchical structure to encourage innovation and "because it should be more situational and fluid." The structure is described by owner Bill Gore as a "lattice" connecting all employees to one another in order to work in small, self-managed teams.

The egalitarian spirit of W. L. Gore shows in the selection of the CEO. The Gore associates make their choice for the job by voting the CEO into power from their own ranks.

Some associates, however, have earned the simple appellation "leader," based on the situation. For instance, the Gore culture describes a leader as someone who can attract followers. This means that whoever has the right experience or knowledge to solve a specific problem or best produce an innovation, emerges as the leader of a particular project. However, with this freedom of choice comes commitment, so when a leader surfaces among a team, (s)he assumes the responsibility to complete the project and is held to that standard by the team members.

At W. L Gore, senior leaders do not appoint junior leaders as is expected in a traditional hierarchical

or command and control management environment. Rather, associates become leaders when their peers judge them to be such, based on the specific qualities that make them good at what they do. A leader at W. L. Gore garners influence by exhibiting a capacity to get things done and excelling as a team builder.

In this flat, lattice-like culture, associates make the biggest contribution to team success. When they do it more than once, they naturally attract followers.

"We vote with our feet," says Rich Buckingham, a manufacturing leader in Gore's technical-fabrics group. "If you call a meeting, and people show up, you're a leader."

This kind of out of the box thinking is so radical, it would not work for some organizations; the bureaucratic infrastructure alone would prevent it. Instead, those organizations can't seem to escape the traditional top down, command and control structure, regardless of whether or not it works. The old structure is so embedded into the organizational culture, that any other way to imagine functioning is impossible.

Have you ever called a meeting where no one showed up, or people rudely sauntered in late, claiming your meeting wasn't important because they thought your project would never materialize?

Remember that feeling of defensiveness, anger, desperation, and being out of control?

Or think of times you've been assigned to a project run by someone who had no idea what he or she was doing. Wouldn't you have loved to "vote with your feet?"

I've sat in numerous meetings where I could feel myself becoming a little scared and overcome with suspicion because the "leader" gave out erroneous information or had a sloppy approach to a problem

I knew full well how to solve. But I was too low on the "food chain" to be asked to contribute, and the arrogance and ignorance of the "leader" caused the company to go down a very deep, expensive rabbit hole, before realizing they were going in the wrong direction.

Simply allowing everyone in the room a voice could have saved time, money, and effort. This practical approach is the concept behind W. L. Gore's organizational philosophy. You don't get to be a leader there because someone else appointed you. There is no Peter Principle. No nepotism. No incompetent and unthinking managers who ignorantly carry coffee into a clean room area.

A problem is presented to a team, and the person with the most experience or understanding of the problem becomes the best person to lead. Followers rally around the emerged leader to support getting the job done right.

> **What would it be like for you to "vote with your feet" and chose the team you wanted to work with?**

Imagine, if you're an employee, what that would be like in your organization? What would it be like for you to "vote with your feet" and chose the team you wanted to work with?

Or imagine you became a leader because you are the very best person in the room to perform a specific skill. What if your colleagues knew it, and your boss seconded the motion?

What if your boss was hired based on talent and ability, not because (s)he knew someone who pulled or pushed him/her through the HR system?

You might begin to love the thought of going to work every day. You might be thrilled to dig into an interesting new project, where your contributions were seriously considered instead of ignored.

Making it work

It's precisely because of the issues described throughout this book that I wanted to bring something more uplifting to you. There is much wrong with organizations around the world. However, just as you learned in graduate school, there are organizations who believe in the "human" side of "human capital," and put that belief into practice by utilizing and leveraging the talent they feel lucky enough to attract.

In the case of Gore, regardless of race, gender, religion, or any other form of being different, your words are heard. You're more productive, and the company benefits from your independent thought. Speed, agility, customer satisfaction, and innovation result from going beyond the old way of "management."

If you worked at Gore, you'd be spared the dread of running your badge through the card reader every morning and feeling a phantom stab in the heart as the heavy, metal turnstile clunked open (as I remember in one of my past lives).

What does this mean in terms of the correlation between communication, leadership, and team building? The ethos, or corporate culture at W. L. Gore clearly is in step with the company's mission, vision, values, and goals, which we will address in future chapters. Their guiding principles are:

1. Freedom
2. Fairness

3. Commitment

4. Waterline (not jeopardizing the company's long-term plan).

Moreover, the company thrives with their flat, "lattice" organization structure. There is no "red tape," no layers, no barriers to communication. Teams are built around natural leaders. "Leaders" can't be convenient political appointees, or "rotated" into a corporate "welfare" job (as in *The Dilbert Principle*). The leadership style is based around a simple leadership principle: "If you prove you can lead, people will follow."

Teams are created around the simple mission and vision, keeping all employees motivated and engaged at a high level. Proof is in the pudding, as there is no boss to micro-manage or "oversee" work.

Employees must be self-starters, self-motivated, and require little supervision. This pre-requisite lays the groundwork for a specific type of employee; no laggards need apply. For contrast, in large organizations, its well known that people can hide on the job. There are many examples of this: from running legitimate errands to traveling to other buildings or other sites, and endlessly attending conferences and meetings requiring expensive travel.

However, the most egregious, flagrant illustration of the ability to hide I've ever heard of, were reports of people actually sleeping on the job in an out of the way area near the receiving dock where some people would hide, under the presumption of going to "smoke." On more than one occasion, people were found propped up on bags and boxes, fast asleep during regular working hours. There was no explanation and no consequence. Their leader was off site, so no one was watching. It didn't matter if

their work got done or not, they survived by staying under the radar for many months. No passion or competence needed to hide from work. These employees would have no chance at Gore.

For a clear definition of how W. L. Gore Associates operates, Michael Pacanowsky, a long time consultant to Gore reports on his website,

> *"The leader emerges because of his or her passion, credibility, competence, capacity to make things happen, capacity to help others get things done, and ability to create a narrative about the importance of some activity within the larger context of values and culture at Gore."*

Even more interesting, the Associates at Gore not only determine who their leaders are by who emerges as the best person for the job, but they determine each other's salaries as well.

How comfortable would we all be if our peers determined our salary, or if we determined our leader's salary? Most people would be shocked to even be considered for that opportunity. But performance on the job where people don't work together, but rather in a vacuum, is similar to producing a viable, technical or scientific study. Before publicly releasing the work, it has to be peer reviewed to be credible.

So being judged by your peers for your work means you've proven yourself credible on the job. And it keeps everyone honest, too. You can't hide from your peers if they are controlling your paycheck.

> **Being judged by your peers for your work means you've proven yourself credible on the job**

51

According to the Gore "Culture Press Kit", the founder, Bill Gore, took the idea of the "lattice" organization from his work on small, intimate task forces within Dupont in the 1950s. He was determined to build a company based on the idea of personal interaction with skilled people sharing ideas and leadership roles.

What would it take to reorganize other US companies into "lattice" works? Who would benefit? What would be gained or lost? Could the idea of "pods" or "task forces" or "skunk works" be integrated into our everyday work environments? How would we develop the trust that it would take? What happens to ambitious, competitive people? Where would we start the process? Would people be comfortable giving up their highly sought-after bonus-based jobs?

In a freewheeling, Darwinian environment like the W. L. Gore culture, a leader is faced with "survival of the fittest." If he/she is aggressive and has a strong track record of success, is credible, passionate, gets things done, and is competent, he/she will attract followers and support for innovating new ideas and bringing projects to completion.

This is an interesting ethos because it forces a continuous stream of creativity to flow. It also compels team members to gravitate toward the leader with the most open idea flow. Teams exist as long as the leader consistently produces success; so, a natural symbiosis occurs as well. And because there is no pressure from a debilitating bureaucracy, ideas become reality. If not, a new team leader emerges, and the leadership cycle repeats.

It's also fascinating how "influence" has recently become one of the key criteria of leadership. At W. L. Gore, influence and leadership are one and the same.

As Lawrence of Arabia said in his book *Seven Pillars of Wisdom*, "You may lack power and authority, but you can develop influence."

At Gore, with their innovative, lattice structure in place, people have the freedom to express ideas and the personality to emerge as an influential leader. In most companies with traditional organizational structures, power and authority are woven into the fabric of leadership roles. Most employees are uncertain how to break through that wall of power to create their own influence. The only effective way is by using influence which is cultivated over years throughout a career. Even without power and authority, people can get things done if they are able to sway the powerful through using influence.

Opportunities will rise for ad-hoc leadership duties in many settings. Say you're tasked with leading a diverse group of contributors through a major project. You draw up your plan, craft your budget, map out your work breakdown structure, and assign roles and responsibilities. What could go wrong? No matter how dedicated your teammates are, you struggle to meet your milestones.

When you probe deeper, you find that in addition to working on your project, a few of your teammates have not been relieved of any of their regular duties. They've been working late, and too many personal activities have been missed. Now their spouses are losing patience, the kids need rides to and from places, and they've missed a number of personal events, birthdays, concerts, recitals, and games.

This was not the work environment he or she expected. However, there are not enough people available to get the work done so those left behind are continuously asked to do more.

What can you do? You have no power or authority to change their workloads. Now is the time to call in a few favors, in the form of exerting the influence you've earned over time. You've volunteered for this job, so your boss should be on your side. You meet with the boss, and she makes a phone call or two. She is able to get at least one person released to your team full time. You devise a plan to rotate the busiest people around the project schedule and personally walk the plan around to each contributor's boss. Since your boss has already been successful, you bring up her good will and review your plan with each boss, one at a time.

Since there is precedent and your plan has your boss's blessing, just like in case law, they follow precedent, and give in a little. Now they're willing to release some time for the good of the project. After all, it's a multi-million-dollar bid, and they realize their bonuses are also riding on its outcome. You've successfully used your well-earned influence and brought your team together.

You've used your influence and created a mini-lattice organization

For all intents and purposes, you've created a mini-lattice organization and now can settle your team into successful project completion.

Without your use of influence, you never would have created a viable team. Your project may have missed the customer's deadlines. Proper reviews may not have happened. Because you invested in cultivating relationships across functions, you reaped the rewards. You have proven that relationships between human beings go further

to influence decision makers than the power and authority you didn't have in the first place.

Of course, your experience is based on the organizational structure and culture of your workplace, especially where influence and favors get results. What might be different if you worked at Gore? At Gore, you'd become a leader by demonstrating and promoting your good ideas and having others agree and follow along with you. You'd complete your project more quickly and with greater creativity, innovation, and more latitude.

The "lattice framework" at Gore is egalitarian, not authoritarian, and it lends itself to the success of talented people, like you. Regardless of your social status, gender, or any other discriminating factor, the Gore approach allows for growth within teams. That latitude fosters the growth of their bottom line and increases the company's leading edge technological advances, proving beyond a doubt, that you *can* have fun and make money too!

> *"I dreamed of an enterprise with great opportunity for all who would join in it, a virile organization that would foster self-fulfillment and which would multiply the capabilities of the individuals comprising it beyond their mere sum."*

— Bill Gore, 1961

The W.L. Gore model of business is attractive for all the right reasons. But most large organizations operate quite differently, with a structured hierarchy,

a command and control model, and some effort made to instill organizational values – thus influencing employee behavior at all levels.

Does this desire to influence value-based behavior actually work?

Chapter 5

Peace for Pay

*"The rate of change is not going to slow down
any time soon."*

— John Kotter

THERE IS MUCH TALK today about establishing organizational values and ensuring all employees follow them. However, often what the organization says it values and what it *actually* values (validated through accepted behavior), are very different things.

The organization may state values such as: People, Integrity, Commitment, Excellence, and Community. There may be awards given several times a year to employees who exemplify each of these values.

However, in a series of interviews conducted for a 2009 research paper I wrote for my master's degree, only one respondent out of 10 knew what the specific company values were, even though everyone had a "values" card worn along with their badges. Many said they didn't feel they needed the values card, as these same values were intrinsic to them. They said they lived by their own values system and didn't need the organization to tell them how to behave.

Interestingly, I interviewed a VP who pointed out that the reason the company instituted the values card was because, "We can't teach values, but we can teach behavior."

How values are valued

After extensively peeling back the onion on the company's implementation of values, I concluded that people often believed the stated values were shallow in actual practice. Of all the values, "excellence," widely interpreted as "performance" or "the bottom line" was the most important. And while the other values were not tied specifically to compensation, overt and embarrassing violation of those values were shown to lead to a heavy penalty.

To demonstrate, let me share – each local staff meeting at every level always started off with one slide on the company values. The slide was shown for only a few seconds and then it disappeared so fast, if you blinked, you missed it. This obligatory slide vanished quickly to allow the manager to get on with "real work." Rather than embarrass the boss by asking for a review of the values at the moment the slide is shown, employees would wait until the meeting was over and then privately discuss an issue that had come up during the week and question how the company values were impacted by that event.

When I interviewed these employees, they always presented the disconnect between values and expected actions. For instance, employees were asked to pay suppliers for work not yet completed so the sale could go into a certain quarter. This seemed contrary to the company values and wrong to them. They presented this issue to the boss in terms of: "What company value does this action represent?"

As can be imagined, there was no explicit answer from the boss to this answer, just an awkward and embarrassed smile.

The perception given to people on the front lines is that gentle pressure at the right levels can begin to engender a sense of urgency, but until leaders

demonstrate they understand and embrace company values and are willing to act on them, fear, anger, and complacency continued to persist, because people were not sure exactly what they were supposed to do; acting contrary to the values could have negative consequences, but so could recording an order late.

It appeared to me that true cynicism took hold: employees had come to realize they could "go through the motions" and not "rock the boat" and as long as bookings, sales, profit, and cash targets were met, none of the other values would have any real impact on their daily work.

To answer the question at the most elemental level, "What do people in the organization value?" we need to look beyond the employee values card. Based on my interview sample as well as multiple examples of anecdotal evidence, it seems many people trend toward placing value on survival. "Peace for Pay" and "Active Exit" strategies were apparent in daily discussions as well as in the samples taken for the October 2009 research.

There seemed to be a high level of frustration, a perception of meaninglessness, and little real employee connection to the stated values: People, Integrity, Commitment, Excellence, and Community. Widespread superficiality, "going through the motions," and operating in a daily depressing fog seemed to pervade cube stations across the company.

Daily examples supported this theory. For instance, the values card for the "People" value stated: *"You are important to us. Earn respect and treat others fairly every day. Commit to developing yourself and others. Seek Life Balance."*

However, this "value" seems to fail when put in practice. For example, a new director decided to bring his own admin with him to his new job, displacing

the current admin. The current admin was then told she had to reapply for her job, and she received no backing from her management. She then had to lodge an HR and legal complaint on her own, feeling she had nothing to lose, since she would probably be out of a job either way.

Believe it or not, in this actual, real life case, the admin won! But what did she win? Following her triumph, she had to work for a manager who tried to get rid of her and she was aware that the admin who was brought along with the new director would now be out of a job. If the director had left well enough alone, none of this would have happened. But he wasn't putting people first, only his own selfishness.

I am certain neither of those admins feels truth in the "People" value statement: *"You are important to us."*

As a result of this type of behavior, many people place value on ensuring their 401Ks stay intact and they and their spouses stay healthy enough to enjoy a long retirement. Peace for pay.

I personally learned to escape this kind of "quiet desperation" by leveraging the many benefits the company offered in its quest to fulfill its "People" value. The company paid 100% tuition for degrees – up to $10K per year – and offered much in the way of recreation (company gym, wooded walking trails, free semi-annual parties) and multiple other company benefits. It would have been a waste not to take advantage of these perks.

Truth or consequences

What issues can we recognize today as causing fear, anger, and complacency? Issues leaving the "People" less than enthused about their job or their company? What about those employees who finally get real and trade 'peace for pay'?

I maintain the shallowness of implementing the stated values is the main cause of fear, anger, and complacency. Since most people acknowledge the hypocrisy and double standards, they then feel they may risk their jobs if they try to right a wrong. In fact, without strong internal advocates, righting wrongs may be considered a contact sport.

Here's how that works. An employee at the same company experienced cognitive dissonance in supplier ratings. He discovered a program which was clearly failing to meet any cost, schedule, or program milestones had been rated at a higher level than it deserved. It was discovered that this system was regularly put in place to cover the company's weakness in managing the supplier. When the employee inherited the supplier, he immediately rated its performance below par, and consequently took much criticism and pressure from management given its previous acceptable rating.

To his credit, his response was that if the suppler was not living up to the Statement of Work (SOW) – an extremely detailed document that captures and defines all aspects of a project as well as the schedule for project completion – and failed to meet schedule, he would not change the rating back. There was no argument or fuzzy logic involved. Previously, others with less experience had feared such challenges as career-limiting and under pressure had left the rating in the acceptable range to appease management.

> **Be honest, always do the right thing**

This demonstrates how having to challenge management to live up to the "Integrity" value (*"Be honest, always do the right thing"*) on a regular basis

61

can engender frustration, anger, and a sense of complacency, and as in any management challenge could become a "contact sport."

Corporate Values, as presented by an organization's management, might masquerade as support and guidance for employees with the expectation that the values are followed. But when company executives anywhere are compensated and rewarded the same way Wall Streeters are, by sales and quarterly numbers, you have to expect Wall Street behavior. You know, the kind we saw with the character Gordon Gekko in the movie *Wall Street*?

Gekko famously says "Greed, for lack of a better word, is good."

And, "The most valuable commodity I know of is information."

And, "Money never sleeps, pal."

Is this the value of "Excellence" my survey subjects referred to as "Performance"? Or is it just another way to say, get those sales, regardless of what happens later, this quarter, we all increased our annual bonuses.

Measuring success in this case may not be about values, but more about greed.

The question then is: What happens when success and failure have a cause and effect relationship? Which comes first, the chicken or the egg?

Chapter 6

A Marriage of Success and Failure

"The real test is not whether you avoid this failure, because you won't. It's whether you let it harden or shame you into inaction, or whether you learn from it; whether you choose to persevere."

— Barack Obama

SO FAR, you've read about what leadership looks like in different organizational structures, the egalitarian approach at the Gore Company, and in Chapter Seven we'll see attempts to be more efficient in *The One Minute Manager*. Sometimes people are so overwhelmed with the bureaucratic approach, they're willing to hang on for the sake of security, as in "Peace for Pay," similar to the world of "quiet desperation" aptly described by Henry David Thoreau in his book, *Walden*, written in 1854.

When we go further into the experiences of the individuals who show up to work every day, and navigate their way through the "slings and arrows" of their daily grind, we witness the impact of all leadership decisions. As an observer of many significant corporate dramas, I've learned how people feel when leadership decisions become personal. As a coach, I've been

fortunate to support people in their careers when leadership has their future in the crosshairs.

In fact, my former colleagues still seek out external support and encouragement in the form of professional coaching quite often. It's been a privilege and honor to work with several over the years.

One such colleague, Peggy, I had known for many years as a coworker. I always admired her many accomplishments in her long, dedicated career. She was a genuine and sincere person and a hard worker. Peggy spent much of her time focused on her job. She was single and had no children, so her professional life was everything to her. I remembered a time when Peggy missed her flight for a Greek vacation because she was so heavily involved in a multi-day program management review. The review was intense, and she had completely lost track of time.

When she called to make a coaching appointment we agreed to meet in my office a week later.

At the appointed hour, Peggy knocked quietly on my door. She seemed embarrassed to be involved in a coaching program, but I assured her, dozens of other executives had come through my door. I took her coat, she made herself at home on my couch, and we shared some coffee.

After some small talk, she was ready to speak her mind. The work problem that haunted her had nothing to do with winning or losing as a leader in her capacity at work. It was bigger than that – it had to do with aligning her values with the values espoused by the company. The test of her personal values came through two crucial experiences she had on a multi-billion-dollar program. The goal of our engagement, we decided, would be to explore these in terms of her values.

The events most on her mind were tied together: her least satisfying and her most satisfying experience on the job. Ironically, these two events were related to the loss and regain of the same program – a very big program with a winning $1.7 Billion price tag. The bid her team had submitted was $2.15 Billion!

We know that values drive behavior and that corporate values do not always align with our personal values. In the case of Peggy, her values would drive her decision-making regarding the next steps in her career path. We spent time breaking down what values were most important to her.

Regardless of winning or losing, Peggy held three crucial values for work:

A) Trusting relationships

B) Enthusiasm for the job

C) Being credible to superiors and direct reports.

She relayed the story of the 'losing' bid, as we can imagine her feelings when she saw her $2.15B bid was crunched down to only $1.7B as having lost rather than won that round, during our first one-hour session. Together we decided her story about this major loss and subsequent win back was closely tied to her personal values. We decided we needed to link a negative experience to a success where she had applied what she learned.

Uncovering Peggy's Least Satisfying Work Experience

At first, Peggy only briefly discussed her least satisfying work experience. Her reluctance is common. I see this in a number of clients, no one

likes to admit to their own failures, but I convinced her that failures had to be explored to make progress. Upon further prompting, Peggy began to discuss her experience in more detail.

She mentioned that her least satisfying experience was as a youthful, new manager, thrust into a work situation she could not control. Her role as a new hire was as the business development lead on a major program. It wasn't long before Peggy knew she was in over her head. She had little to no knowledge of the project, was unfamiliar with program schedule and cost restrictions, and was operating under a very tight budget.

Moreover, her boss refused to allow her to travel. In the world of high stakes business development, meeting the client face-to-face and establishing a close relationship is key to winning these very large, high value programs. The disappointment was apparent on her face as she told me this story. She seemed nervous, bouncing one leg continuously, and fidgeting in her chair. We took a short break and she continued her story.

As the business development lead, within a four-month period of time she and her team were responsible for losing over $1.7B worth of sales for the company! No matter how big your company, or how many millions the programs are, $1.7 Billion is still a big number.

Peggy became filled with discouragement and self-doubt after that. She wondered about her reputation in the business and her job stability.

"I felt incompetent," she said. "I worried that I'd never work on another high-profile program, even though that's what I was hired for. I was making a lot of money and I wanted to show them I could earn it."

Even though she was hired late in the business development process, she realized she was being held accountable for losing an opportunity that had been in the works for over three years, prior to her joining the company. Furthermore, the project had been sold as a slam dunk for the company. They had had this business contract for over 20 years, unopposed. They felt like they had knocked out all the competition. The prevailing thinking was that putting in new, raw talent wasn't a concern.

But this knowledge did nothing to alleviate Peggy's fears after this big loss. She worried that the people working under her did not trust her, did not properly communicate with her, and that the Senior Vice President who was guiding her was sporadic in offering direct guidance. At one point during the program, she had to hunt him down to get crucial answers on pricing strategies. She relayed to me that he seldom made in person appearances in the kludged-together temporary work area, and he watched the internal program spending budget like a hawk. Peggy came to realize that since the company assumed that this $2.15 Billion program was always theirs, he didn't feel the need to go out of his way to make sure his team was winning.

Contributing to her sense of failure was the feeling that her direct reports were in competition with her, as she had been hired from outside the company, which made her an amateur in their book. And they competed with each other, each person holding information close to his vest.

In this type of corporate world, knowledge is power, and who you know gets you ahead

If you have ever worked for a big, complex company, this may sound familiar. People jockey for promotions, good assignments, travel to interesting places, and seek facetime with the boss. In this type of corporate world, knowledge is power, and who you know gets you ahead. Peggy admitted she felt the team wasn't willing to share with each other because they each wanted to prove they were better than the newcomer. Consequently, there was some overt jealousy among the team over Peggy's being selected for the position, and rather than focusing on a big win for the company, the team's energy was spent in political positioning

These events contributing to the big loss left Peggy feeling disappointed in herself. She was blaming herself and beginning to question her own leadership skills.

After this loss, only four short months on the job, she began to consider leaving.

Her feelings of sadness, worry, and exposure were beginning to weigh on her, causing stress and disillusionment. She expressed this to me with sadness in her voice, and her eyes began to well up with tears. We took a moment as she released the tension she had held on to for so long.

Peggy's Most Satisfying Work Experience, the Big Turnaround

As often happens in life, Peggy's story of the big turnaround demonstrated her ability to be creative, think outside the box, and use her leadership skills.

Her most satisfying time at work, happened to be the story of the recovery from the big loss.

Feeling down about the debacle of the losing bid, she initiated a frank one-on-one conversation with her boss, even though she was truly afraid she was going to be fired. Instead, the boss sat her down and told her two important points:

1. He had invested a lot in bringing her into the company.

2. He was not going to let her go after the experience of losing such a huge program. He knew she was smarting from the loss. However, the major lesson was in the losing. The opportunity presented itself to recoup and do the right things to win back this huge chunk of business.

Partnering with senior management, she was tasked with turning the company's way of doing business around. Her decision was to create a radical culture change, and fast!

First, she knew she needed the best people for the job, so she was trusted to pick only "A" players from every geographic region. She introduced the concept of price-to-win, that is, learn as much as you can about the competition's pricing scheme and get your winning price under that threshold.

Under her leadership, the original bid of $2.15B was brought down to $1.7B by creating independent cost centers and outsourcing production, therefore lowering expensive overhead costs.

She explored creative ways to gather the competitive intelligence the company lacked in the first go-round. Because these processes were all new to the business, she convinced her peers and superiors that a pivot had to take place in order to stay in the winner's circle every time. Thus, a new

way of thinking about winning business evolved from a sole source mentality to a competitive one.

As a result of winning back that business, Peggy was recognized as a major part of the company's success. She was gifted company stock, a large monetary bonus, and several achievement awards to hang in her office.

In addition, due to Peggy's leadership in changing the culture, she survived a major HR assessment, where almost every other member of the team was let go or told to retire. In this company, this HR assessment counted heavily for her to continue as a manager there. Corporate HR played a major role in talent retention and development. The company's success was closely tied to keeping the top talent and trimming the rest, and that philosophy was no secret. In fact, the CEO wrote several books about the importance of placing the right people in the right job.

As a result, senior management tasked Peggy with producing a new strategy for new business acquisition. And, she had less than 24 hours to produce it. The day senior management gave her the assignment, they told her the strategy was to be presented to the company's management team the following morning!

To her credit, Peggy produced a one-page document that outlined a new strategy overnight, and with only a one-word change, that strategy for winning was adopted by the company. As Peggy told me this her whole demeanor changed. She brightened up, and leaned forward in her chair, more than happy to share the details.

As a result, she was sure the team she assembled was committed to her processes, and by turn, it

became a very rewarding experience for her and her team. Peggy remained in that position successfully for several years.

This turnaround gave Peggy much needed confidence. She felt that the trust her management team now had in her flowed to her new reports, and she gained credibility from both. As a result, her enthusiasm for the job became contagious with her team members, all working hard on the new strategy with excitement and anticipation. Peggy felt relieved, protected, like a survivor.

Discovery

What Peggy discovered through her coaching sessions with me was that her key criteria for success on the job is to ensure that there is mutual trust, a sense of urgency or enthusiasm for the job by all team members, and that she needed credibility from both her superiors and her direct reports.

With these elements in place, Peggy had a recipe for success. Without any one of these elements, failure for her is probable.

The value in what happens within a coaching program flows both ways. Working with Peggy, I discovered how a person's basic criteria for success or happiness in a leadership role needs to be articulated and recognized before a person can begin to take steps towards fulfilling their stated goals. In Peggy's case, her failure and success stories were linked. However, yours may not be.

> **The value in a coaching program flows both ways**

It's interesting to note that her criteria were tightly aligned with her personal value system. Without understanding values as a basic approach to success, goals and the criteria for achieving them, is harder to attain.

This chapter deeply delved into one person's story, but it serves as a reminder that when people's personal values align with company values, the work becomes more than a paycheck. When that happens, for most people at every level, it feels as if there are very few obstacles to getting the job done, that personal gains are secondary to team gains, and trust and integrity are embraced and demonstrated in the behaviors of all.

Establishing values and visibly living by them is the sign of a true leader. Values merge into every aspect of a culture and when everyone embraces them, success happens. To align values is not an overnight task, it takes time and commitment.

And to be successful, it takes more management skill than can be achieved in one minute.

Chapter 7

How the "One Minute Manager" Works with Corporate Dead Wood

"...When you go too fast ..., you're not paying ...
attention to your team and how they think."

— William Vanderbloemen

K EN BLANCHARD, organizational author and an influential leadership and management expert, is well-known for his "One Minute" books, widely read and studied in management schools. He focuses, on the efficient day-to-day management of people and organizations. Blanchard, of course, is a prominent speaker, as well as an author and business consultant. He is chief "spiritual" officer of The Ken Blanchard Companies, a worldwide human resources development company.

As an author, Ken has written several books including the now famous, *The One Minute Manager*, which has been widely noted as a valuable tool for developing leadership. Blanchard has openly said he based his later work on the tenets established in *The One Minute Manager*.

When I first read *The One Minute Manager*, it seemed to me that his approach was based on the assumption that the organization was working with a deep bench, and the employees were easily motivated

by simple straightforward concepts. Blanchard posits his ideas for an ideal setting, where people admire management and have faith in their decisions. That's why the basic theory behind *The One Minute Manager* is that people only need simple, clear direction to be successful.

This is boiled down into three practical rules of management:

1. One Minute Goals

2. One Minute "Praising"

3. One Minute Reprimands (recently updated to One Minute Redirects)

The bottom line is to give people mutually defined goals, make some excitement for success, and deal with mistakes quickly and appropriately.

As Blanchard's research has borne out, these simple rules can fit many circumstances for the most part, such as: childrearing, coaching teams, as well as the ideal organizational environment.

Stating that managers need to believe in people and treat people with respect pretty much sums up his philosophy and appears to be based on the assumption the workforce will respond positively to management's latest process improvement or change management effort. This idea doesn't work in an atmosphere where the best person for the job is not always the person that has the job. To a veteran employee of a large organization, it demonstrates Blanchard's lack of understanding of the mainstream workforce and the relationship between managers and their people.

According to Blanchard, this faith and respect is what leads to feelings of employee satisfaction for a job well done. When people feel satisfied in their work, they feel good about themselves, and are more

efficient and effective (The classic E2C2, with E2
being efficient and effective and C2 being capability
and capacity.)

But doesn't that rely on the depth and quality of the organization's talent pool?

Does it allow for nepotism and cronyism? For
"favorites"? The boss's son or niece who needs
something to do rather than hang around the house
waiting for a job to come their way?

According to Blanchard, successful employees
can be motivated by positive feelings generated from
clearly established goals and expected behaviors.
This, he declares, propels people into far better
performance, every day, not just when they are in a
"good mood." But does that hold up in all cases? In
most current management theories, management
must earn the respect of the employees through
their honesty and integrity. We talked about that in
Chapter 3 extensively.

Plus, multiple studies show that employee
engagement and satisfaction improve productivity
more than any other process or technique. So then,
what is the criteria for a "good mood"? Positive
feelings in the workplace are most often generated
by fellow co-workers, not by management goals.

And Blanchard's theory offers no answer to
disgruntlement when people are passed over for
promotions, raises, or career enhancing assignments.

Blanchard also focuses on managing through
a democratic process. He states that an autocratic
managerial style will only alienate employees and cause
them to not believe in the work they are accomplishing.
His philosophy is that managers must be able to
communicate with their employees and discuss

those things that are causing a negative feeling in the workplace. This is the democratic process in action. The reality is that the democratic process cannot exist in a large multi-faceted organization. When managing billions of dollars of revenue and tens of thousands of employees, democracy, where everyone's vote counts, is out of place.

In my 30-year career in these types of organizations, the management structure was very controlled. Like the military, inside these organizations, there is a clear line of authority – a chain of command, from top to bottom, and unless a manager is a weak link, employees need to work within that framework. It can be career ending to go around the direct manager. Bucking the system is guaranteed to generate negative feelings on both sides. Blanchard's idea is that there must be discussion of issues that create those negative feelings with the direct managers, however, these matters generally are delegated to the Human Resources Department or the Employee Assistance Program.

> **When managing billions of dollars of revenue and tens of thousands of employees, democracy, where everyone's vote counts, is out of place**

A democratic management style with open communication is admirable, but impractical in large, complex organizations. The institutions and businesses they represent are simply too large to be democratic. Strategies and policies must be uniform and administered in a consistent way to develop

desired behaviors and branding associated with that organization.

According to Blanchard, in *The One Minute Manager*, the workplace environment should not be run by the employees' wants and needs. There must be give-and-take between managers and their employees. In turn, a good manager must also be able to relay concerns of productivity and establish goals for the employees so as to not only increase production, but also maintain the quality of the product. A manager who is people-oriented will have employees who want to work and be productive and it is through happy, satisfied people that results are produced.

Individual managers who support their people tend to generate more satisfied, engaged employees. However, if the manager is not people-friendly, the work still must be accomplished, while maintaining quality. One manager I knew supported me with every decision I made. He didn't question my work and he gave me a significant raise within a short period of time.

When that manager left, my life became hell. The new manager tried to stop me from introducing any new ideas, and it seemed he was openly looking for ways to push me aside. He constantly probed into how well I knew the company president, since he was the one who recruited me. This manager was scheming as to what blow-back he might suffer from the company president if he rocked my boat.

The pressure was unbearable, but I still had to perform my job just as I always had, to a standard of excellence that my previous boss expected and received. It didn't matter how satisfied or happy I was on that job, I still had to perform.

Dealing with a "weak bench"

I am not alone in my assessment of Blanchard's concepts. Some scholars disagree with his approach to giving people as much free reign as he proposes, without qualifying the employees first. The argument states that those not mature enough in their jobs, won't be able to function successfully in this type of atmosphere and will fail, creating a "weak bench."

Many businesses do not deal with the issue of a weak bench, so Blanchard's management approach can't be universally applied until companies deal head on with dead wood and hangers-on. In a large, complex organization, the massive size and scope of the institution or business can allow for dead wood and hangers on to survive for a very long time. In some cases, no one even knows what these people do. Nepotism and cronyism are often responsible for the dead wood and the others as well.

> **Blanchard's management approach can't be universally applied until companies deal head on with dead wood and hangers-on**

In one case, a lovely couple were hired. The wife was an electrical engineer and fit nicely into the organizational structure. However, the husband could not make the adjustment to a large U.S. company. He had difficulty wrapping his mind around the corporate structure and expectations. He was moved from department to department for years, and finally was laid off. For whatever reason, as nice a man as he was, he never fit in any department he was placed.

Other examples are friends and relatives who are brought in and never pick up the nuances of the job. In recent memory, I knew of one person put in charge of critical parts for sensitive equipment. It turned out that he was the son of the boss's wife's hairdresser. He had no skills for the industry or the specific position. His incompetence hurt productivity and morale throughout the department.

Proposing that managers need to believe in people and treat people with respect is the summary of *The One Minute Manager* philosophy. This positive faith and treatment are what Ken Blanchard believes lead to employee feelings of satisfaction for a job well done. He leans on the posit that when people feel satisfied in their work, they feel good about themselves, and are more efficient and effective in the workplace.

Can we have a successful manager in one minute?

While there is nothing intrinsically incorrect about his theory, it is not granular enough to apply universally. Experience in the workforce is more apt to reflect what really makes a good manager. Hence, how can we have a successful manager in one minute?

Here are the one-minute manger goals Blanchard shares in his theory:

1. The First Secret: *One Minute Goals* – Blanchard's belief that goals can be defined in one minute. These goals would have to be simple, as in "put these cans of soup on this shelf," to take only one minute.

2. The Second Secret: *One Minute "Praisings"* –
 Everyone appreciates the "Atta Boy/Girl"
 moment, but a written thank you or a gift
 certificate takes more than a minute. The
 pat on the back only goes so far.

3. The Third Secret: *One Minute Re-Directs*
 (Updated from One Minute Reprimands) –
 Simple tasks may take a one-minute redirect,
 as in, "not those cans of soup, these cans,
 over here." Spending one minute on a
 reprimand or redirect makes more sense
 than nagging, but simple ideas for simple
 people seems to be Blanchard's bottom line.

You can see how the elementary ideas he suggests
are not usually found with sophisticated employees
in a complex organization.

These concepts need more than one minute to be
effective with highly talented people performing high
level work. But how good are meetings at making us
more effective?

Chapter 8

Death by Meetings

"The hard truth is, bad meetings almost always lead to bad decisions, which is the best recipe for mediocrity."

— Patrick Lencioni

DURING MY 30-YEAR corporate career, I often led meetings, reviews, strategy sessions, etc. In the rather undisciplined work culture that existed, conducting any meeting was often a major challenge. Starting off, I knew I had to outplay the potential meeting attendees, because there was always a useless challenge which I viewed as stalling tactics: complaining about the physical location, the time of the meeting, or the seating arrangements, which had no bearing on the meeting's outcome.

In a way, people couldn't be blamed because most of the meetings in that culture were totally deadly. Many times, I felt as if not only was my brain numbed, but my entire being was becoming anesthetized.

It's somewhat confusing until you finally realize that the "deadly meeting" syndrome is actually real.

I'm sure you have sat in a meeting where the attendees regularly committed the "seven deadly sins"

of meetings. As described in *Entrepreneur* magazine the "Deadly Sins of Business Meetings" (2012) are:

1. Meetings that become useless rituals.
2. Meetings that are a one-way conversation.
3. Meetings with lax leadership.
4. Meetings harping on setbacks instead of strategies.
5. Meetings that disrupt the most productive hours.
6. Meetings held in a bland environment.
7. Meetings that are too formal and rigid.

I likened conducting meetings in that environment to the hopeless efforts of Sisyphus, punished by Zeus, to roll a boulder up a hill in Hades, only to have it roll back down again in perpetuity.

And if you work with engineers, you will find their attitude towards meetings is like being punished by Zeus. Managing them is almost a Sisyphean effort of its own and can be just as complex and confusing as "herding cats." Engineers tend to be individualists, as are cats, and not so easy to manage or control. The undisciplined behavior of some of the engineers I worked with was part of the "Wild West" culture I experienced, back in those days.

Do meetings have to be like herding cats or resemble Greek mythology?

We can't avoid meetings. But if no one steps up to fulfill a leadership role in this circumstance, how will any meeting become productive?

Getting a group under control takes planning and preparation. Good leaders inform people ahead of time as to the purpose of the meeting and distribute the agenda items in advance. And a good leader

sticks to the agenda, tabling any off-topic discussions for "offline" conversations.

Imagine, you're already going numb in a meeting you thought was to discuss a major program plan, but instead, the conversation veered off early on into last night's game or an upcoming concert. You might be tempted to walk out, because now you're wondering why you are wasting your time sitting there.

A good leader cuts off the irrelevant topic and pulls people back to reality. Leaders can't afford to let people drone on when they are off topic, because others begin to feel sedated or worse. The best leaders know how to keep a meeting progressing. They plan the agenda with a finite amount of time allocated for specific topics, with an eagle eye on the clock.

What happens when a topic, for instance, an agenda item about a complex technical issue, comes up? A few engineers enter into a detailed debate regarding the excruciating details and the rest of the team begin checking their watches and scrolling their phones. The meeting has degraded to a debate between two or three people, and nothing else is getting done!

Or, what happens when somebody decides to bring up last year's budget, which is nowhere on the agenda? What if someone has an old ax to grind and they want to get it off their chest? What if one person brings up a previously tabled item, and half the room decides to rehash it, in a side bar conversation.

Regardless of the circumstances, or what outside, off-topic, unnecessary items come up, the person in charge must interrupt and table those items. Letting people rattle on and on only to hear themselves speak is what gives meetings a bad name and creates dread when people know they have a meeting coming up. Runaway talkers and poor leadership, without a semblance of discipline, typifies "death by meetings."

How can we create a meeting strategy that doesn't conjure up images of skeletons around the table? To be effective, we have to get creative. Another leadership tactic, essential for running smooth meetings, is to have an easel board handy and assign someone to put irrelevant items in the "parking lot." The presence of the "parking lot" gives credibility to the ideas raised, and yet transports everyone back to the reason they are all there in the first place.

An even better meeting strategy is to save anything debatable for the end of the meeting - that time when people once again start looking at watches and scrolling through phones. Controversy is sure to rouse everyone, and the temptation to go off the rails is always there. Keeping people on target and "out of the weeds" is the role of the leader in any meeting, whether or not the leader is formally appointed.

In my corporate career, to set the right tone in meetings, I always insisted on the appropriate meeting venue, and my area had all the right spaces for this purpose. I usually had to convince one of the major program managers, directors or Vice Presidents to hold his/her meeting there, rather than in some dreary, stuffy conference room in the main building (where the lights would go off randomly, leaving us in total darkness). My area was brand new, with fully equipped conference rooms, both large and small, technical support, smart boards and Wi-Fi access, among other attractive amenities.

By contrast, the conference rooms in the main building hadn't been updated since the 1970s. Some rooms still had similar furniture as seen in "Mad Men" the show set in the 1950s and 1960s; fabric covered orange swivel chairs with only four wheels (instead of the OSHA required five). Some of those chairs were a safety hazard, people fell off them regularly, especially when boyishly tipping back.

In addition, the old conference rooms had equipment that was a kludge of pieced together hardware, maybe the only current gear was the Polycom speakerphone, replacing the 1970s model, the SR 2000. The TV monitors were old cathode ray tube models, as opposed to the state-of-the-art video conferencing equipment in the new area. I knew there may or may not be overhead projectors. I witnessed people awkwardly running meetings with vintage handheld projector models. Often, the air handling wasn't good, and you might be uncomfortably hot or cold, depending on which old room you were stuck in. As far as the lighting was concerned, in alignment with corporate sustainability policies, the overhead lights would go off if movement was not detected within 15 minutes, so we were often sitting in complete darkness until one of us moved.

Visualize for a moment even the best planned and run meetings conducted in that environment. It was not exactly conducive to rousing participation. The worst thing about meetings in those areas was that they engendered an old style of thinking. Managers tended to drone on or argue over minor points. There was a lot of posturing, "gotchas," and run-away egos in those rooms.

Properly organizing meeting and teamwork areas proved to me, over and over again, that venue can make a big difference in the attitude of people attending and the success of the meeting. The area I created and controlled, offered every possible convenience: comfortable seating, all the network and wireless requirements, video conferencing, white boards, smart boards, and my staff took care of any other needs: pads of paper, pens, coffee, water, snacks, and anything else the team required.

Of course, I always made sure there were plenty of refreshments available to keep people motivated to

stay. We didn't fancy people going off in search of a bottle of water when our refrigerator was stocked. No one had to leave the building to get coffee or tea. We needed to keep people in the area working, sometimes for very long hours. Inadequate nutrition and hydration impact brain chemistry, which controls concentration, memory, and mood. Having food and drink around helped stave off "hangry" engineers.

At my meetings, a published agenda with roles and responsibilities clearly defined was handed out at the outset of every meeting. My training as a teacher kicked in, and I didn't trust people to print out their own copies. My way, there was no option to just leave the agendas on the table or worst yet, watch attendees try to share; if I didn't bring copies for all, the sheets of paper would just waft around, become scattered and scrambled, and someone would always complain they still didn't have a copy.

> **Having food and drink around helped stave off "hangry" engineers**

I asked people in advance NOT to use their phones, laptops, etc. during the time we were together.

But no matter how hard I tried, some people continued to bring their bad meeting behavior with them to each meeting. One person carried on an entire phone conversation in the middle of making his own point! (I later discovered that he did the same thing in his own staff meetings.)

Others would have their laptops open, typing away, probably sending out nasty-grams about the progress of the group.

During these meetings, I held my composure and politely asked that electronic devices to be turned off

out of courtesy to others. But too often my request fell on deaf ears. Once, I noticed a Vice President scrolling and texting during an entire meeting. Not once did he look up! One senior engineer typed away on his laptop during meetings, others took phone calls from their wives, regularly. One veteran engineer routinely peeled a huge orange at the table and ate it heartily while the meeting was going on.

Admonishing this kind of behavior had temporary effect. I'd ask again for the devices to be put away, and within a few minutes, I'd notice several heads bowed, hands under the table; professional people, absorbed by their phones. The excuses were all the same, "I'm good at multi-tasking," "I've learned to do two things at once," "Juggling tasks is my specialty."

To which I replied, *"Research shows multi-tasking makes you stupid."* I made a point of looking directly at the offenders. (I often felt like a room monitor in a junior high cafeteria.) This fact about multitasking is taken straight from the May 21, 2015 headline in the Sydney Morning Herald, reporting on a study from Macquarie University in Sydney, Australia with the same findings. It also noted, besides making people stupid, device addiction is just plain rude.

I can honestly say that as unruly as these characters were, our venue, with all the services included and my insistence on an agenda and creating both an in briefing and out briefing package, forced attendees into industriousness. The briefing packages had to be completed before the meeting adjourned. I also made sure no one could leave my meetings without making a specific contribution, and I would call on people to ask about specifics; "Larry, what did you mean by...?" or "Tony, you said that you had a source for xyz, is it available?"

I kept wondering, however, why keeping people's attention in meetings was such a challenge, so I did

some research. *Meeting King,* a meeting watchdog site, states, "Bad meetings are a source of negative messages about your company and yourselves." This quote struck home, because I felt responsible for insisting people stay on task for so many years.

About three years later, I changed jobs within the company and no longer controlled the meeting atmosphere in my new department. I suddenly found myself back in the *Death by Meeting* experience.

In my new department, the staff meetings seemed futile. No major decisions were ever made. No one committed to anything. People appeared almost frozen as they slumped around the table, eyes glazed over, jaws slacked, openly yawning in utter boredom. I witnessed these meetings bring about a sense of corporate ennui among the staff. There certainly was no energy in the room, the inanity of the meeting sucked the life out of every person present.

The problem was that we all knew the manager was not the least bit interested, because weekly staff meetings were obligatory. More than once, I imagined myself flattening, deflating, like a cartoon character, sliding out of my chair and slithering snake-like out under the door.

Often the agendas had not been updated from the previous week's meeting. And people brought hidden agendas. And I could tell there was some fudging going on. The cryptic language used around the table indicated that if you were not an insider, you'd never know what the others were talking about. Plus, human needs like food or drink were never offered. Bio breaks had to be spontaneous, just get up and leave, or you'd be bursting by the time it was all over.

The department staff meetings were no better. They were deadline driven. We skated right over issues discussed at higher levels like company values, leader

action plans, culture issues, diversity, safety, etc. Instead, we dwelt on those deadlines that directly affected the supervisor. Entire meetings were full of a focus on deadlines for performance appraisals, deadlines for training, deadlines for expense reports. With no refreshments here either, people couldn't wait to escape for coffee, water, or a snack.

Who can honestly say they've never experienced this mind-numbing type of meeting? Even worse, who expects to appear again and again at the same droning, tedious gatherings in the future?

I almost laughed out loud when I read the suggestions for the "Four Meetings" in an excerpt from Patrick Lencioni's book, *Death by Meeting*. These include - the Daily Check-in, the Weekly Tactical, the Monthly Strategic, and the Quarterly Off-site Review. I can't imagine those kinds of meetings ever taking place at any level lower than Vice President in my previous organization where nobody could be bothered with that level of detail and regularity at the middle manager level.

Research from the Wharton School shows that shortening a meeting can actually make the meeting more productive, just based on human nature alone. When people feel a slight time crunch, they are more apt to stay focused and stick to the meeting points. And shorter meetings result in happier employees because time is an essential element to the workday, and people do not like to have their time wasted in a useless meeting.

Some organizations theoretically use staff meetings to "flow down" the ideas of senior leaders. The results of their executive level strategy meetings are supposed to

> **Shortening meetings can make them more productive**

be transmitted to the lower levels via a gathering of mid-level managers and their direct reports. Then, after senior leaders' pearls of wisdom are communicated, the newly informed employees get immensely excited about these plans and ideals (such as company values and behaviors) and start implementing them right away.

However, when middle managers do not spend time explaining the messages or are not held accountable for making them happen, the average employee, "Marty Meets," is not ever going to get the message. And this leaves Senior Leaders wondering why the communication stream is not working. Poor communication from middle managers was what drove "Marty Meets" to email company executives their complaints, and then the comfort level between employees and the middle managers began to shift in the wrong direction.

In short, over time, employees and even senior level managers can be been beaten down by dull, monotonous meetings. The boredom factor makes it even more important for senior leaders to shift their thinking about how meetings are organized and conducted, and make sure there is a commitment to follow through on proper meeting protocol.

A mindset change at the top can positively or negatively impact how people who must attend any meeting not only feel about that meeting but how they engage in the meeting and their attitude toward meetings, before, during, and after. Consistency across the board would go far to change many minds.

Leaders can be in complete control and embrace their authority regarding the way meeting are held in their organization, if only they wouldn't leave it strictly in the hands of their managers. Most managers are "Peace for Pay" types and won't enforce anything that makes their life at work more challenging.

Do we really want the deadly meeting syndrome to prevail?

Consider the importance of people when planning a meeting. People want to learn what's going on inside the company and they want to have a say in critical topics of discussion. Let's consider our human capital as more than an intangible asset. First remember what keeps people attentive and engaged, and then go on with your planning.

Some lessons learned from deadly meetings:

1. Remember you are dealing with human beings with human needs, like food and drink: water, coffee, tea, juice, etc. Something to nosh on is also needed. People don't function well if they're hungry.

2. People need ventilation and temperature control. Don't make the heat or the cold wind blowing through an open door make people leave to get their coats. They may never return.

3. Test out the lighting. Is it sufficient? Check to see if the lights stay on for the whole time you're occupying that room.

4. Attention spans are short. Request electronic devices be shut off or left outside the room. Fine people if they are looking down at devices and not paying attention or if the phone goes off during your meeting. It's disrespectful behavior. The fines are then donated to a favorite charity. And the offending employee gets the receipt from the donation.

5. Prepare yourself in advance. Design an agenda with time frames for each topic and stick to it. Cut off the ramblers and bloviators.

6. Have a parking lot for off-topic items. Assign someone else to notate the "parking lot" list.

91

7. Expect everyone to contribute. Ask specific people to focus on certain topics, speak to their areas of expertise.

8. Ask for artifacts to be produced so people have something specific to refer to when the meeting ends.

9. Wrap up the meeting within the time frame you promised. If your agenda says 60 minutes, don't go over. People will most likely get up and leave anyway.

10. Limit the attendees to only the essential people. You don't need a cast of thousands to complete your agenda. Too many people only invite more circulating nasty grams and will undermine your purpose.

When you commit to written outcomes from specific meetings, you then have a record of what was said. If at some point, the outcomes or action items are challenged, you have documentation at hand. In the electronic age, it's not that easy to erase facts, but it's not surprising when people try to ignore what you've said, take your words out of context, or twist your words into the narrative they want as the legacy. And we all know by now, that even video can be interpreted to mean the opposite of what we all witnessed with our own eyes.

Our next chapter deals with how easy, although stressful, it is to recreate reality for the purpose of staying in control of the narrative.

Chapter 9

Down the Memory Hole We Go

"If one is to rule, and to continue ruling, one must be able to dislocate the sense of reality. For the secret of rulership is to combine a belief in one's own infallibility with the power to learn from past mistakes."

— George Orwell,
Nineteen Eighty-Four

WORDS HAVE POWER. Leaders need to choose their words wisely to maintain their credibility and trustworthiness. When leaders use words to obscure the truth, they undermine trust, transparency, and morale within the organization and in the public eye. By now we all know that "rightsizing" means layoffs, "challenge" stands for a big problem, employees are "slots," "backdoor" is a verb meaning perform a clandestine activity, and "neutralize" is a nice way to say kill.

A leader's perversion of a word's meaning can only exist to serve needs not connected to a greater good, but to obfuscate truth, and endorse outright lies.

Years ago, my job was teaching English at a major high school outside of Syracuse, NY. Among the many classic works of literature assigned, was George Orwell's novel, *Nineteen Eighty-Four*. Although

written in 1948, so many of the outlandish plots and themes of the novel have come to be reality. We actually invite Big Brother into our homes via Zoom, FaceTime, GPS, smart watches, smart phones, doorbell cameras, etc.

In the Appendix of the book, Orwell describes the language he used in the novel as Newspeak. Newspeak is a language designed to control every aspect of an individual's life by combining specific words to keep one's focus on what Big Brother wanted them focused on and to eliminate any words connoting negativity. If we examine Orwell's message carefully, it's not hard to imagine how our own world has evolved to resemble the world of *Nineteen Eighty-Four.*

If we consider the Enron scandal of 2001, the leaders at the very top of the company fooled everyone by creating fake umbrella companies and "creative" accounting practices to conceal staggering debt. For example, instead of using the term "loan" for some of its debt, Enron called the transactions "certificates" and "funding agreements," innocent enough words.

But what does it mean when we talk about a "change agent" or "disturbance handler"? Do we think of leadership or yet another way to paper over more failed corporate efforts with euphemisms that mask the truth?

An Unperson or UnGood Ideas

A totalitarian state's practice of shading the truth through creative language manipulation was Orwell's inspiration for the creation of Newspeak, the deceptive language that made the bad news and failures of "The Party" into the Gospel truth and created confusion and dissonance within the book's main characters.

In Orwell's iconic dystopian tale there was no word for "bad"- only "ungood."

Other examples from the book are "blackwhite," neither black nor white; "unperson," a person eradicated from existence; "facecrime," guilty of "thoughtcrime" by facial expression (just thinking of something the Party considered criminal); and "thinkpol," or thought police.

Other ironic words were created to baffle and confuse citizens such as, "doublethink," a brainwashing process where an entire population is expected to accept as true that which is clearly false, or to simultaneously accept two mutually opposing beliefs as correct, often in violation of one's own memory or sense of reality.

We have our own ironic names for things which we may not like such as the retired ICBM, the "Peacekeeper" missile; downsizing; neutralizing the enemy; animal by-products; bliss point (the point at which you can't resist eating an entire bag of potato chips); and other confusing words and phrases, all meant to mean the opposite of what they actually say.

The latest doublespeak comes right out of Washington, D.C. – "escalate to de-escalate," referring to the action of bombing a key enemy military officer to scare an enemy into submission. Or, referring to ideas, health crises, and more as "hoaxes" to distract people from the truth of what they see happening all around them. In the midst of a pandemic, our leaders announced that the "heat" of April would make the virus affecting so many people across the country just "disappear." Their further assertions that "injecting" disinfectants could kill the virus and later, reframing the exchange as a joke, generated a great deal of worry and apprehension among the public, as many became too afraid to leave their homes.

Words Create History

Why are words and what we mean by them so important? Words have the power to praise or humiliate, words can change the course of a life - from "cancerous" to "cured" and, in isolation, words can alter our perception of ourselves or our impressions of the world around us, forming a core belief system that stays with us for life.

Words (and images) create history, they reflect time, a record, a phase of life, an era. I came across a wonderful definition of why words are important:

> "Words are important. We forget that sometimes. We forget how dangerous and beautiful words can be. Simple words can completely change your life. Yes, words are important because we need them to communicate but the way that words are presented, spoken, and written are a whole different level of communication."

It's how we communicate words that matters. How words are presented, spoken, and written – and either way – words can change the course of history, can change people's lives forever. Essentially words are a call to action.

Leaders need to be watchful when they use words. Their organizations might conjure up some ironic or deceptive words or phrases to define themselves, change behaviors, or to hide a wrongdoing. For instance, major corporations use the term "seamless" to describe eliminating layers and therefore jobs; new male military recruits being referred to as "ladies" to get them to act like men,; or the tobacco industry in the 1960s conducting its own "research" to prove cigarette smoking was not harmful to health.

So how do we know when words are doublespeak or newspeak or euphemisms, jargon, or bloviation?

And what action can be taken when words are used to obfuscate the truth?

Down the Memory Hole We Go

In the Orwellian world of *Nineteen Eighty-Four*, words are strictly controlled. The "Ministry of Truth" exists to control history through revising "facts" into "alternative facts" to create censorship through creating lies.

The protagonist, Winston Smith, works at the Ministry of Truth – another term that misleads. He is routinely assigned the job of revising old newspaper articles and photographs to support the propaganda of the government.

For example, Winston may be tasked with retroactively changing a prior announcement about a war or some other major event, to reflect the latest acceptable government policy. The truth clipped away and sent down the memory hole, a chute which led directly to the building's incinerator. The old information then never existed, either physically or in anyone's mind. People forgot about the truth, and instead, history was recreated, according to the rules of the Ministry of Truth.

As Orwell describes Winston's workplace:

"In the walls of the cubicle there were three orifices. To the right of the speakwrite, a small pneumatic tube for written messages, to the left, a larger one for newspapers; and in the side wall, within easy reach of Winston's arm, a large oblong slit protected by a wire grating. This last was for the disposal of wastepaper. Similar slits existed in thousands or tens of thousands throughout the building, not only in every room but at short intervals in every corridor. For some reason they were nicknamed *memory holes*.

When one knew that any document was due for destruction, or even when one saw a scrap of waste paper lying about, it was an automatic action to lift the flap of the nearest *memory hole* and drop it in, whereupon it would be whirled away on a current of warm air to the enormous furnaces which were hidden somewhere in the recesses of the building."

At one point in the book's agonizing twisted plot, Winston is shown evidence of a coverup by the ruling Party. Winston becomes incredulous that such documentation even exists. However, the evidence is destroyed and sent down the memory hole before his eyes and then he is told that it never existed, and furthermore, no one has any memory of it ever existing. Winton realizes that he is experiencing doublethink in action, as everyone else in the room denies any knowledge of a politically inconvenient fact, or the action taken to get rid of it.

Orwell's "Big Brother" government actions are based in creating only convenient truths, and if entire populations accepted the lie which the Big Brother forced upon them – if all records told the same story – then the lie became fact, true history, and was established as truth. "Who controls the past," ran the Party slogan, "controls the future: who controls the present controls the past."

And yet, according to the novel, the past, though of its nature alterable, had never been changed. Whatever was true today became true permanently, in everlasting perpetuity. It was quite simple. All that was needed was an endless series of triumphs over your own memory. "Reality control," they called it: in Newspeak, "doublethink."

To establish trust with clients, members, customers, partners, and the public, organizations of any size can't avoid truth telling. Doublespeak,

gobbledygook, and creative misrepresentations are always found out, either by internal whistle blowers or outside investigations. Enron couldn't sustain its creative financing with words, BP couldn't continue minimize the effects of its exploded Deepwater Horizon oil rig and the illnesses it caused the clean-up crews (one woman being told to 'treat it

> **To establish trust, organizations can't avoid truth telling**

with Dawn dish detergent'), and corporations can't impress stakeholders by institutionalizing a group of "Game Challengers" who lack the power or authority to enact any changes that stick.

These organizations can only wish the Orwell's "memory hole" existed.

But Orwell didn't envision the permanence of digital technology. Today these contradictions and digital memories live on forever. Human memory lapses become a choice. Unaltered, digital video doesn't lie. We all saw the plumes of crude oil billowing through the Gulf of Mexico in April of 2010. We've seen the perp walk of the Enron leadership team after their deception was unearthed. Today's corporations can't erase failed efforts at change management when there is a solid digital trail to verify it, regardless of efforts to make reality a fuzzy illusion.

What is the learning as we consider these examples of destructive, ironic, or oxymoronic language, knowing that these examples only scratch the surface of obfuscation of the truth? How can we be sure that history won't repeat itself?

In the Enron case, new legislation was put into place, the Surbanes-Oxley Act. Right now, the blame in the BP Oil case is still being spread around. And the negative health effects of cigarette smoking are

well known. But these are all fixes after the fact. These actions only look backwards to correct a wrong. According to Yval Noah Harari, in his book *Homo Deus*,

> "The best reason to learn history: not in order to predict the future, but to free yourself from the past and imagine alternative destinies. But, of course, this is not total freedom – we cannot avoid being shaped by the past."

Imagine for a moment, a world where there is no "moral muteness" or cover-ups, where there is no need for whistle blowers, lawsuits or special corporate "ethics" training (considered by some an oxymoron).

Imagine what it would be like for you, as a leader, to embrace truth, honesty, integrity, and candor wherever or whenever you notice a moral challenge. What would you be feeling? What would it look like? How are people acting? What are you hearing? Charge up all your senses and imagine that world.

Now, remember your image of the world you just created when you show up at work each day. Embrace that image of challenging questionable behavior or confusing language. We have to ask ourselves if we have the courage to do the right thing, not just for the sake of convenience, but to satisfy our own moral compass. When you take on the mantle of leadership, remember to keep your inner truth intact. Truth may be inconvenient, but it's truth that makes us fearless.

In the words of George Orwell himself,

> *"In a time of deceit telling the truth is a revolutionary act."*

Chapter 10

Lawrence of Arabia's "Pillars of Wisdom"

"You do not need to be in a position of power.
You need only be in position to influence
those in power."

— T. E. Lawrence

WORDS HAVE POWER, we now know that to be true. But how and when leaders use those words are the authentic markers of effective leadership. How a leader positions him/herself points to his/her ultimate level of success and effectiveness. Positioning in any organization regardless of size is directly linked to a leader's successful leveraging of power and influence. Without an intimate understanding of these two characteristics, leaders are no more than babes in the woods.

There are so many ways leaders can achieve their goals by learning to use power and influence. The issue is recognizing where the power and influence are in the organization.

Getting permission to attend an important women's conference in my previous life taught me how to use power and influence to its fullest. What I found most interesting, is that much of what I've learned came from Lawrence of Arabia, an Englishman who helped overthrow the Ottoman Empire with members

of the Arab States. His decisive lessons on capitalizing the use of power and influence to achieve ultimate success inspired me to act accordingly.

In most large organizations, relationships and knowledge can move mountains. In short, it's about who you know *and* what you know. Establishing close relationships with decision makers at any level often makes the difference between success and failure. By leveraging close relationships with the right people, I learned to use power and influence to achieve my goals.

What's Women in Defense?

My education on this strategy has a somewhat prosaic beginning. After 10 years of working in my previous career, I was invited to attend a conference for Women In Defense (WID). WID is an organization offering support and education for female professionals in the male dominated defense industry. "How do women develop and maintain power and influence within this industry?" the conference asked.

For years, women in defense fought to have their voices heard. Even the most talented, gifted female engineers struggled to reach top ranks and work on important projects. The goal of this conference was to provide women with strategies to conquer anti-female biases that kept them out of the succession plan and consequently, out of the C-Suite. Because I lived with this subtle discrimination firsthand, I was convinced attending the conference would help me and other women that I knew in the industry gain the confidence to excel in a man's world.

I wanted to join the conversation – but I knew I'd first have to navigate the tricky, moon-like internal corporate terrain to get approval for the trip, which required travel to Washington, D.C. with two overnight stays, totaling about $2000.

I knew this request would be challenging in a department that rationed out three-hole punches, so I presented my request several weeks in advance to my supervisor. He promptly ignored it, albeit with a sardonic chuckle and look of surprise, asking, "What's Women in Defense"?

> **I'd have to navigate the tricky, moon-like internal corporate terrain to get approval**

Reactions similar to this throughout the defense industry were part of the reason that WID existed, to change attitudes towards women's advancement in this macho industry.

After three weeks of waiting, I inquired about the status of my request. I was told that my supervisor needed more information, so I provided a brochure from WID outlining the conference agenda, speakers, and the big-name sponsors in an attempt at rational persuasion. I had to convince him that WID was not a coven of angry women, but a bona fide force in the industry, with many of competitors and other major players attending and supporting the conference with major sponsorships.

Another several days passed, and I was told that I should prepare a briefing package for his supervisor. I prepared a detailed package and also mentioned two previous company top leaders who had sponsored me in the past and who supported WID. And so, I waited. Several more days went by with no word. Days turned into weeks, and the conference deadline drew closer. Still nothing. When I asked for status, an apathetic shrug of the shoulders was the response. I realized at some level, someone was dragging their feet, and my boss wasn't interested enough to give them a nudge.

Two days prior to the conference, I finally was granted permission to attend, but registration for the conference had already closed. After shaking off my initial feelings of desperation, I contacted the local WID board members and they approached the conference chair to open registration for me. Because I initiated the request early, and received permission after registration had closed, my creative solution worked!

After many more inexplicable experiences like this, I began to fully realize how power and influence are leveraged in large, multi-layered organizations. That chain of command was a bureaucratic morass, and almost nothing in big companies was ever going to happen fast. And to get what I wanted; I was on my own. That was my introduction to a central cultural truth: use who you know and what you know to achieve the goals that are otherwise seemingly unreachable.

Years earlier, Donna, an engineer and a rare female director observed, "The key to successful leadership in this company is influence, not authority." I agreed. In my time working at this company, I often found that dealing with the person with influence was the only way to get things done. I had to face the realization that in big organizations, you have to watch your own back.

People aren't going to open doors for you just because they are in your chain of command. You are only another piece of paper on their desks, another warm body assigned to perform a task. They need a reason to support your ideas and actions, and without latching on to the right flesh and blood connections, your efforts are mostly fruitless. I've carried this mantra through the rest of my career, and I leveraged power and influence enough to land on my feet more than once.

How does Lawrence of Arabia fit in?

Life in this environment reminded me of the life of Lawrence of Arabia, a British Army officer who is known for assisting the Arabs against the Ottoman Empire during World War I. Lawrence became a trusted ally to the Arabs even though he had no power or authority in the Arab world, all he had was influence, cultivated by relationships with Arab royalty. He leveraged these relationships to lead and win several key battles in the overthrow of the Ottoman Empire. I was always intrigued by Lawrence's use of influence to gain power, and how it could be used successfully in a business setting, as I learned about his famous escapades while conducting research for one of my graduate classes.

I read a piece by Richard Stiller, a software engineer and project manager at Sun Microsystems (now Oracle), and an admirer of Lawrence, regarding using power and influence in leadership. In his paper, "Influence as Power," he writes about the impact that influence has within the workplace.

Motivated by a personal business crisis, Stiller drew upon the experiences of Lawrence of Arabia, capitalizing on his personal knowledge of Lawrence's history to examine how influence and power lead to success in unlikely circumstances. Stiller leveraged his fascination with Lawrence's role in the Arab Revolt of 1916 to develop solutions to a personal work challenge. This strategy ultimately played a major role in saving an important project: a software product eventually renamed Java.

Here are the tenets of Lawrence's code, "Pillars of Wisdom" for every challenging circumstance:

1. You do not need to be in a position of power. You need only be in position to influence those in power.

105

2. Find the Prophet. This is the person whom you will influence to make your vision a reality.

3. Keep your agenda a secret from those who would undermine it.

4. Share your agenda with those you trust. This will allow you to drum up support when the time is right.

5. Focus your vision by giving it a goal. Give your vision a 'Damascus.'

6. Do not seek permission to influence those in power.

7. Seize the opportunities to influence events as they come your way.

These "Pillars of Wisdom" helped me overcome my feelings of isolation and helplessness in a business challenge, for me, attending a conference. Instead of powerlessness, Lawrence's philosophy teaches us to use power and influence to attain our goals and achieve the success we want; Pillars of Wisdom, indeed.

I called upon several of Lawrence's pillars to attend the conference, also: I was not in a position of power, but I could influence a seat at the table. I kept my focus. I did not give up even though the conference was closed by the time my trip was approved. I didn't ask permission to contact the local chapter, I just did it. It was my only choice since people in power blocked me from the standard registration window.

Ironically, no one asked me for a trip report, although I sent one anyway. It was as if the event had never happened. Also, I was surprised at the lack of presence by my company at this important conference. Many other companies were represented there with two and three tables of 10 completely full. These women were senior level people, Vice

Presidents and Directors, as well as managers. Since I had no official place to land, the WID officers invited me to their table, where I made even more connections, and saw some familiar faces.

Attending the conference was not the only incidence where calling upon Lawrence's philosophy helped me solve a complicated situation. I learned to leverage support by continuing to build relationships on many other matters:

- Completing a large facility build out in record time.

- Landing on my feet when I was threatened with termination.

- Transitioning smoothly from a long medical leave to a voluntary layoff at the end of my career.

Without using influence, none of these matters could have been successful.

The conference taught me to expand relationships within WID. I met influential women from many companies and military branches. From cultivating these relationships, I became a speaker at WID events. I helped a female client find a job at one of the WID member companies.

> **No one has to feel helpless, powerless, or vulnerable**

There are many cases where we may not have the authority to achieve our goals. However, when we reach out and learn to form and grow influential relationships, opportunities for success seem to multiply. It's up to every individual to develop the authentic connections that can catapult a career to new levels, or just achieve what some would call impossible. No one has to feel helpless, powerless,

or vulnerable. Engage your Prophet, (s)he will help. Envision the future you want and employ Lawrence's code to navigate your course.

"... the dreamers of the day are dangerous ...,
for they may act out their dream with open eyes,
to make it possible."

— T.E. Lawrence,
Seven Pillars of Wisdom

Chapter 11

Ethics
Doesn't Live Here Anymore

"Relativity applies to physics, not ethics."

— Albert Einstein

WELCOME TO COWBOY MANAGEMENT. If you've never experienced corporate Cowboy Management, you might still think of cowboys as the rugged characters like "Rowdy Yates," played by Clint Eastwood in the TV show of the late 1950s, *Rawhide*. No pillars of wisdom here, cowboy management was thought to be an attractive management style where being aggressive and driving results were considered desirable leadership traits. Those cowboys got things done, sometimes forcibly, and sometimes by charm and sheer talent.

But morale, retention, and engagement were diminished by the cowboy management style, because it was often based on fear and intimidation, and tread on the feet of ethics. It became too costly to maintain, and soon seemed to fall out of fashion.

Why? Because the workforce has changed since the 1980s. What worked then, doesn't work now. And since cowboys were traditionally all men, women are more often affected by the behavior characteristic of

the "Wild West". Women are not always prepared to "saddle up" and are more unprepared for the rough and irreverent behavior of the "Wild West" culture often present in so many organizations.

Many years ago, when I was just starting a new position in a large organization, it didn't take long to realize that the place was run by a classic version of cowboy management. In particular, a wide disparity between personal and organizational ethics existed. I was recruited to my new job as the leader of a brand-new group to create and manage policies and procedures that would also be new to the organization. My previous job was similar, however that was with a competitor to the company that hired me, and the two cultures could not have been more different.

In my previous job, ethics was a serious subject. Ethics violations, or even the appearance of impropriety, carried serious consequences: termination, suspension, even up to and including civil damages. Ethics was such a serious matter because there was a history of ethical violations, and the government came down hard with fines and sanctions.

> **Without ethics to guide people, we were operating in the Wild West**

Culture shock doesn't adequately describe the laxity and tolerance of ethical violations I observed in my new workplace. My new company apparently had slid under the radar with their unethical behaviors, especially when it came to interpersonal relationships. The moral compass of this company balanced precariously between the written ethics policies and documentation, and the unethical behavior of its employees at all levels. Without ethics to guide people,

especially managers, it seemed we were operating in the Wild West, complete with Cowboy Managers.

When some new, dramatic organizational changes took place within the management team, the ethical behavior acceptable to management noticeably deteriorated, especially at the local site level. An ill wind blew through, like opening Pandora's box, and it unleashed a panoply of unfortunate events, affecting all areas of the business. Diversity and inclusion seemed to fly out the window and the old boys' network became more firmly entrenched than ever.

In particular, I was appalled to see the treatment of women change from marginalization to outright sexist behavior. At least four women were forced out or resigned due to sexist treatment by their bosses

Other ethical "messes" entailed outrageous behavior by more than one man in charge.

One woman who was the wife of a Vice President used her role as his wife to access company assets. Her personal use of a company employed secretary to manage her personal appointments, set up cable TV installations, use company employees to set up her internet access, and more, were well out of the range of organizational or personal ethics. It was well known that personal ethical violations had ruined the military career of the same Vice President, so what behavior could the organization expect?

Still another Vice President trampled over people, specifically women, and attempted to cover his tracks when the situation heated up. Highly educated, qualified women were overlooked for promotions, left out of key meetings, and denied important travel. Women who spoke up or disagreed were completely ignored. Women who complained about bad treatment

had the tables turned, suddenly, they were the poor performers, or disrupters, and the outcome was either lost wages or be placed on "Improvement" plans. Women became invisible.

In my experience there, I saw many managers at the mid-levels who lacked basic ethical codes of behavior and closed their eyes to breaches of this behavior. Some openly participated in misleading their management about sales numbers, proper use of policies, and ethical client interactions. They bought into the idea of cowboy management and thought that by doing "whatever it took" to get results, they were completely justified.

Ethical messes do catch up with the Cowboys

Ethical messes are fairly common for organizations using the "cowboy" approach to ethics. Aside from the expected collateral damage around retention, morale, and engagement, eventually, the numbers catch up, and without regular quarterly gains, the "Cowboys" eventually get run out of Dodge.

When we think of ethical messes, any number of public scandals come to mind. The 1970s Watergate Scandal, the Harvey Weinstein Scandal, Enron, Lehman Brothers, the BP Deepwater Horizon oil spill, the Volkswagen emissions scandal. In each case an ethical principle was violated. In each case a person who held some responsibility of public trust, committed unethical acts: financial trickery, lying, cheating, sexual abuse, among others.

There is another fascinating case involving the president of an Arizona company and how he handled the feedback from his own 360-degree professional assessment, so called due to the feedback sources from peers, direct reports and

superiors. The president was set to retire and ready to name his replacement, a current staff member. Within the 360 report, he had received one negative comment, however, which irritated him. Determined to find out which staff member made the remark, he turned to his HR department.

Since this was confidential information, the HR manager was not forthcoming. In the form of intimidation and threats he bullied HR into revealing the source – egregiously unethical behavior for both of them. When he discovered that the comment came from the woman who was his choice to replace him, his endorsement transformed into revenge. Suddenly, her performance reviews plummeted, and this stellar performer was now considered an anathema.

This shocking chain of events occurred after her years of dedicated service and positive feedback. How ironic that these events took place after the "inquisition" to flush out the offender. Why, all of a sudden, was she was failing? The sad truth is the company president was so thin skinned, he couldn't handle any vestige of criticism, and so, our hard working talented female executive was terminated. She undertook a valiant effort and sued the company on the basis of gender discrimination.

After her dismissal, the company offered her $300,000 to settle, but she chose to take her case to court. In the end, the court sided with the company, stating the president's comments on her performance review were opinions, not based on specific profit and loss calculations, and therefore, she had no case. She walked away with nothing, except a very large legal bill. The irony is, the cap for settlements at the time was $300,000! The president of the company retired and collected all his benefits, and she was left with nothing, on the street, looking for a new job.

113

Not all people at the top escape the consequences of unethical behavior. In a 2017 global study by the Society of Human Resource Management (SHRM) it was found that 36% more CEOs were fired between 2012 and 2017 due to "ethical lapses" than in the previous five year period. "Bribery, sexual indiscretions, fraud, insider trading and negligence that leads to environmental disasters" are stated by SHRM as the principle reasons for the firings. When unethical behavior emanates from the top, the company, its brand, and its employees are impacted.

> **36% more CEOs were fired between 2012 and 2017 due to "ethical lapses"**

All of the elements of unethical behavior, lying, bullying, misrepresentation, gender discrimination, were factors in one particular situation that left a lasting impression on me: A new manager, trying to prove himself by exerting power, singled out a female department head to intimidate her to the point where she would be out of the position she successfully performed for eight years, despite glowing performance ratings with "exceeds" in many areas.

Apparently, the manager went off script and made his decision based on personal feelings. This woman was outspoken and wasn't shy about sharing her opinions. She was a non-technical woman working in a technical world, where expressing disagreement countered expectations for females in "support" roles. Her direct supervisor didn't like dealing with the inevitable blow back, so he offered her 90 days to find a new job, inside or outside the organization.

If you find this situation odd given our supposed enlightened employment status, don't. We all must

understand that regardless of what a company's
public image is, what their branding looks like, who
they show as happy employees on their website,
there is still an element within the recesses of these
corporations that make their own rules. The woman in
this case was being intimidated for two reasons: 1. Her
boss didn't like her. He thought she was too pushy
and 2. He thought he could make an impression at
the top levels for putting a "troublesome" employee in
her place. When fear wins, common sense loses out.
She didn't understand her options and there was no
one to offer the correct advice.

Even though she had been recently promoted
and received a rating of "exceeds" the year before,
the woman's fear and intimidation drove her out
of the department, with the warning that if she did
not find another job within the company within 90
days, she would be terminated. She was not the type
to take this lying down, as they say. She resisted
the unethical efforts and almost received a letter of
reprimand when she refused to cave. What made the
situation even more bitter was that the department
VP didn't back her, although she had done much to
help him over the years.

As a last effort in the fight (she said it felt like
hand to hand combat), she put into action her
relationships with her former boss, now also a
VP, and the President himself. Just as the work
of Lawrence of Arabia suggests, using the boss's
influence and power helped stop the letter of
reprimand and supported her in finding a new
assignment out of that toxic environment. Her savvy
in these types of internal political struggles gave her
the fortitude to keep going. She made direct phone
calls and emails to both senior people and met with
each of them in person.

A 7:00 A.M. meeting with the president turned in her favor when he offered her a number of different opportunities. Her former boss, now a VP, encouraged her choices. The rest of the senior leaders realized that through her connections and willingness to use them, she had power.

Because her immediate boss had created such a "hostile work environment," she probably could have kept her job, however, after such poor treatment, she welcomed the chance to try something new. Ironically, the two women they tried to get to replace her both rejected the notion, stating that they were not qualified to do the job. As so often happens, in the end, the job never was filled, and there was frequent feedback about what a mistake it was to move her. Eventually, the whole department closed, and the building housing it was sold off. It is now an antique car museum.

Even though a company may have behavioral standards for ethical conduct, without a basis in morality as a "moral person," there can't be a "moral" manager. Personal morality and character leads people down the path of good decision making. Without an internal moral compass, people are ruled by their worst instincts. The moral ineptitude of the woman's boss showed his worst tendencies, that is to treat this woman worse than he would treat his own family member, or even a stranger on the street. He didn't like her, and his lack of moral judgment was his excuse to show it through using his power unethically.

> **When a leader lacks moral conviction, "moral" and "ethical" can be left open to interpretation**

In my experience, it is always worth exploring the tendency of any company president to hire people with questionable ethics. While the president may look for qualities of aggressiveness, drive, a results oriented focus, and he or she may appreciate a domineering style, these Cowboy Management qualities ignore the fact that many of those kinds of hires will often not share the president's own personal value system.

Leaders must remember, it's not the 1980s anymore. Cowboy management is out. Even though they hear the message from business schools and are aware of the latest studies, it doesn't mean leaders will follow along. Sadly, when a leader lacks his or her own moral conviction, regardless of organizational ethics and behavioral expectations, moral and ethical can be left open to interpretation.

Signs of hope

There are signs of hope, however. I've heard that Facebook CEO, Mark Zuckerberg has taken a stand on unethical use of his platform, specifically in regard to misleading medical or political information. Twitter executives followed by banning or labeling false or misleading information.

On a grand scale, these policies improve the morality and ethics of a company.

But imagine, if you will, moral and ethical behavior manifesting itself in how the people who perform the work are treated, how they are made to feel when they walk through the door each day, and how the behavior of executives at every level reflects the actual company values. Imagine a world where people act as if they've read that landmark book,

All I Really Need to Know I Learned in Kindergarten, by Robert Fulghum.

The lessons from that book are easy:

1. Share
2. Be kind
3. Clean up after yourself
4. Balance work, play, and learning

Even cowboys can understand these little reminders.

Chapter 12

Let's Put Humanity Back Into HR

"Never forget the human in human resources: The best leaders balance a passion for the business with a compassion for people."

— Jack Welch

PICTURE THIS SCENARIO: A woman arrives at work early, as is her daily routine, hangs up her coat, places her purse in the bottom drawer of her desk, sits down at her keyboard. She discovers she can't log into her company computer. She notices someone else is logged in under her name. Company policy requires her to report this to her HR person, but when she does, her HR representative brushes it off as a technical glitch.

The next day she notices a note on her desk to appear in HR. To her shock and dismay, after 22 years of service with this company, she is fired on flimsy grounds (failing to report a tardy employee). No two-week notice or severance package is provided. She is in so much shock, she collects her personal belongings, turns in her badge at the door and leaves, still shaken from the experience.

This is Human Resources?

Apparently, her leadership team was not informed or aware of business school work on more positive – or at least less negative – termination processes.

The truth is, when it comes to human interaction, academia has well-known and long-established processes based on data and analytics that point leadership in the direction of using compassion and humanity in sensitive termination conversations. But this message isn't going much further than the publications that print the information.

Instead, companies, due to the 2020 COVID-19 pandemic, tasked their HR teams to look hard at ways to layoff, fire, terminate or furlough their "human" capital. And the HR people executed this charge in the most indifferent ways. Employees were subject to callous and insensitive behavior executed by their Human Resources teams.

It seems incredible that in the 21st century such Gothic behavior still exists. But I have to believe that each one of us has witnessed or been a recipient of such uncaring behavior, executed by the mysterious denizens of the HR world.

Ironically, despite detailed COVID-19 regulations that were well communicated by state and local governments, HR people everywhere appeared to be in a state of bewilderment. HR forums were flooded with comments and questions from HR people as well as from business owners desperate to explore ways to skirt compensating employees under the CARES Act and Family First Coronavirus Response Act (FFCRA). The note below has been taken directly from one of those forums:

> "Our company owners aren't thrilled on paying for 2 weeks of sick leave (48 hours total) so they are being resistant towards the 2 weeks paid sick leave. Can I have him [the employee] use

1 week of PTO and then we pay the 2nd week of leave? I didn't know if this was possible. We are a small company of under 50 so we are just trying to avoid losing money where we can."

Sadly, it seems as if some of these people are so inexperienced and untrained they are asked to *invent* ways to avoid the rules, looking for answers to questions that should be referred to legal counsel:

1. "[Could we] ask executives making over xx $ amount to take a cut in pay - say 10%?

2. "If so what documentation/authorization do you need?

3. "Does this need to be communicated to all staff?"

Is this really the function of an HR department: to skirt around the rules, acting as a "resource" for the humans in their organizations; "bending" the rules in the company's favor? Shouldn't they be figuring out the best ways to administer the new rules so that:

1. They keep their companies out of trouble

2. They support employees by explaining how the new rules apply and how and when to use them

Years ago, in a private conversation in a closed conference room, a Vice President I knew well dismissed HR as "an arm of management." In other words, HR is powerless unless management instructs them to take a specific action. So regardless of the whitewashed title of "Business Partner," regardless of the level of education or number of certifications, HR is viewed as the executioner, after management has played judge and jury.

Obviously, the leadership team doesn't consult HR beyond the technical aspects of getting the wheels of administrivia rolling in a termination, firing

or demotion. Between HR and legal, they make sure the employee is never going to sue and there will be no negative blowback to live with.

I'm not sure "an arm of management" is the way HR people would like to view themselves. We all know that HR is usually mired in performing many administrative tasks: compliance, tracking performance reviews, payroll, employee records, updating policies, maintaining databases, conducting surveys, and keeping HR metrics. But are these duties in the realm of "human resources or human relations"? These jobs appear to be more transactional than transformative and many will one day be replaced by automated systems. In fact, many companies now outsource these functions as non-essential to the core enterprise.

To be honest, I've never seen HR as a resource or a help to my career. In fact, I recall another conversation with another manager early in my career, "Never go to HR for anything. They'll consider you trouble." The message was clear: employees complaining to HR would be a human problem they were not prepared or inclined to solve.

> **"Never go to HR for anything. They'll consider you trouble."**

In American social media, HR forums in the midst of the 2020 COVID-19 pandemic, confusion about work rules shared under crisis conditions continued for months. Surprising questions about unfair practices arose that would normally be dictated by common sense. Meanwhile, employees and their families became ill or needed home care.

For instance, "A friend's sister was fired from her employer in Ohio for refusing to wear a face mask with a political message printed on it. I know we're an at will state but can they legally do that?"

And this one: "An employee had an allergic reaction to a substance on the job today. If their job may cause them to come in contact with this substance frequently, is that grounds to disqualify them for that job?"

One wonders about the training and background of this HR person. Did they skip the class where employee legal protections are taught? Who would label this response a "human" reaction to this person's health problem? What if the employee was their sister, brother, mother, father, son, or daughter? Would the HR person want that employee disqualified from earning a paycheck? When I read that question, I could only conclude that this HR person doesn't know his/her stuff or have the wherewithal to consult the company legal counsel.

There is a law called "The Americans with Disabilities Act (ADA)" that requires "reasonable accommodations" for an employee with a specific health issue. A simple Google search could have turned up that answer.

I found it incredible that during a global pandemic, there was such a myopic view of humanity. But if my Vice President "confidant" was correct, in these cases, management was most likely calling all the shots. The HR people, working in a command and control top-down environment, were required to do just enough to protect themselves and the company, while remaining indifferent to the impact on fellow employees.

In the throes of the pandemic, humanity seemed to evaporate when employees needed to care for loved ones or when employees themselves needed to recover from COVID-19. The following statement really made an impression on me:

> "Hi, I am looking for a termination letter to send to an employee that has exhausted FMLA ... Do you have anything I can use?"

123

No mention of other leave the employee may be entitled to, or an alternative solution to firing the person. It's easier to just get rid of him. I am certain that HR itself wasn't making that decision. The company leaders had policies HR was required to implement. In this case, leadership apparently considered human capital their biggest expense, creating HR policies with big gray areas, either right on the line or a tad over the line of legality, and with little concern for their human employees.

When leaders can't or won't recognize their human capital (the greatest company asset) as humans, with real human needs, including lives outside of work, with children, pets, homes, and relatives, cynicism takes hold among employees, and the HR department as well. This attitude may very well be the basis of "Peace for Pay" which we talked about in Chapter Five.

On further review

I was so intrigued by the dearth of human consideration coming from these "professional" HR forums, I was compelled test my theory of how HR has lost its focus on humanity. Simple Google searches resulted in scads of stories of behind the scenes behavior in the world of Human Resources.

One tale I found particularly provocative involves an HR intern shadowing the HR Director on termination meetings. At every termination session, the HR Director coldly recited the same sentence: *"By the way, if you're planning to sue us, good luck because we have the best outside counsel in Los Angeles."*

The article goes on to say that the author realized the HR Director didn't even hear herself after a while. The words were automatic and became a standardized part of the termination process. This Human Resources

Director had obviously lost touch with her own sense of humanity and allowed herself to denigrate the person being fired, who was already feeling vulnerable.

Where did that speech come from? Did the HR Director make it up, or was it based in a policy designed to discourage law suits regardless of the cause of termination? Who makes up such callousness on the fly? I can say with certainty that such a policy originated from the organization's uppermost echelons.

A CNN Business report advised in a termination setting, the employee must be shown "empathy" and cautioned "against using any harsh words or mean emotions during the termination." The report went on to say that the termination should be handled by the direct manager, with HR present or not. Obviously, that protocol didn't happen in the case mentioned above.

In my opinion, Human Resources needs to move beyond being the extended arm of CEOs and business owners. The HR people in any company need to be more effective and value added, rather than simply echoing and executing what management wants.

One wonders, why so many HR departments act like the notorious "Catbert The Evil HR Director" in the famous Dilbert cartoons. In the HR social media platforms, I've often commented, "You don't want people to think you are 'Catbert'". With that perspective, I'm confident being seen as Catbert is not the way HR wants to be perceived.

Just for reference, and maybe a chuckle, though the meaning is far from humorous. In a Dilbert cartoon, Catbert issues a new "family friendly" policy from his computer in a most impersonal fashion: "The company will no longer allow time off for the death of a family member." In the next panel, Catbert continues, "This 'family friendly' policy will remove your incentive to extend vacations by killing

relatives." In the final panel, Catbert proclaims "And more good news: We're canceling your life insurance, so your family won't try to snuff you out either."

This joke is clearly a parody on company bereavement policies. Imagine, extending your allocated bereavement leave, identified by blood relative, with vacation time alone!

In another senseless notion, let's talk about policy requiring employees to relinquish the frequent flyer miles they accumulate while on company travel. At my very first corporate job, I recall employees lining up outside the finance department to surrender their airline frequent flyer coupons. Eventually, the finance department was too overloaded to account for thousands of frequent flyer miles and hundreds of employees. The policy became too cumbersome to administer and was abandoned. One asks, what was the point of this policy in the first place? What did the company do with all those frequent flyer miles? What purpose did the company have for sending employees all over the U.S. and the world, then denying them the benefit of the frequent flyer miles?

Have you ever wanted a department transfer or an internal promotion, but HR policy gave your manager the power to stop it? I remember a case where a secretary applied for a promotion and transfer to another department but was stymied by her manager. Why? Pure selfishness on his part. Because he considered her to be a great secretary and didn't want to lose her innate talent and ability merely because she, herself, desired career advancement. I worked at that company for four years, and that secretary never rose above her pay grade. Making arbitrary decisions that make no sense is cartoon strip material. HR professionals need to be mindful of the impact their policies have on the humans who have to live with their consequences.

The reality is that today's business leaders need to acknowledge the human in Human Resources. Until robots take over every human task, organizations are comprised of people, flesh and blood human beings with thoughts, feelings, and opinions. We humans have families, and pets, and as humans, we attend our child's T- ball games, we go to movie nights with our other human friends, go out on picnics, and take vacations. We humans go to church, have sickly human parents or children, and experience human loss and tragedy. Like all humans, we strive to make sense of our lives in every way and that includes trying to understand 'human resources' at work, because sometimes, it just doesn't make any sense.

The quest for common sense

How do we reconcile our quest for using common sense and truth in a non-sensical work environment?

Too often people in leadership forget that a company, together with its human employees, must be working toward a common goal to gain success. Employees need positive motivation to continue to work year after year. Forgetting to solicit the voice of employees in establishing that common goal is reflective of a business climate where quarterly results make or break a career, and how you achieve them does not come into question.

Regrettably, it is also reflective of the growing callousness of our divisive society today. Humans, for all of our faults, for all of our technology and the connectiveness it can provide, still crave respect, integrity, dignity and love – in a environment that not only illustrates human value, but supports us in valuing ourselves.

Studies show that we humans are happier and more productive in an environment of integrity

127

and respect. The "cowboy-style" management we discussed in the previous chapter is counter to the fast and profitable results the company pursues. The cost of cowboy management to the organization can be steep. For instance, the impact of healthcare costs is one area where cowboy management takes its toll: the stress of the workplace under this kind of management causes healthcare costs to skyrocket up to 50% higher than competitors'. Another study indicates that there is "a statistically significant positive impact ... for firms that measure high on [having a] culture of integrity – positive results not only in ... profitability, but also ... in higher productivity, [and] better industrial relations ... are reported."

How do we accomplish a more human climate?

When leaders demonstrate trust in their employees, employees feel more valued. Believing they matter to the company motivates employees to become more engaged and willing to take on more responsibility. Why? Because they feel their contributions are appreciated and valued. Organizations that trust employees and "make it personal" make the employee experience worthwhile. A recent survey found that "employees in a trusting environment felt 76% more engaged than those in 'low-trust' workplaces."

Leaders and HR managers need to embrace the reality that human happiness goes beyond bringing home a bigger paycheck. Often, human recognition and support makes employees want to be at work, and the paycheck is only one source of satisfaction.

Establishing and maintaining trust requires constant reassessment, as business conditions change. The Civil Rights Act of 1964 changed much

in the rules of employment and the workforce, and as legislation on every level of government changes and adjusts to the times, organizations must also change. What was correct business procedure in the 1950s, and 1960s, or even up to and including the early 2000s, is far from acceptable today.

The uncertain days of the 2020 pandemic taught us that the need for more flexibility in how work is conducted is greater than ever. How we work from home, communications with employees, and conducting meetings have all dramatically changed. A company needs to make whatever changes are necessary to stay profitable and keep employees engaged, especially in shifting and uncertain times like a worldwide pandemic, or 9/11, or even an internal upheaval. Clear, concise, and accurate communication is necessary. Employees and leadership need to interact and ensure they are speaking and hearing the same messages.

There are so many ways all of these elements can be implemented: through training sessions, employee handbooks, surveys, town hall meetings, badge card messaging, any way management and employees can stay on the same page.

And isn't it worth it? Working to put the human back in human resources is a major step toward creating a positive environment where people feel valued and will do their best work.

Recently, I visited my favorite salon for a haircut. The hairdresser who worked on me was brand new to that salon and relayed how excited and happy she was to have made the move. I asked her why she left her previous salon, and guess what? She left after seven years of dedicated work because she didn't like her boss (who happened to be a friend of the family). She didn't like the restrictions, lack of

communication, long hours, and the tension filled environment. Communication was so poor, she wasn't sure what hours she was assigned to work and what her duties were when she wasn't styling hair.

Unsolicited, she volunteered to me that she really loves her new job and couldn't stop praising her new boss. The environment was so easy going and friendly. Her previous manager created a culture of stress and high pressure and lost a devoted, talented worker to a competitor. Maybe if her previous employer had treated the stylist with respect and integrity, she would have stayed.

How hard is it to extend common courtesy to employees?

And that seems to be the crux of the matter for my new hairdresser: her boss couldn't extend basic manners and respect to the stylist and that stylist could not imagine herself spending any further time there. She didn't have to, she had other options. It sounded like she left a fear-based culture to me.

What can we do to cultivate the right attitude toward each other in business and in our everyday lives? In recent research, "projecting warmth" has been shown to be a major factor in establishing trust. Other researchers mentioned in the article (Adam Grant, Amy Cuddy, Jonathan Haidt) also support the concept of higher productivity when employees are happy and motivated by the boss's positive behaviors.

It may be a surprise to many HR managers, but a recent survey by Gallup shows that employees actually prefer "happiness to a higher salary."

One company I worked for paid very well, even better than competitors, but the Cowboy Management culture engendered a stressful, dog-eat-dog environment. If an employee could find

a niche where his boss was good, then the employee would survive nicely. But in cases of a weak, or overbearing boss, the culture felt oppressive and unbearable. Many people left that place citing workplace stress as the principle reason.

Now let's look back at the scenario that opened this chapter. Picture this, a talented, hard-working woman comes into work early, as is her habit. Puts away her purse and hangs up her coat. Her boss appears in her office and asks to speak with her. He tells her because of her outstanding performance on her latest project, she's now going to be that project's Program Director. She's offered a pay raise and a promotion.

The next morning, when she arrives at work, there is a note on her desk from HR. She wends her way through the building to the HR suite and is called into the office of the HR director. He hands her an envelope. Inside is her offer letter for her new position, and also a $5000 award for her outstanding work. She floats away as if on a cloud, feeling happy and grateful, with her company loyalty intact.

"The essence of being human is that one does not seek perfection."

— George Orwell

Chapter 13

Corporate Soap Opera
or Drama in the Workplace

*"Wise men talk because they have something to say;
fools, because they have to say something."*

— Plato

FROM THE TIME of the ancient Greeks through the age of YouTube and Tik Tok, people love drama. Drama is not just the stuff of soap operas, movies, television and politics. Wherever you find people, you'll find drama. And for all of us who pack ourselves up every day, and trudge off to earn a living, we've learned how dramatic a place work can be.

Work is the place where you will see and hear occurrences that even Hollywood could not make up. No one would find credibility in the stories. Here is the drama of Jackie's story.

Management and Other Plans

Several years ago, while at a training session with a major manufacturing company, a colleague alerted Jackie that in a conversation with their boss, he was told that management had "other plans" for her.

This news did not sit well with her colleague as he was totally overloaded, and at that time she was taking over much of his extra work. He was in charge of cross training the whole department on a new, complex software platform, but had been given no relief from

Oh, an opportunity to excel?

any of his other responsibilities. This way of doing business was not uncommon there. As the workload increased, the number of people doing the work would often decrease.

Jackie found this news ironic, as she had just returned from two weeks of training, in the specific area for which she was hired. It made no sense to move her after the company invested thousands of dollars in travel and living, plus the course itself, only to move her someplace else where I had no expertise. It seemed crazy, well, not really as it turned out.

Later, her boss stopped by her office and after some brief chit chat regarding her trip, he said they needed to talk and took her into a conference room. By this time in her career, she'd learned not react to such pop-up meetings because after years of these mostly useless events, she thought, why spend her psychic energy unless it was an actual emergency? She practiced composure and let her inner "Zen" govern her emotions. Her boss had a reputation for weakness, so it was probable he'd slip up and blow the conversation anyway, whatever the news. She kept in mind to take whatever the "news" was by practicing "executive presence" and remain unruffled.

Some additional chit chat continued, and Jackie finally asked him to get to the point as she had a lot of work piling up on her desk, given that was her first day back from training. He told her there was an "opportunity" that had just come up.

Jackie replied, *"Oh, an opportunity to excel?"*

He grinned sheepishly and said there was a job in "planning" and that he had set it up for her to talk to the "planning" manager later that day. In manufacturing parlance, "planning" refers to the

planning for production, which, as she later learned, means making sure the right piece parts were released to the manufacturing floor at the right time. As he talked, he spun the opportunity as a way to learn a different part of the business. He went on to say he had been in planning about 15 years ago, so he didn't want to describe what planning was now, as it could be completely different than it was in his day. Despite her pressing him for more details, he insisted things probably had changed so much, he couldn't give any further information. His circumlocution was a red flag, and she took note of his evasiveness. It certainly was a signal to pay attention to whatever came next.

She even thought of taking a positive look at this proposal. She began to fool herself into thinking this might indeed be a good move for her. While not sure exactly what "Planning" meant, she felt that a change might open opportunities for promotion and add to her resume to show more varied experience in the sector. But as she thought more about it, it seemed to be a confusing time to be making this kind of a change for her. It didn't seem to make any sense since the company had just invested several thousand dollars in training her in a completely different skill set.

Regardless of her confusion, she was asked to refresh her resume and send it along, as her manager offered to make the call to the hiring manager, and she complied. He was supposed to make the call that same day. But an interesting series of events began to unravel her boss's ill-conceived plan.

First of all, it was foolish of her boss to assume that she wouldn't ask around about this move. After spending well over 10 years in the company, she had formed trusting relationships with people of all levels who were willing to pass on information. Also, given the fact that in any social group, people are going to talk and share information, it was a poor assumption

on his part that she would just accept a major career change out of nowhere. All employees in the company knew how vital it was to find out information via "The Grapevine" in this case, making a few calls, stopping in people's offices, and generally asking around the tiny coffee shop and dining center.

Jackie could rely on the grapevine because "secret" moves like this often affected people's jobs, the location they were assigned, and promotion possibilities. Employees talked because management often sprang surprise decisions upon them, just like this new "opportunity" was sprung on her. No one likes to be surprised. Being surprised could undermine a career, without being tapped into the right people who feed precious information. The unofficial undercurrent "wave" of information flowed freely through the organization to counter management's secrecy attempts. It seemed there was a friendly "fly" on every wall.

A memorable example how this "wave" worked was when people talked about an imminent firing. Rumors grew that a manufacturing VP would be fired. His behavior warranted it and employees wondered when the ax would fall. In a few weeks, they learned he took his company laptop to Hong Kong (a security violation), and there were "irregularities" in his relocation accounting (fraud). Furthermore, it made no sense given that this VP had lived in communist China for 10 years (conflict of interest). As the "wave" proliferated, employees bet on a short tenure for him. Soon enough, the CEO announced that he would be "leaving the company" and someone else would take his place. Once again, the "wave" proved to be a reliable source of information.

The Unraveling of "Other Plans"

With the accuracy of the "wave" in mind, at lunch that day Jackie asked a friend what she thought of

this move. Her friend noted that the system platforms in planning used at the time were going to be replaced soon and reminded her that she would be learning an old technology, so she knew very quickly that the reality was this move would be no gain for her career.

After lunch, another colleague pulled her aside and in a theatrical stage whisper said, "Jackie, that job is not for you. You are way overqualified. That job entails entering parts into the inventory system as they come in from vendors and making sure they are distributed on the manufacturing floor. Besides," he hissed, "that hiring manager is a complete ass. You don't want to work for him."

And so, the drama began, however unsure Jackie was of which Act she was now in. The unfolding of the plot began to reveal itself in Shakespearean proportions. These enlightening conversations with her colleagues, drove her to further investigation. She looked up the hiring manager in the company directory and discovered that "Planning" was actually "Planning and Inventory." Jackie knew nothing about either subject, and inventory control was an entry level job, several levels below her current position. This just didn't sound right. She had just returned from the training center in Texas for two weeks of training in subcontract management – a more senior and more responsible role than what she was seeing in "planning." What was the point of placing her in a job that required moving parts around the manufacturing floor?

Jackie then realized there had to be a reason someone wanted to move her out of her department and into "planning" or anywhere else for that matter. She knew it wasn't for the sake of "opportunity." At this point, she decided she would let this incident, this drama, play itself out and see where it would lead. Onto the next Act, whatever that would be.

Before leaving work, Jackie refreshed her resume as asked, and dutifully sent it to her boss. She also sent him a separate email expressing some questions and concerns that she had on the subject:

[Boss]:

Seems "planning" is really planning and inventory. Not sure this is the right move for me.

Would like to further discuss options, as it's confusing as to how this places me into an upward career path.

Frankly, the more I learn about this position, the more I doubt it will leverage my strengths and skills as my current position does.

While I understand the need for training on these various databases, it's unclear how soon I'll be up to speed in this role in order to make a viable contribution.

Looking forward to discussing this at your convenience.

A bad feeling overcame her during the night and she woke up furious. Around 6:00 A.M., she jumped out of bed and went to her home office. It took her a few minutes to gather her thoughts, but she knew she had to take matters into her own hands. Determined to get to the drama's climax and denouement with the least collateral damage, she sent a quick email to her Vice President. Luckily, she knew him from a previous life where they had worked closely on several large projects in another city.

[Dear Mr. Vice President]:

Wondered if you would have some time for a career discussion. Would like to discuss future opportunities at your convenience.

Thanks, Jackie

When she got to work that day, her colleague who had advised her against the job, had also done some

additional investigating. He discovered that someone else had been promised that job and she was another major player, a person to be reckoned with. It seemed that the "backfilling" process would be one big mess if she were to take that position.

Later that morning, she received this email reply from the VP:

> Jackie,
>
> I would be happy to sit with you and discuss your career. I am due to travel down to your site soon, I will be sure to have Karen set up some time for us to talk.
>
> Take care, [Vice President]

Within a few hours, her boss was at her office door. Once again, they to the conference room. His opening sentence, after she was seated, was, "I read your email last night. You're right; the planning job isn't going to be a fit for you."

She told him she thought he was right. "I would have let the hiring manager come to his own conclusions," she said, "but the move into 'planning' doesn't make any sense because the technology is ready to be replaced, and I just returned from two weeks training which cost the company thousands of dollars. Wouldn't the company be best served for me to use my new training right here, as expected?"

You be the judge. This was clearly political posturing turned into office drama, corporate soap opera stuff, but how else could Jackie have handled it? She needed to get to the final Act and end the play.

From the political standpoint, Jackie wondered was there any influence on her boss by her friend, the VP? Was there an early morning phone call from the VP asking the question: Why does Jackie want to talk to me about her career? Or was this "opportunity"

political blowback since she had previously uncovered and reported on incorrect reporting regarding a supplier's timeliness which her boss and his cronies had covered up for years?

Jackie still wonders to this day about the political implications of this drama. She knows she did the right thing. It was her career that was being interfered with. Without her own due diligence, she could have committed career suicide.

Because she was determined not to be bulldozed by dumb decisions, she investigated the "opportunity" herself. She spoke with others to get a feel for what this move really meant, and while she did as she was asked in updating her resume, she also reached out to an executive who was a friend to ask for a few minutes of his time. In no way did she upset the applecart by implicating her boss's bad decision – she merely asked for time to talk.

It's true, wherever there are people, there will be drama, the ancient Greeks knew it well. Due to the variable nature of humans, bad judgment usually instigates bad drama. But bad judgment doesn't dictate the whimsy of management decisions. True leaders ask the right questions and tease out truths, heading off the drama and redirecting the "players" back to the "roles" they originally "auditioned" for. Otherwise, we end up with complicated story "treatments" no Hollywood producer would touch because they are just too far-fetched and absurd to be believed.

Like Rasputin, perhaps?

Chapter 14

A Modern Day Rasputin

"Consultants are mystical people who ask the company for a number and then give it back to them."

— Unknown

IT'S **NOT UNCOMMON** for leaders to face "big rocks" to solve, as a recent article labeled corporate problems. These are complex issues, and with full plates, leaders turn to other experts for support and guidance. As one wise leader put it to me *"Mary, none of us know what we are doing, we're all guessing."*

When faced with an intransient culture, resistant to change, leaders hire consultants to assist in their efforts and decision-making process, and to overcome their "big rocks." Jack Welch famously leveraged the organizational leadership expertise of Noel Tichy to introduce the concept of the "Learning Culture" to GE, and in the mid-1980s he ran GE's Leadership Center. Similarly, W. L. Gore (Ch. 4), hired Michael Pacanowsky, another organizational change expert, to help guide the company for 29 years instilling the "lattice" structure throughout the company.

My experience is very different from that of GE or W.L. Gore. After over 30 years in the industry and many experiences with a variety of consultants, it's hard for me not to start a discussion on the topic without a few consultant jokes.

A consultant is ...

- Someone who takes the watch off your wrist and tells you the time.
- A man who knows 99 ways to make love but doesn't know any women.
- Someone who is called in at the last moment and paid enormous amounts of money to assign the blame.

One consultant specifically stands out in all my years' experience, Ken Markell. Ken was hired to bring "change" to the culture at a large Fortune 500 firm over a period of 10 years. Ken's key strength was his ability to influence the right people at the right level, especially the company president. He had a number of intriguing ideas, mostly centered around turning around the prevailing "entitlement" culture and transforming it into an "ownership" culture, a long-term goal of the company president. It turned out to be a lucrative four- or five-year assignment, since "entitlement" was deeply entrenched into the corporate DNA and undoing it would take a Herculean effort. Now, Ken didn't have the strength of Hercules, but he did have impressive staying power.

It appeared that Ken, this new consultant, was hired to be a "disturbance handler," a job description I discovered in the *Harvard Business Review*:

> "... the disturbance handler role depicts the manager involuntarily responding to pressures. Here change is beyond the manager's control. The pressures of a situation are too severe to be ignored – a strike looms, a major customer has gone bankrupt, or a supplier reneges on a contract – so the manager must act."

When I read the description of a disturbance handler, I immediately thought of the role Ken had played. Although Ken was not responding

involuntarily, it was apparent the company president did not want the job of dealing with an entrenched culture. So, the chore of engaging the transformation from "entitlement" to "ownership" fell to Ken.

Ken earned a high salary, but many employees felt he did not provide the services for which he was hired. Instead, they felt he led the company president down a circuitous path without addressing the "functional and structural changes" needed. In fact, Ken's nickname among employees was "Rasputin" for the undue influence he appeared to have over our leader.

Futile exercises

One change Ken instituted was a personality analysis assessment that all employees were required to take. The results were to be displayed on employee badge cards and on 5"X7" plastic stands in work areas. The assessment wasn't unique to Ken or the company and was in the same category as many other well-known personality assessments. This one measured people's personality by applying the interpretive results of a multiple-choice test everyone was required to take. The results were like an ink blot test, as various shapes determined a strength in the form of colors indicating where someone's personality was strongest in a number of situations.

The assessment supposedly predicted how a person would act under pressure, in public, and how their inner thoughts predicted their behavior.

As you can imagine, people were not happy about walking around with badges that showed personal information about their personalities on public display. Many people considered the information gathered in the assessment to be private.

In addition, Ken and our president selected certain employees to undergo "change management" training. These people were called "White Knights." Ken and the president recognized that fundamental changes in how the company did business were needed to deal with new challenges. They came to the conclusion that in order for the company to be successful, their internal and external processes, structures and management style needed to transform in accordance with the changing business environment.

This change would involve successfully shifting from a sole source environment, where the company automatically acquired new and follow on business without competition, to a competitive environment, where numerous bidders entered the fray. It could also mean changing from a major subcontractor role to a major prime contractor.

Company surveys showed the biggest obstacle to making change happen was the middle management layer. These people had been in their jobs for years and found ways to circumvent anything new because to them it didn't make sense and it was too much trouble. After all, they'd been successful doing what they'd been doing the same way for over 20 years.

Ken and the president felt that by selecting people from the layer under middle management, they could bring needed cultural revolution to the company. Since the company was known for its "entitlement culture" they might have anticipated the ensuing challenges: The people choosing the "White Knights" were the middle managers themselves, the ones who were mired in the old way of conducting business. Additionally, something went terribly wrong with the selection process, for the "White Knights" became known more for their arrogance and superior attitude, and less for making viable change, much to the chagrin of other employees.

Ironically, becoming a "White Knight" seemed to be the path to promotions and better jobs, because at the time, just about every "White Knight" appeared to be promoted ahead of other employees, regardless of competency. Consequently, the only change apparent to the employees, was to produce yet another crop of supercilious, insufferable coworkers.

Indeed, some of the exercises the "White Knights" were told to do made no sense. At one meeting I attended, the entire group of 80 people arrived only to find the conference room doors locked, instead of propped open as expected. These doors had always been open well before the meeting started, so to find these doors closed and locked was disconcerting to say the least. To add to the confusion, our usual spot for coffee and water was deserted. No food or drink in sight, again, very much out of the ordinary. We all knew there were strict rules about being late, but it was only 7:00 A.M., and most of us had not had our coffee or anything to eat. The dining center was an entire building away, and people began to panic. We all knew that being late was not an option, but we all wanted our coffee! Everyone in the group was overcome with confusion and worry, and I figured this was yet just another silly game the management team and Ken were playing on us.

I knew there were small convenience spots in most of the buildings, although I didn't know if they had coffee, so I decided to find out. I needed my caffeine! The little shop indeed had coffee, and I was the first one in. Only a few of the 80 people even noticed that I had made this detour, and those few and I got our coffee and were back at the meeting room in plenty of time. Later, we heard that the catering service had forgotten the morning coffee service delivery, but that was not credible. No one forgot a meeting scheduled with Ken and our president.

It turned out this exercise was designed to make us "think out of the box." But most of us were disgusted rather than inspired. If this was "change management," we were not buying it. The coffee service finally showed up at 10:00 A.M., but by then its presence was anti-climactic.

In this sense, the shock value of the locked doors and the lack of coffee service didn't really teach us anything about change management. We were so stunned by the incident, the only feeling most of us had was resentment. It didn't matter whose idea it was. It only mattered that we felt played with and blindsided.

Another incident apparently designed to imbue change management in people was what looked like "Truth or Consequences". In a misguided effort to improve communication, both the president and Ken told their life histories, and then each "White Knight" was expected to do the same. The "White Knights" didn't seem to understand tact or diplomacy. We heard stories of divorce, abandonment, and hardship. Great personal sagas for sure, but how these stories impacted the company's ability to change its culture was lost on many of us.

In another incident, I witnessed the conference room doors being locked from the inside at exactly 7:30 A.M., so any late arrivers would have to bang on the door to get in. Sure enough, as the president was speaking to the group from the stage, we all heard loud banging on the doors. Everyone froze in their seats. No one dared to get up and open the door. So the president walked off the stage, while still talking, only to open the door and castigate the late comer in front of the rest of the group.

The question here is: by orcestrating these performances, did the consultant, Ken, accomplish his mission of change management? Did he live up

to the label of "disturbance handler"? It appeared Ken at least went through the motions of everything that was required of him: he administered the personality test, he led the meetings of the "White Knights," he worked with senior leadership at retreats and conferences on topics ranging from changing mindsets to proper talent placement.

Bad examples

One element that could not be predicted by Ken, or anyone else, was the caliber of people who were chosen to take part in this change management experiment. Ken could not foresee how the personality assessment would be used, thereby making employees feel their privacy had been invaded. Nor could he have envisioned how wrong the "White Knights" would present themselves to the rest of the company.

And how imperfect the "White Knights" proved to be! Selection mistakes were common. One participant, a female engineer became manager for a huge program (multiple billions) and her job was jumped two levels, into the incentive compensation range. Her nervous personality and lack of confidence impeded top performance and she never really got the hang of the big job. She bounced around until she landed in a different location, moved out of engineering and into diversity training. She always looked so nervous and self-conscious, other employees nicknamed her "Eight Cups of Coffee."

Another female "White Knight" jumped two levels from contracts to subcontracts, despite a reputation for non-responsiveness, non-communication, and being overly sensitive. Soon the complaints rolled in. People complained she didn't know what she was doing. She mixed up client files, confused one program for another, and proved overall difficult to work with. Because she knew someone who protected her, she survived, but not based on performance.

147

After enduring a year of this "change management" training as a "White Knight," most of those people moved on. The irony is that even though they were hand-picked for the "White Knights" they turned out not to be the best choices for the job. And, no mystery, bad decision making can be traced back to their managers, who incorrectly perceived the program as some kind of "development program." The people chosen for the "White Knight" program were moved up the chain too fast for their level of competency. It began to be the easiest way to get promoted if you could survive the whole year of "White Knight" meetings and the sometimes inscrutable projects.

Based on shaky postulations, the "White Knights" fell out of favor quickly.

Then, there was a sudden change *of* management at the top and our president was let go. Rumors flew of Foreign Corrupt Practices Act (FPCA) violations, but to this day no one knows the truth. Without the president in the picture, Ken's tenure with the company came to a halt. The new management didn't feel they needed to spend the millions of dollars a year Ken cost when he brought so little value to the company. His dismissal was swift.

The company reverted to "continuous improvement" and its old, established employee diversity groups to initiate change. Employees tossed out the personality cards and displays, and the "White Knight" effort joined the change management bone yard, with similar futile change management programs: "Red Tape Removers," "Transformers," "High Impactors," "Gladiators," and other "Flavor of the month" efforts.

Ken, like others before him, led the company down a path it didn't need to tread, and paved the way with the company's dollars. If the consultant's job is to serve the best needs of the client, to

"undertake a special project on its behalf" as stated in the research, in this case, this consultant failed.

It's hard for me to believe Ken had confidence in the unorthodox "change management" exercises used in the "White Knight" experiment. Common sense would dictate that you don't lock people out of a room, bar entrance early in the morning without the expected coffee service, or allow people to grovel in their despairing personal stories in order to engender change. Not one of these practices improved the company's readiness for change. No company processes, procedures or policies, were ever improved or modified by the "White Knight" experiment.

In fact, old line managers dug in deeper, sticking to the letter of the law, once the "White Knights" were dispersed and Ken and the president were gone. Did Ken mislead or misunderstand the president? Bringing him back year after year, collecting his millions, makes me wonder what those two were really up to. I know Ken consulted all over the country. How he could go along with such useless and pointless activities seems to border on the unethical. I often wonder, since he had a reputation to uphold, why didn't he guide his client to a better outcome? Where was the accountability for making real change happen? What was the basis of his contract with the company?

> **Good consultants make a difference in how a company responds to change**

These are critical questions to answer *before* hiring any consultant. Consultants are responsible for the success of their clients. If clients could make the needed changes on their own, they would.

We may joke about consultants as a matter of course, but good consultants make a huge difference

in how a company responds to change. Consultants used at GE under Jack Welch guided GE's HR and Talent Selection process. W. L. Gore Company kept one consultant for 29 years to support their unorthodox "lattice" organization.

Good consultants work hard to avoid even the slightest appearance of impropriety and make sure to steer the company in the right direction. Good consultants bring more than experience, they offer insight, integrity, and results.

Although there were many offenses committed by the consultant featured in this chapter, truly the most damage was done to himself. By engaging in these misleading business practices, the consultant damaged his reputation, which is a consultant's stock in trade. Without a good reputation, a consultant really has nothing at all to offer.

Consultants offering solid, evidence-based guidance truly help an organization grow and maintain its competitive posture. They support trends that make sense and are accepted universally at every level. When the consultant's work doesn't enhance the reputation of the person at the top, the leader's credibility could be seriously damaged. And as historians have postulated, with the Romanoff family in 1917, once Rasputin was overthrown and assassinated, the dynasty was gone forever within a few weeks. If Ken had guided Tom better, and offered his best knowledge as a consultant, where would they both be today?

We can only take the lessons to heart. Choose your closest confidants wisely.

Chapter 15

"Games People Play"
Zen Principles

*"The eternal problem of the human being
is how to structure his waking hours."*

— Eric Berne

PEOPLE LIKE GAMES. They're entertaining and
fun, and when played in the office, they might be
a way to actually avoid doing work. Procrastinating
at work is one issue, but people can "gamify"
relationships as well.

If you're familiar with some old favorites like
"Monopoly®," the object of the game is for the winner
to take all. How about "Battleship®"? Another game
of strategy where the winner successfully sinks all
the ships of the opponent. And in the game called
"Risk®," once again, through strategic means, the
object is world domination by defeating all the other
players. How clever of the game inventors to engage
the human drive for competition and add the element
of strategy or positioning in order to win it all.

And so, it's not unusual for people to play games
in the workplace or in their individual decision
making. Playing games is a natural spinoff of our
innate desire to win it all and, even more importantly,
our need to gain control. But what's the strategy most

often employed to get the win and achieve control? People are not likely to overtly make moves and give away their position. People tend to avoid risk and may lose their nerve to say what's exactly on their minds, so acting covertly is their back up position, their strategy. Playing games at work also may manifest itself as a way to pass the buck, blame someone else, or to win favor by the executive in the corner office and take on more work than you can actually handle.

When grownups play games the result can be deception, manipulation, or maybe even sympathy. Let's say the boss calls a meeting looking for suggestions for an upcoming project, and instead of listening to people, he says "Yes, but..." and denigrates every response. He's playing "the boss is always right" game.

A co-worker is late again for a crucial meeting, and someone challenges the lateness with, "Why are you late again?" The person responds with, "Why are you always picking on me?" The late comer has wasted your time and is playing the "victim" game.

Playing games is not limited to work. Game playing is also common in personal relationships, including marriages. Have you noticed husbands and wives not always acting like adults, or one partner who takes on a parent or child role? One partner or the other plays at different parts depending on the basis of their relationship. I've come across several of those in my career. The one I want to talk about today relates to our leadership discussion and understanding the role that playing games has in the workplace.

The games Janice played

Let me introduce you to Janice. Janice is a bright, young, mother of two children, married, with an unpublished book. She has a PhD. and is a lecturer at

152

a local university. She has two dogs and a large house with substantial acreage. While her husband is clearly a Baby Boomer, she is several years younger than he.

She came to coaching to work out dissatisfaction with her career at her university, and to seek other, more satisfying avenues for career development. Through our coaching sessions, what emerged was Janice's inability to focus on any particular activity which would bring movement toward her goals. Her lack of focus added to her frustration and feelings of discontent and was the hallmark of her decision-making process.

She often expressed a desire to engage in activities she loves and pursuits that were "fun" for her. To Janice fun meant spending time with friends, wine tasting outings, going to the beach, paddle boarding, and anything that wasn't specifically tied to keeping a job or a home. Janice is a more typical case than you may think. Let's not judge her just yet. Like many other people I've worked with, Janice could not adequately articulate the distinction between items that were important and not important. To her, everything was equally as important. And this lack of distinction is a recurring theme in dealing with many leaders. As mentioned in an earlier chapter, leaders are often faced with challenging decisions. And analysis paralysis slows the decision-making process and delays actions critical to the survival of the organization. Janice's story is a case in point, and each time I revisit her story, a new realization about people, games, strategies, and actions materializes.

Prioritizing seemed to be a struggle for Janice. As previously mentioned, to her, everything was equally important. Brainstorming solutions yielded a "yes, but..." in just about each case. Janice agreed to experiment with small changes, but other areas,

which she classified as "mundane," presented more of a struggle. She felt that her every day, dull, mundane tasks were no less important than her desire to pursue more creative outlets. The cognitive dissonance caused our discussions to become rather circular in the probing and exploring stages. It seemed regardless of the phase of our conversation, none of Janice's own solutions seemed to stick, but were more like of pieces of tape where the adhesive backs are worn off. No wonder she was "stuck." Not unlike many leaders, she could not settle on a reasonable path forward. Her vacillation and aversion to commitment caused chaos in every aspect of her life, from her job as a university professor to her family and personal life at home.

Janice's husband felt it was a "time management" problem. But she resisted the concept of management of any kind. She also rejected the notion of "time control," stubbornly adhering to her limiting mindset, "You can't control time." Although time management is a huge challenge for many people, regardless of stature or role, Janice clung to a core belief that she lacked the ability for "time management" or "time control. It became clear to me that she was confusing the concepts of "control" and "management." She believed time was cosmic and immutable, like the rotation of the earth around the sun.

I know from training and experience that gaining control over one's external environment, including time, is critical to our ever-elusive feelings of happiness and well-being. The ability to overcome "overwhelm" and feelings of being "out of control" comes from a realization and awareness that not all things deserve equal amounts of time or attention. Think of time in military terms, assigning each hour its own numeral over a span of 24 hours. Each is discrete, singular, and AM/PM are easily distinguished. The hours

organize themselves. Using each hour individually, you realize how important time is, helping to organize your thoughts and control your days.

The work of capturing time centers on choice, deciding what is most important – learning to prioritize and focus. Not easy in our pressurized world of multi-tasking where women, especially, are supposed to do it all and have it all.

> **The work of capturing time centers on choice**

After several meetings, I accepted that Janice lacked understanding of how to function in a world she found so confusing. Beyond the issue of time management, she said her husband commented to her, "Not everything has to be fun." I imagined his exasperation as she spoke. She didn't seem to understand his point. She preferred to pursue only things she considers interesting, fun, and creative. This leaves her feeling weighed down and obligated as a mother, wife, householder, and university lecturer. All of this often left her with a sense of guilt when relaxing with her children or just reading a book.

The most appropriate approach to helping Janice was Eric Berne's concept of *Ego State* and the *Games* and *Scripts*. Berne defines "Ego State" as "a way in which we think, feel and behave." The three Ego States are: Parent, Child, and Adult. Scripts play a part in how we communicate. For example, we could act as a hero, villain, or martyr, depending on the circumstance. In current language, we might describe scripts as a person's core beliefs that drive his or her life.

I recognized that Janice presents as a combination of Free Child, playful, creative, and emotional; and Adapted Child, reacting to the world, and either changing to fit in, or rebelling; focusing on Rebellious Child. These are typical roles as defined by Berne.

155

It's interesting to conceive of people acting in these roles. Ideally, we strive to be adult to adult as much as possible. But have you ever had a conversation where you felt emotions that came out of nowhere? Suddenly, you felt like you were being singled out, or were suddenly very powerful, or a fear of responsibility crept up on you. These feelings are triggered by the role they unconsciously evoke, depending on the circumstance.

For instance, haven't you been in a conversation with your Mom, and suddenly felt an urge to respond the way you did as a teenager? That's the rebellious child coming out in you. Once you grasp your reaction to a situation, you are better able to control your response, whether it be in Berne's terms or in terms of core beliefs. Awareness of your next steps is the goal.

With clients like Janice, discovering awareness by applying the Zen principles of being centred and developing deeper consciousness help them focus and connect to the inner wisdom that creates autonomy.

To help her gain greater independence in her decision-making process, we used a Zen-like approach where Janice allowed herself introspective focus on her circumstances which led to deeper clarity overall. Zen principles teach a measure of detachment. Janice moved into a state of being objective or taking her reactions out of a potentially charged situation. Learning to step back and detach is not an easy practice, however, when she consciously reminded herself to step back from an emotionally charged situation, and take a moment for thoughtful reflection, she became more aware of her behavior and looked objectively at her circumstances.

Conversations like this are fluid, but it's understood that conflict might arise when "critical parent" and "playful" or "rebellious" child appear.

Games and Scripts are likely to appear in everyone's common interactions: "Harried" and "Why Don't You – Yes But" immediately come to mind for Games. "I'm not OK, you're OK" and "I'm okay, you're not okay" are the most likely underlying scripts in this scenario.

Janice's story, shared in our meetings over time, revealed a fun-loving nature, but also someone who often does not complete tasks (unfinished book, that she refuses to self-publish, has an incomplete short travel essay, a very disorganized basement which she wants to convert into a TV room), and yet continues to tackle new projects (starting a perfume business) while expressing dissatisfaction with herself for her many unfinished projects. As noted earlier on, she resists structure or management of any kind, feels imposed upon when faced with grading students' papers; however, when relaxing, feels as though she should always be doing something else.

Janice presented as a woman who struggles with living in the present moment. She expressed her anxiety and feelings of failure when not completing projects, rationalizing that things must be done perfectly or not done at all.

Who does she sound like? Does she sound like you or someone you know? How many of us are living our lives much the same way? Are you allowing internal political games to get in your way? While leaders need political savvy, destructive games played at a high level, can be career ending. Leaders need to remain objective and make decisions without emotion in order to be effective in moving to the next level or tackling an internal organizational dilemma. Striving for perfection in every endeavour with heavy emotional investment leads to frustration similar to Janice's. She strove for perfection and beat herself up when she couldn't meet her impossible standards, which only caused her more exasperation.

During one session, I asked Janice outright. "What is stopping you from finishing your novel?"

She burst into tears.

When asked, "Where does your need for perfection come from?" she cried again and stated that it came from her mother. With further probing, Janice said her mother always kept an immaculate home, with everything tastefully appointed including her gardens. I asked Janice if her mother had any other obligations outside of the home, she admitted that her mother was a stay at home Mom and never worked outside the home, therefore her mother poured all her energy and creativity into making her home "perfect."

In later meetings, Janice reflected on an acquaintance with a very beautiful, well-kept home. Again, I asked if the person had any other obligations outside of the home. Janice became very wistful and stated that this person was also a stay at home mom.

"I just don't have time for all that," she told me at one session. "All the time and organizational skill – trying to organize my time, my husband's time, my daughter's time, I just can't do it!"

I waited for her next comment, knowing it was coming. *"Besides, homemaking is so mundane. It's just not fun."*

Clearly, she struggled to prioritize a task, unless the task itself was "fun" or creative. Janice's current Child state was becoming unsatisfactory to her and her husband, and to grow and behave in an Adult state, I knew she would have to change on a very elemental, core belief level.

Many people in leadership roles survive for years without changing their core beliefs. If they revert to childish behavior when they get bad news, face

a crisis, or perceive a political slight, they resort to screaming, hiding, whining, or expect someone else to clean up their messes. Janice had to adapt to adult realities, to relinquish her "child" mentality and embrace a resilient mindset.

I could see Janice did not understand completing tasks in the moment or doing just one task at a time. She had not reached beyond the Game state to progressing into Berne's state of Autonomy.

Janice's lack of completing her coaching homework (Rebellious Child) and engaging her husband to help her with them (Rescuing/Nurturing Parent) underscored my sense of what we were dealing with. The Rebellious child was often part of our conversations. Truth was, she often lost her notes from previous meetings, even when provided with paper and pen

With Janice, strong use of acknowledgment, affirmation, and encouragement of her strengths (desire for creativity, playfulness, and fun) was our path forward. She agreed to take baby steps to begin to achieve her goals. She obtained a notebook for our meetings on her own. She made her new office at the university a pleasant place to complete her students' grading. She took on fewer unpaid tasks, explored her potential perfume business, and turned down taking on heavier teaching load.

After some resistance (she did not want to be like a woman she knows with a gigantic calendar in the kitchen with a different color for each family member's activities – Rebellious Child), she agreed to experiment with

> **Strong use of acknowledgment, affirmation, and encouragement of her strengths was our path forward**

creating one unified calendar for her whole family that all can access. She agreed that the best path forward for her was to set small, manageable goals, and not self-flagellate if her plan happened to fail.

Like many of us, Janice was not centered, had not tapped her inner wisdom to bring her life into balance. My choice of Zen Principles aided her to move forward and achieve Berne's concept of "Autonomy."

Applying Zen to leadership roles

Working with Janice prompted me to look at other clients' lack of focus and organizational skills, and how I have seen the same issues in some of the leaders I've worked with in my career. The lack of ability to move beyond the Ego States, Games, and Scripts to the state that Berne has labelled "Autonomy," akin to the Zen state of Mindfulness or Awareness, was holding all of them back. What I've seen in practice, and throughout my career, is that relying on a fixed Ego State, Games and Scripts are one-way people avoid hard decisions.

We can revert into a child state, play ritualistic games of winners and losers, and rehash old scripts to avoid resolving dilemmas, and making other hard choices. According to Berne, without resolving the ego states, games and scripts, people remain wedded to their old ritualistic behaviors and may never advance away from the comfortable roles of manipulator, martyr, or rescuer, to name a few.

Introducing calming experiments for clients feeling overwhelmed, like Janice, soft music, a scented candle, deep breathing, or being covered with a blanket may work as a comforting technique to create an atmosphere of safety and security. With these tools, paths to the brain are stimulated to

be more open, and core beliefs can be challenged. Asking questions such as these below can help people examine their actions and behaviours for games, scripts and ego states:

"What is stopping you?"

"If you put your concerns in priority, what would be most important to you?"

"What is a first step you can take now to make these changes?"

"What can you control?"

"What is realistic for you?"

"What has worked for you in the past?"

Open ended "what if" questions are useful to guide people to a place where they can come to their own inner realization of what actions they need to take to achieve greater centering, awareness, and well-being. It is in this state that clear-headed decisions can be made.

What if one day, the boss comes to work acting like a tyrant and that's the day he has to determine people's raises?

What if a co-worker constantly asks for help then breaks down in tears every time the assignment gets challenging, and her work is now way overdue?

Or if a friend starts bossing others around at a friendly lunch date?

What happens when people are told to evacuate a flooded area, and they refuse to leave no matter what?

Decisions regarding rational action can be made more easily when approaching them with calmness, and steady emotions. Along with transactional analysis, emotional intelligence plays a part in decision making.

Dropping out of roles and throwing away old scripts and ego states provides the setting for calm decision making. Reaching the state of "Autonomy" allows the mind to be uncluttered. Reading events through clear eyes, a surgeon makes the exact correct incision, a pilot lands the plane on the correct runway, and a wide receiver catches the ball effortlessly.

When people are overwhelmed by confusing priorities and can't break out of an old belief system, the ability to make good decisions can elude them. Through thoughtfulness, awareness, and self-reflection, rational people can embrace conscious decision making.

Consider that next time you pass a brand-new, fire engine red Dodge Challenger, or that twelve-acre horse farm you've dreamed about, or even that fancy, expensive prep school you've imagined for your kids. What is your decision based on? Scripts, Roles, Ego State, or calm rationality, rooted in awareness?

Let's hope for the sake of your bank account, it's the latter.

Next, we go from Zen to "island life" – filled with tough decisions.

Chapter 16

A Decision Must be Made

"Good decisions come from experience.
Experience comes from making bad decisions."

— Mark Twain

THROUGHOUT OUR CAREERS, we'll experience games that can turn dangerous. We all know stories of top executives who confused taking big, bold moves with stepping on land mines. And yet, people seem to love playing games. High stakes games often surface throughout literature. In *The Most Dangerous Game*, for example, a well-known hunter, Rainsford, falls off a ship and swims to a remote island inhabited by Zaroff, a man who loves the challenge of games, very risky, dangerous games. In short, the stranded hunter, Rainsford, becomes the hunted by Zaroff, in a "most dangerous game." The two men use all their innate wits and human intelligence to survive and win this game, with each man's life at stake.

Rainsford unwittingly becomes the "game" in this story, and the wiles and decision-making skills he used in his own big game hunting are stripped away when he must play this game man against man, with very limited resources. The point of the story is that playing games, dangerous games, can appeal to the basest of human instincts, survival.

Games, in general, lend themselves to using the best judgment we have, based on the most accurate facts we have. In times of fear, crisis, and chaos we instinctively turn to our leaders, for decisions, to rely on their good judgment. We can't afford to play games. We are seeking answers; a smart analysis of the facts that direct us to the "right" choice, because often our lives, our survival is at stake.

Research shows that judgment "is the core of exemplary leadership." When faced with danger, our leaders need the ability to grasp all the facts and possess the fortitude and experience to make the right call. People trust their leaders to act in the best interest of the organizations or the people they serve to lead them to a steady path. People do not expect their leaders to put personal, organizational, or political interest first and make judgments to benefit only themselves. Putting one's own advantage first is contrary to effective leadership principles and lends itself to the realm of playing dangerous games.

In the literary classic, *Lord of the Flies*, William Golding presents the dichotomy of human judgment; "conflict we humans experience with living by the rules of society, in peace and in collective harmony, or crumbling into social Darwinism, survival of the fittest and natural selection. Lack of survival becomes the fear." Golding reveals how his concept of social Darwinism works by imagining a society established by unsupervised teenaged boys living in isolation. In a social order stripped of rules and laws, the boys soon devolve into "tribes" and some even begin to act like "savages."

And Golding had a point that made sense in the post-World War II era, and still makes sense now, almost 70 years later. What happens when there is no leader? When chaos takes over and regular, normal people display their most uncivilized selves?

Social Darwinism can explain much of the behavior in the 2020 pandemic: Plundered store shelves, unsafe herd immunity policies, and the itching impatience to abandon the "shelter-in-place" mandate in order to jump start the economy. Those behaviors were widely considered sacrificing society's most vulnerable so the rest of us could go back to work and ensure the stock market's upward movement. Ultimately, the fear of want demonstrated how selfish and callous much of society can be when living through the strife and confusion of a global crisis like a pandemic.

It's interesting to note that during the "Gilded Age" of the late 1800s, the concept of Social Darwinism became easily adapted into upper class Western society, a trend which believed social Darwinism to be a laissez-faire approach toward capitalism, immigration, the public's health and well-being, as well as many other social challenges of the day.

The belief that if left alone, the world would take care of itself seems to have seeped into 21st century thinking, especially since 2016.

Reflecting back on the "Gilded Age" with its well-known societal excesses (think Newport Mansions) and laxity toward social concerns, is a chilling reminder that history repeats itself, and we never seem to learn its lessons.

Peace and Harmony

In *Lord of the Flies*, the protagonist, Ralph, assumes leadership, but struggles to keep peace and harmony while stranded on a deserted island. The story occurred during a worldwide panic, when a nuclear attack on the United Kingdom seemed imminent and the boys' transport plane was shot down and randomly landed on a deserted island. Ralph and

his supporters attempt to establish democracy through rules and assigned roles. They create rules such as where to relieve themselves, how to keep the signal fire going, always holding a large conch shell when speaking to the group, and not interrupting. Ralph also devised rotational roles for the boys, such as, who would keep the signal fire going, who would build shelters, and who would gather food.

The boys all agree at the outset that a signal fire must be continuously lit if they are to have any chance of being rescued. Disorder and disruption surface when their signal fire dies, just as a potential rescue ship passes the island. The boys responsible for keeping the fire lit had abandoned their posts to join another group's hunt instead.

The two groups quickly become enemy tribes and throughout the rest of the book the boys' behavior becomes ever more violent and vicious. Fear of one another runs rampant through the two camps. The conflict between social order and social Darwinism, survival of the fittest, destroys whatever harmony and collaboration there might have been on the island. The essential needs for staying alive, cooperation and collaboration are ruined. The strongest leader, the leader of the hunt, Jack, set the tone, transforming all the boys into near savages.

Once within Jack's circle, the boys paint their faces prior to their hunts, the paint becomes a mask hiding the boys' fear and uncovering the more savage side of humanity. They chant during their hunts "Kill the beast, cut his throat! Spill his blood!" This reinforces the mob mentality they have descended into. The paint and the chanting allow the boys to hide their true selves in the

> **Social norms help guide our sense of right and wrong**

safety of a mob and killing becomes ritualistic. There is a certain amount of horror when they paint their faces and chant "kill the beast" then turn on another boy from Ralph's group, and kill him too, in the same exact way they kill the wild pigs they hunt.

Equitable Access

Lord of the Flies demonstrates that without strict guidelines for social order and a leadership team to protect us, human beings easily begin to metamorphize into beings we hardly recognize. Our baser nature emerges. Under duress, we develop a mob mentality, ignoring our socialized manners and common courtesy. And it feels so natural, so easy. We toss aside social norms, and we abandon the rules because within the mob mentality, who's going to stop us?

Maybe human nature's darker side emerges in a crisis, like a professional hunter being hunted himself with limited resources on a deserted island. Is it our karma? Or do we, each individual, bear some responsibility.

A survey of financial leaders discovered that they scored high on antisocial traits and lower than average in emotional intelligence. These are people under constant stress, willing to do whatever it takes to come out on top, to win. Their behavior, much like the boys in *Lord of the Flies* and Zaroff in *The Most Dangerous Game*, defies social norms which dictate calling upon our better selves instead of our very worst instincts. We need these social norms in place to keep order and predictability in our lives. Social norms help guide our sense of right and wrong. In each case, the main characters of the books lost the ability to make that moral distinction.

Judgment

The 2020 pandemic exposed many bad judgment calls, simply because important options and the risk of their potential consequences, were never given enough serious thought. Citizens looked to leadership to have answers to the problem, to maintain "normalcy" and to offer support. We expected our leader's team to present the full range of options with open debates on the best way forward.

Just as in business, when political leaders rely on instinct alone, judgment is colored, important facts are ignored, and society can only rely on best guesses. This leadership equivocation compels people to resort to some of the worst possible behavior.

Regardless of the decisions that have or have not been clarified, no organization's leader, business or political, should be governed by speculation, conjecture, or gut feelings. Collectively, the people wonder, who's in charge here? Who's watching our signal fire? Who's calming our fears?

It's a matter of decision making and judgment calls. We have to ask, how are decisions being made at the top? Are we receiving clear, direct communication, or mixed messages? Do we need to investigate our own facts, and act accordingly? We want to avoid the downfall of the boys stranded on that island in *Lord of the Flies*. We don't want to kill off our better selves and alter our societal structure into chaos and anarchy. We look for a leader who will pull us back from the edge of the cliff, and into sanity again.

"Leaders need many good qualities but underlying them all is good judgment."
— Harvard Business Review

Chapter 17

Sell Yourself &
Make Success Happen

"Find the Prophet. This is the person whom you will influence to make your vision a reality."

— Lawrence of Arabia

WHY IS IT SO IMPORTANT to learn how to promote oneself in challenging situations, where our credibility and career are at stake? And how do we accomplish that without appealing to our basest human instincts (turning "savage" as in *Lord of the Flies*) and at the same time staying on task and focused, even Zen-like? When major challenges confront us, we need that innate human drive for motivation, while we practice executive presence and emotional control.

Overcoming challenges with grace and the right amount of push is part of learning to be an effective leader. Sometimes we need to be prepared to find and pull a rabbit out of a hat or otherwise rely on sheer luck. But as a wise man once said, "You make your own luck."

When we gain enough wisdom and maturity to integrate instinctual drive, executive presence, and even luck, big challenges can be conquered, regardless

of their time and place. And if we pay enough attention to the human side of the challenge, we can often see the pathway to success. The following story shows how one person faced a challenge, and had to marshal all her savvy, smarts and instincts to create a successful outcome.

Following the money

Way back in the early 2000s, a new manager at a large manufacturing company, was assigned a major ($1.8M) renovation of a specialized facility. The company wanted to build a new Business Development Center. Let's call our new manager Marcy. Her expectations of smooth sailing with this project evaporated quickly once she began to painstakingly uncover the money trail.

Marcy had experience, domain expertise, and had crafted the vision for the new Business Development Center and the company had never seen anything like it. The entire concept took visionary thinking as the facility was a completely new design with every newly conceived product to optimize teamwork. Collaborative work areas, white board walls, and many more amenities were planned.

The existing area for this type of activity had been kludged together with purloined furniture, second-hand corkboard, antique computers and servers, and no classified area.

To Marcy's dismay, in keeping with a particular company standard, she was told the vision was too expensive, too advanced, and not likely to happen. She was also told many others before her had tried and failed multiple times to manifest a similar concept.

Moreover, the once-promised money trail Marcy had counted on had mysteriously gone cold. Instead,

her manager had just enough funding to commission an architect ($85K) to develop a comprehensive set of detailed drawings based on her new design concept.

Once the drawings were completed, she took the huge roll under her arm and one by one "up-sold" it to company leadership, while not widely advertising her plans to the pessimists and skeptics.

Marcy knew the leadership team, comprised of about 8-10 senior engineering and management types, was very influential, and could make or break any project, but particularly one of this size and scope. Additionally, this group was so diverse, she knew she had to be prepared to appeal to a variety of leadership styles.

No doubt, this was a tough group to sell. Marcy resolutely made her rounds at every opportunity, meeting with the leaders both formally and informally, one-on-one and in small groups, equipped with her roll of drawings, explaining all the detailed architectural views and elevations face-to-face. She also prepared a predictive usage chart projecting the use of the facility out 18 months. She included photos taken from a facility of similar design so they could grasp the visual perspective of a completed facility. She approached each meeting prepared to clarify their understanding of the features and benefits of such a major undertaking.

Almost two years went by with no action, and no promise of the facility becoming reality any time soon. Marcy continued her presentations and talks, always face-to-face, always prepared with her large, (by now fraying), roll of architectural renderings, and her photos, staff loading charts, and well-rehearsed mini speeches. By now, her feet steered themselves to the executive office suite as if guided by autopilot.

While among the leadership team there were many supporters, one stood out as her "Prophet." One day, after months of positive feedback and no concrete action, she was summoned to the VP's office to again discuss funding for the facility. Sitting pessimistically among the other stakeholders, in disheartened disbelief, as she had been set behind frequently, her "Prophet" tried to reassure her by repeating, "Marcy, we have the money." She just shook her head in response, exasperation and defeat evident on her face and in her body language. She was all frowns, her arms crossed tightly against her chest.

After a few more times hearing her "Prophet" reassuring her, Marcy voiced her incredulity that any money was forthcoming. Then, her "Prophet" opened his briefcase and took out a chart depicting detailed funding allocations for the remainder of the year. He pointed to the longest bar on the chart and said "Marcy, there's the money. You've got the money."

Against all expectations, the "Prophet" had made her vision a reality.

To Marcy's credit, the facility was completed within three months. It was truly the most unique facility of its kind in the entire company.

Selling *your* vision

What's interesting about this major campaign is that "selling it" was almost completely personal, a hands-on and face-to-face endeavor. With such a tough group to sell to, no other method would have worked. This manager realized that the leadership team was not "buying" the facility; they were "buying" her. She had to be personally credible first.

Imagine for a moment if Marcy hadn't recognized the importance of managing up. What if her boss had done all the talking? She realized it was her job to upsell the concept, and if she couldn't manage that herself, she knew her boss would feel no obligation to do the work of selling the new center. He was a busy director without a lot of time to spare, and he expected her to get the job done. Marcy had to learn some political savvy, to position herself for success. She found a mentor, a "prophet," as we talked about in Chapter 10, and that made the difference between success and failure.

She had to prove that she was more than a warm body or "slot," or just another token woman placed in the job to make HR happy.

> **She had to be personally credible first**

Realizing she was dealing with high powered people, Marcy was clever enough to know she had to appeal to their appreciation of talent and solid planning. So, she made phone calls, set the appointments and spent most days tracking the people whom she needed to back her plan. There was never any doubt that without these key leaders on board, the project was never going to happen.

In her meetings, she was articulate and prepared. She also took time to learn the personal backgrounds of each leader; what sport they played in college, where they went on vacation, whether they were renting or buying a house locally.

That personal touch really made a difference. They saw her as a person, not just another employee asking for something outrageously expensive. There were plenty of nay-sayers from other quarters, but the most important opinions came from the

executive suite, so that's where she spent her time. She reached out to secretaries, colleagues, friends of friends to gather information, and became a familiar face around the plant due to her efforts.

It doesn't take much to manage up, just be a human being, and recognize the human in everyone else as well. Especially those who control the budget.

The lesson learned in this case is once we plot our course for success, keen situational awareness is essential. Success hinges on paying close attention to cultural norms and organizational surroundings and learning to leverage the right people and circumstances at the right time. To make change happen, leaders need alliances, and alliances are built upon trusting human relationships.

Without wisdom and maturity in decision making, only base instinct remains, and trust is replaced by suspicion and doubt. And we remember how that worked out in other challenging situations like close elections, survival on a deserted island, and controlling a pandemic.

From making magic happen to the dangers of magical thinking.

174

Chapter 18

A Year of Magical Thinking

"Life changes fast. Life changes in the instant.
You sit down to dinner and life as you know it ends."

— Joan Didion

MAGICAL THINKING, delusional thinking or wishful thinking all indicate a hope for something other than what has become, in the present time, tangibly real. When faced with a truth that we find impossible and unacceptable, it's a human characteristic for our brains to reject what our senses already validate as true. To deny reality, the brain and body may go into shock, suspended sense of reality, like a patient who loses a hand, but still experiences "phantom pain" in the place where the hand once was. Or leaving a loved one's clothes in the closet years after the person has died because we expect them to need those things.

Magical thinking, or denial, is actually a coping mechanism, giving people "shelter from harsh reality, and living in denial may allow a person to keep a distance from the trauma until they are able to tackle it." But there comes a time when reality must set in. By living in a continual state of magical thinking, we end up sabotaging ourselves. It's just sweeping the truth under the rug. And truth can't be denied.

We all remember when the Twin Towers fell in New York City in 2001. It was a terrible blow to the nation and sent shock waves of grief throughout the world. Even though the disastrous event was televised globally, no one could grasp what happened right before our very eyes. How could these planes go down? Who was responsible? How could this happen in the United States, the most powerful country in the world? Never in its history had the continental United States been struck by a foreign entity. Our oceans had always protected us. But once the Towers collapsed, there was no denying it, we were under siege.

Many Americans were "shell shocked." They had witnessed the disaster but could not accept the facts. We had been attacked. Many witnesses to the terrorist attack went into a state of denial. Two huge buildings, a quarter of a mile high had crumbled to the ground. In a daze, many people could not come to grips with what they saw. And everyone saw it. It was shown around the world, in a continuous loop.

Personally, I was at work when the towers fell. Within minutes, every TV in the office was tuned into pictures of the tragedy. The following weekend, I went to New York City and saw and smelled the smoke coming up out of the manholes. I saw the devastated buildings and first responders walking around in shock. It was as if we were all attending an enormous funeral. Everyone there was paying respects to the city and those who died in the wreckage.

In the aftermath of this catastrophe, loved ones' pictures were posted all over New York City: in subway stations and public spaces, wall upon wall of photos of those who were missing, with the thought that they might still be alive and needed to come home. The photos had messages written on them with names and phone numbers. The pictures and messages stayed in place for months and months.

Somehow, the grief-stricken loved ones believed the likenesses and messages would bring back their brothers, sisters, fathers, mothers, cousins, or co-workers; bring them back home, for what would our lives be like without them? We could not imagine it. We now know this was magical thinking.

Magical thinking is based on rejecting what is real in life and clinging to what was or what should be and believing that it's within your own power to make things change. You might even say it's delusional thinking, however magical thinking is reserved for those events that seem to be out of control, unexpected, sudden. It's not uncommon to plunge into magical thinking when dealing with a loss, grief, or tragedy. What helped New Yorkers move out of the paralysis of unreality and into action was the leadership of New York City's top officials. They knew they had to put the pieces back together. The mayor, fire and police chiefs brought morale back to the city by rushing to the scene, keeping open communication with the public, and staying focused on rescuing and recovering as many people as possible from the wreckage.

Leading isn't magic

Leadership lessons learned from New York City's officials during the Twin Towers attack became the stuff of textbooks and scholarly writings. What rose from the smoking wreckage of the Twin Towers could not be denied. It was living proof that the death and destruction we wanted to unsee were real. We wanted to disbelieve those horrific events, but denial only made the recovery worse. As devasting and irreversible as the loss is, how we face it and our consequential actions becomes its history, to be remembered for generations to come. No room for the luxury of "magical thinking" in that tragedy.

However comforting it may be, we can't allow magical thinking to fog our judgment or blur decisions. In *The Year of Magical Thinking*, Joan Didion analyzes and replays the heart wrenching scenes following the death of her husband, author John Gregory Dunne in 2003. She retells in vivid detail each ignored signal prior to his death and relives each raw emotion through a reporter's analytical lens. Despite her observatory style she recreates her grappling with visceral pain and loss over and over again during the year that followed.

"Yet I was myself in no way prepared to accept this news [of my husband's death] as final: there was a level on which I believed that what had happened remained reversible ... This was the beginning of my year of magical thinking."

Think of the last time you experienced a great and inexplicable loss. When you knew, at that moment, that instant, in the blink of an eye, that everything changed irreparably. As human beings, we experience these instances both personally and globally. Whatever it was that happened, we find ourselves afterwards searching for the stability that "normal" brings. Normal is gone and we want it back.

What is often ignored in life is the fact that we experience loss and grief from workplace issues as well as issues from our homelives.

> **We experience loss and grief from workplace issues as well**

As Joan Didion shares in her book, our first response is denial. We feel better by convincing ourselves the emotional issue isn't real, it didn't happen, it exists somewhere else just not with us. We think, "There was a mistake, my job will still be there in the morning."

We can't give away Mom's clothes, because she may rise from that sick bed, throw off her life support tubes and need all the clothes again. We expect the beloved departed pet to greet us at the door.

Do we create this magical thinking to solve our problems or to run away from them? In Kubler-Ross's landmark book *Five Stages of Grief*, she describes the emotions grieving people experience: denial, anger, bargaining, depression and acceptance.

These, we learn are not linear, we can go in and out of any of these stages at any time after a loss. Years ago, I read this book when was going through a divorce. I didn't understand the confusing feelings, and then I realized I felt a deep sense of loss. The book helped me understand that no one sails through the grieving process. It's a slow progression. Magical thinking can take over at any stage, or all stages until the process finally ends and the grief becomes part of who you are.

Everyone likes to avoid the hurt that grief can bring. The danger in not dealing head on with our pain, is that we might slide into that Magical Thinking because things are so out of our control, we begin to believe that our own thoughts, wishes, or desires can influence our external world. Just as athletes might wear the same pair of socks for good luck or request the same lucky number throughout their careers, superstitious behavior lends some semblance of control to unmanageable events. The hope and denial, the illusion of magical thinking can seem as tangible as the first inhale of the clean, sharp scent of newly dug spring earth.

On the more ominous side, grifters, hoaxsters, and con artists may prey upon people looking for hope. Throughout history, charlatans have taken advantage of people's fears in a crisis and created scapegoats,

phony cures, or "other worldly" explanations. We want
to have faith in the magical unicorn that appears
regardless of our circumstances, in our workplace
or personal lives, because we want to be rescued or
seduced by the magic.

Who could forget the disastrous 2010 BP Horizon
oil spill in the Gulf of Mexico? Beaches and fisheries
all around the Gulf were poisoned with oil slicks and
globs of tar for months. And yet, at the height of the
spill, when millions of gallons of oil continued to
course relentlessly into the Gulf, BP's CEO, Anthony
Hayward, infamously stated, "I just want to get my
life back." Magically thinking his life could snap
back to normal while millions of Americans and the
wildlife they depended on were so severely damaged
by his company's negligence.

We've learned we can't wish our troubles away.
Ignoring problems makes them worse. We can't
ignore an odd-looking facial mole, we can't ignore
a leak in our gas tank, we can't ignore our overdue
bills, or our child's bad report card. We can't ignore
disease, poverty, crime, economic distress or climate
change. The consequences are too great to pretend
these conditions don't exist.

So, how do we survive our troubled times sensibly?

Is it through over analyzing, denying, or blaming
someone or something else? Do we allow ourselves to
embrace our "magical" thoughts even as we avoid the
ugliness or brutality of our circumstances?

Yes, in our efforts to comprehend the unfortunate
events that took place, we ruminate and continuously
run the algorithms of every possible cause or outcome

of our loss, personal or global: war, pandemics, out of control fires or floods. We relive our conversations over and over in our heads, we endlessly play "I should have said...," or "I shouldn't have said...," or "I could have done...", continuously and consistently fooling ourselves into imagining we have the power to create another truth. But the truth is, there is a "new normal" and it cannot and will not be denied. When we allow ourselves to entertain "Magical Thinking," we are merely delaying the inevitable. We need to embrace the recognition and acceptance that as time continues on, so must we all.

As the months and years progress, we must decide which direction our lives will take. Each of us must come to the realization that how we talk to ourselves and what we believe about ourselves influences how we connect with others. As this book is being written we are living the world of a global pandemic and our responses to it vary dramatically. Some people feel patriotic, others worry about health concerns, many see the recommendations from medical experts and state or national leaders an encroachment on their freedoms. Yet, we all want to come out on the other side healthy and sane. Think perseverance, knowledge, positive self-talk, and a recognition that magical thinking is only one stage in a very long process.

Joan Didion says in her book, "The craziness is receding, but no clarity is taking its place. I look for resolution and find none."

Where is your resolution to the time you experienced a monumental, inexplicable loss? What did you do, once you had moved out of denial? Where are you today and can you look back and think, "I did it. I survived that." What did you learn from it?

As in the case of New York City under attack by terrorists, an attack that felled two great buildings symbolizing America's great financial power, leaders needed to stand up in a crisis to bring people out of stunned shock and into action. Every person in the world wished the Towers had never fallen, that the planes never crashed the buildings, that over 3,000 people hadn't died that day.

But, as the whole world came to the realization that the United States was in the worst crisis of its history since Pearl Harbor in 1941, for many, reality didn't gel with the recovery from this great loss, this grief. Many of us relied on magical thinking to cope, to deal, to manage our feelings. We wished, we hoped, we prayed that our loved ones would come home, that the Towers would be reappear, that the death and destruction hadn't happened. But, aside from our collective shock and despair, leaders emerged and stood up.

The mayor, governor, and other officials took charge of the emergency responses and was on the scene within minutes of the attack. A few days later, President George W. Bush stood atop the rubble of the Towers and held his famous "bullhorn moment" as he rallied the workers and the whole country, with his encouraging words of inspiration. And Richard Grasso, the head of the New York Stock Exchange, had the market up again and running just over a week later.

Stay positive, tell the truth, be empathetic, communicate often, don't panic, and stand up

Emergency workers from all over the area swept into New York City to help

the recovery efforts. These leaders inspired all Americans in that moment. Leaders inspired us to form a community across the United States which helped create a safer, more secure nation for our future and the following generations.

So, what was our collective learning from this crisis? What can we imagine from this tragedy? We imagined a sacred memorial where the Towers once stood, the tallest buildings in the world, we imagined a brand-new building, even taller than a quarter of a mile high, the tallest building in the Western Hemisphere. We imagined a stronger economy and a swift recovery.

This is the power of leadership.

Crisis management protocols have evolved from the tragedy of September 11, 2001 and have been used time and time again to demonstrate calm and reassurance to others. Among them are: stay positive, tell the truth, be empathetic, communicate often, don't panic, and stand up and lead effectively.

When learning the art of leadership, we consider how individual personal values, positive action, and fealty to the general good contribute to making good leaders. There's no room for personal posturing or promoting a filtered reality. Leadership, regardless of level, means engendering the trust of those you serve; for without trust, integrity, loyalty, and honesty, people will not follow.

When any crisis hits us, as disaster hit the United States on 9/11, and as it did in the form of tragedy for Joan Didion, magical thinking only shields us from the truth. It keeps us in a state of disbelief, of unreality, of denial. It may take months or years to break the hold of magical thinking.

To truly lead well take every opportunity we see to transform ourselves, and maybe even the world.

"I am a firm believer in the people. If given the truth, they can be depended upon to meet any national crisis. The great point is to bring them the real facts."

— Abraham Lincoln

Where does that put us in the hierarchy?

Chapter 19

Self-Actualization in Maslow's Hierarchy of Needs

*"One can choose to go back toward safety
or forward toward growth. Growth must
be chosen again and again; fear must be
overcome again and again."*

— Abraham Maslow

THE GREAT PSYCHOLOGICAL THINKER and humanist, Abraham Maslow, might view "Magical Thinking" as a roadblock to reaching the ultimate goal of "Self-Actualization," the top tier of human development in his model. Without plotting one's life's journey through the fluid "tiers" or "hierarchy of human needs," Maslow believed that true happiness could never be achieved. Although self-actualization may never be achieved in reality, Maslow believed that making it an end goal is no delusion.

Drawing upon coaching sessions with numerous clients, a common reason for unhappiness at work surfaces because people experience conflicting values between themselves and their organizations. When employees are directed to take an action that they don't believe in, they often feel confused or uncertain about the task. They may even begin to feel like they are doing something wrong when performing

the work. Anxiety and depression can set in from internally challenging their own values every day.

But what if they need the paycheck? What if they knew they were in line for the next promotion? The confusion about values only gets more complex as you add in the complexity of human life: family, education, where you live, and how you live.

Beth's quandary

I remember a client I'll call Beth, who was a high energy, very intelligent, hardworking individual. She was not unlike other clients whose decisions were tainted by fear of losing control over their futures. Her work environment did not align with her own personal values, yet she was driven by career success and financial security. Her quandary centered around the desire to act decisively and the willingness to manage her own life and career.

Beth had a tendency to rely on external means (such as spreadsheets, extensive lists, charts and graphs, etc.) to keep herself in the mode of constant activity. Beth was also a person of high morals. She attended church regularly, and always acted with the greatest integrity and honesty. Beth based her relationships, her work, and her leisure activities on her own moral value system.

Beth spent much of her time at work investigating every possible scenario that could go wrong in a given situation in order to ensure all her flanks were covered. Her image of herself was based on being the "go to" person with all the answers. She also considered herself a very reliable person, with unimpeachable values of honesty, trust, loyalty, and family.

Having been with her employer for almost 13 years, she recently began to feel overlooked by

management, despite her hard work, and her excellent performance reviews. Her self-esteem was beginning to flag, and it was becoming harder for her to perform at her highest levels.

Beth's feelings of conflict grew the longer she stayed on the job, and it was taking its toll. She was having trouble sleeping and developed severe migraines.

It all began when Beth was repeatedly asked to falsely report various events that took place on her assigned program. Perhaps worse than that, she felt she was being placed in a position of compromise, violating her personal code of ethics, when she witnessed inaccurate information being presented to the customer, and unrealistic promises being made which Beth knew the company could not deliver. Beth had to face the reality. The job was not for her. She knew she couldn't just quit, the family depended too much on her income and her personal ego and pride were at stake. Could she transfer, or look elsewhere?

Because violations of the company's own policies and procedures for proper conduct were regularly ignored without consequence to the perpetrators, Beth was constantly in a state of desperation. These actions were contrary to her personal principles. Although her leaders were perfectly content to create false reports based on predictions, rather than facts, and ignore policies rather than be bound by rules, Beth was not. And Beth was not personally influenced by the shady behavior, as her leaders were. Putting bonuses aside, her internal moral compass prevented Beth from knowingly participating in this behavior motivated by money.

Unfortunately, these ethically challenging situations are not unique to this organization or these individuals. When leadership designs compensation programs based on quarterly sales, the managers and directors know

their personal bonuses increase if their sales numbers look good. Whenever ethics was openly violated in any organization, I was always curious about the root causes. Given a lot of thought and evaluating the logic behind the motivation for the display of unethical behavior, I realized that people were willing to lie and cheat simply because they were rewarded for it. When an organization rewards its employees just like Wall Street does, one can only expect Wall Street behavior (think: Enron, FIFA, and the movies *Wall Street*, *The Big Short*, and *Margin Call*).

There are no *Profiles in Courage* when it comes to making bonus and increasing profits.

During our work together, Beth began to realize working for this company was no longer an option for her. The problem was, she felt trapped. Not to mention, she still had loyalty to her immediate supervisor and others with whom she had developed close relationships over the years. Working together, we discovered her identity and sense of self was derived from working at that company, whether or not she experienced happiness there.

Beth's story is not uncommon. Many high achievers allow their careers to creep into their individual personalities. People like Beth spend so much time on the job and glued to iPhones and laptops at home, they experience responsibility 24/7, and all their thoughts are consumed by work.

What would Maslow do?

If this behavior seems familiar to you, you're in good company. Martha Stewart, Tim Cook, Elon Musk and Jeff Bezos are among people who sleep little and work a lot. Their work defines who they are. The difference is, these people have no one else in control of their lives. They lead themselves. In terms

of Maslow, these individuals are at the highest level of the hierarchy of needs, self-actualization. Their work is their love.

Leaders value those who feel at one with work, but at what price? Workers like Beth, whose work defines her, receive no extra compensation for all their effort. However, the bonus checks of bosses, like Beth's, were directly reflected in the amount and quality of Beth's work. Could we call this exploitation? It appeared her leaders were willing to compromise Beth's personal values to further line their pockets, not to reward or encourage Beth and others like her.

This leadership style is more transactional, than transformational. And this dichotomy seemed to epitomize the struggle Beth and others like her experience when doing their best, while wondering about cultural values. In doing so, they are unable to completely achieve Maslow's "self-actualization" level.

It occurred to me, during our coaching, that Beth was operating up and down the scale of Maslow's Hierarchy of Needs; specifically, within the area of self-esteem and self-actualization. With her esteem and sense of self tied to a company she no longer desired to be a part of, many issues of confidence, achievement, and respect came to the forefront through the seven or eight sessions we completed.

Beth felt her ability to problem solve was strong, but not fully developed in her environment. She also felt a degree of gender discrimination since she was not advancing as fast as her male contemporaries. Overall, her sense of morality was compromised by the actions and behaviors she witnessed that were counter to her personal value system.

To better coach Beth, I chose the Humanistic Theory of Maslow's Hierarchy of Needs. Its focus on

moving through the various levels of specific human needs to achieve true self-actualization worked for Beth's case. For those who may be unfamiliar with the man who developed the "hierarchy of needs" approach, psychologist Abraham Maslow stated that human motivation is based on people seeking fulfillment and change through personal growth.

According to Maslow, *"What is necessary to change a person is to change his awareness of himself."*

And, *"Human life will never be understood unless its highest aspirations are taken into account. Growth, self-actualization, the striving toward health, the quest for identity and autonomy, the yearning for excellence ... must by now be accepted beyond question as a widespread and perhaps universal human tendency ..."*

Later, Maslow included the concept of "self-transcendence" in his Hierarchy theory, defined as helping others reach their own self-actualization.

> **Human motivation is based on people seeking fulfillment and change through personal growth**

In Beth's case, my thought was that she may have been able to achieve some degree of self-actualization in some areas of her life, such as family and friends, personal health, significant other, fun and recreation, but her career aspirations held her back from being self-actualized at work.

My rationale for choosing this model with Beth was directly related to the fact that Beth is a naturally self-reflective person and can readily implement change when presented with an intellectual model with which

to work. She also "talks to think" and can bring herself through the various levels of change with little prompting or reframing. She was willing and open to exploration of her self-perceptions, and willing to discuss where her strengths and weaknesses lie in the framework of personal growth and development.

Beth mentioned the irony of her comfort with being alone with just a book to keep her company, even though her persona presents a very people-oriented, outgoing and gregarious nature; she is able to laugh at herself, so using humor within the coaching framework worked effectively with her. For instance, she often humorously portrayed herself as a "hermit" buried in her cubicle, eating her yogurt all alone at lunchtime.

Aside from the fact that eating alone is considered unhealthy by 21st century standards, there are still many people who prefer to sit quietly and eat with minimum stimulation. Plenty of people sit out in their cars or go for solitary walks at lunch time. Isolation isn't good for your limbic system, and it can be ruinous to your career, however, with a healthy drive for advancement, there are creative ways to tap into your inner strength and make the right connections and move ahead.

Two qualities emerged which Beth needed to leverage to advance her career. She began to gain confidence and build the courage to reach out and look for another job which met her criteria for doing good for humanity as well as meeting her own career goals. She made a crucial connection at the headquarters of a mega-giant health care company, and within a few short months, was hired.

Using Maslow's model, a number of visioning and reflection questions have proven to work well for people like Beth. They help people to take themselves

out of the present situation and imagine their future. Beth observed that she had put in place several new behaviors at her new job at the health care company, also reflecting that she felt that some of her old habits might begin to creep back in, and she feared she might push her new self-awareness into the background.

Asking her the question, "What is the learning for you here?" encouraged her to articulate that self-validation (*The Little Engine That Could*) helped her gain the courage and underscored the confidence she needed to damp down the self-doubts and fears from her previous job.

My sessions with Beth were enhanced with a worksheet called, "Meet Your Future Self," which asks 22 questions about what a person's future self would be like. From "What clothes would you be wearing?" to "What is the essence of your future self?" this handy worksheet helps people imagine and then create the future world they want to live in.

Beth was able to envision herself in a future state in which she has reached her goals of satisfaction in most areas of her life, including her work life; where she is doing productive work for the betterment of humanity, and is engaged in the company's charitable work events as an active contributor, thus evening out her "wheel of life" to a more integrated self. Which is what most of us want anyway.

We discussed some of her "mindful moments," when she revealed her fear of taking risks and worrying that if she took risks "something bad would happen". Her "Ah Ha!" moment was when she realized that risk taking was "not as scary as she thought."

To put goals in perspective, it's often helpful for people to employ various tools to set priorities straight. That's what worked with Beth. This way,

it's easier to create a tangible guide outlining what is most important and what is possible if there are no limits. Maybe an introspective person would dream of becoming a great philanthropist and would have the means, like Bill and Melinda Gates, to help the world become cured of diseases and other ills. This vision aligns with an overall desire to work in an industry that reflects personal values and engages in organized works of charity, benefitting others who do not have the means to stay healthy, one of Maslow's basic needs - the need for ease of bodily functions and homeostasis.

In the brief exposure to the Maslow model, I have found it most useful in considering the long perspective of each client. Maslow's self-actualization model works to helps people to see the world through a sense of self, therefore, focusing on a future vision of themselves

When "success" is tied to false values, your path to leadership and ultimate career success can be stymied

and helping to attain self-awareness. Self-awareness is a key step in achieving Maslow's stage of self-actualization, the top of the pyramid

Often, people have the impression that self-awareness or self-actualization, is an isolated process, and they can feel like failures if they can't envision themselves achieving their own definitions of success. But as demonstrated by this case, when success is too tied to false values, your path to leadership and ultimate career success can be stymied. Beth's sense of frustration stemmed from those imperfect leadership models she soon realized she could not live with.

People with high moral values may achieve self-actualization by reconciling conflicts between personal values and company values. When they consider Maslow's hierarchy of needs, it becomes apparent what priorities need to be set to achieve the eventual self-actualization or transcendence. By setting those priorities, decisions can be made. Maybe a paycheck is more important than objecting to in-house poor judgment. Maybe it isn't.

I've learned that in order to reach the top level of the Maslow pyramid, a well-defined set of directions, or a personal map, are needed. How people clear the path, through changing jobs, working less, or developing greater self-esteem is pivotal to envisioning and then creating their future life.

How do you envision your future? Are your leaders clearing the way for you?

Chapter 20

Understanding Cultural Differences

"Globalization is forcing companies to do things in new ways."

— Bill Gates

WHO AMONG US has not heard the phrase, "when in Rome, do as the Romans do"? Yet have we Americans grasped what that truly means?

The phrase counsels us, "Don't be alarmed by local customs. If everyone in Rome takes an afternoon nap, you do the same. When visiting people in the middle east who sit on the floor and eat with their hands, it's polite for you to join them. And in the United Kingdom, follow the rules for afternoon tea which include refraining from blowing on tea when it's hot. Blowing is considered rude behavior. You may be sent packing quickly if you give two thumbs up or a "peace" sign in Greece. These hand gestures are considered highly insulting and rude in that country.

To Americans, these customs may seem strange and unconventional, however, when visiting any country outside the United States, it's important to blend in with the natives, especially if you are there representing your company and to get work done.

Cultural sensitivity is a critical topic to consider in any leadership book, because in many organizations, a quick path to the top includes a tour of duty overseas. In fact, international experience is more likely to help propel your career forward and may be a significant part of your leadership rotation. People in leadership positions, in any large organization, sooner or later, will have to work internationally. So, it's best to get educated on the customs, mores, and social preferences of your host country, even if it's the culture of a country similar to ours, such as Canada, Australia or the UK. Each has specific cultural aspects that should not be overlooked.

There are multiple resources for business people to refer to when planning an overseas trip, as a quick search online will show. However, I recommend a detailed examination, even connecting with the country's local consulate or the U.S. State Department before embarking on your stay. You want to avoid any appearances of impropriety.

Lessons learned

Years ago, while my husband was working in Australia, we visited the home of a Japanese couple. We were in Canberra, the county's capital city, full of people connected to embassies from all over the world. Before entering the couple's house, every guest was asked to remove their shoes. The couple offered each guests a pair of paper slippers to wear while visiting. Many of us were a little put off. Removing shoes was unexpected. But we all cooperated and had a lovely evening knowing we were honoring their culture.

International experience is critical for business leaders. And it's important not to be viewed as an "ugly American" while there. When we travel on business to other countries, we are obligated to remember, while we represent our company, we

also represent our country. Before embarking on an overseas trip, whether for a few days or for a whole year, take the time to learn the culture of the country where you will be working. Committing cultural gaffes may not be career ending, but it's far from career enhancing.

Multi-national organizations should be asking: How do we understand cultural differences in order to integrate workers into a successful cross-cultural business model?

Major corporations, expanding their production and services outside their homelands, need to assist their overseas employees to become more acculturated to the new country and make a smooth transition from their home cultures into a new set of values and mores. Employers worldwide face this question, even more so since the world economy has become so interdependent.

Living in Australia for a year was quite a lesson in cultural differences for Americans. Australians are great partiers, and living next to a hotel with a bar, we learned that the Aussies like to party all night. In fact, food trucks would pull up outside our building between 2:00 and 3:00 A.M. to serve the people who brought their party into the street. After several nights of this, we called the police, who told us they couldn't do anything about it. Apparently, there are no limits to the time of day drinking and partying can take place in the capital city of Canberra.

Also, our hard charging U.S. employees would arrive at work at 7:00 A.M., only to find the offices completely empty. Aussies don't start their day until 9:00 A.M., so the only people the U.S. employees could connect to were their compatriots back home. It was 4:00 P.M. in the Eastern U.S., and there were still plenty of people at work there. Traffic in the capital city of Canberra at 7:00 A.M. was non-existent,

except for milk trucks and newspaper deliveries. The American expats began to believe that the Aussies had a "mañana" work ethic. They certainly valued their personal time.

Examples from around the world

Consider Starbuck's conundrum when attempting to integrate their core values of teamwork, equal participation, and diversity into the moderate to high power distance culture of South Korea. Imagine the shock of the Starbucks executives when their egalitarian ideals were bluntly rejected by South Koreans. Managers were refusing to clean toilets and wholesale rejected the concept of using first names. These typical American values are not rooted in the culture of South Korea.

To preserve its core values, Starbucks came up with a creative solution: Korean employees would choose an English first name. Everyone working at Starbucks was referred to by that English first name only, eliminating the Korean's need for a title and last name, showing position and status in a work setting. This solution preserved their cultural deference to hierarchy and authority (labeled "uncertainty avoidance") and was considered a win-win solution.

Starbucks was also faced with conflicts regarding their corporate value of teamwork and equality, meaning – all employees share all tasks, including washing dishes and cleaning toilets. This meant that male employees would have to engage in these tasks typically performed only by women. To overcome this cultural barrier, Starbucks capitalized on the Korean affinity for "role-modeling and imitating behaviors of top leaders." The male international director for Starbuck's headquarters did all these activities, and provided a picture of himself cleaning the toilet.

Similarly, the Swedish company, IKEA needed to find a solution to the high turnover rate faced with its U.S. employees. Since Americans have strong feelings of individual over group, they were unimpressed with IKEA'S value of equality.

Without job titles or clear job descriptions, the gap between IKEA and the work culture expectations of U.S. employees caused much dissatisfaction among them. Though not specifically called out in the study, considering the degree of cultural differences, it's easy to predict plenty of conflict, as Sweden ranks low on in hard charging, materialistic, assertive behavior. And it's no surprise that the U.S. culture in general ranks on the high side.

The qualities of assertiveness and materialism caused cultural conflict in a more laid-back business setting. For instance, in the Swedish work cultures, men and women may perform the same tasks with less emphasis on gender. In most Scandinavian work cultures, it is not out of the ordinary for workers to leave their jobs promptly at 4:30 P.M. When a CEO in Denmark stands up to leave a negotiation with Americans at 4:15 P.M., the Americans might be utterly baffled. Denmark being a more balanced culture than the U.S., the country values quality of life, nurturance, and relationships over work.

The characteristic of "low aggressiveness" among employees seems to conflict with the American work value of getting ahead and high job mobility. Additionally, in the U.S., the value of individualism is highly appreciated, and employees' relationship to the organization is one of "independence." Achievement and individual initiative will conflict with IKEA's value statements: "Simplicity, humility, thrift and responsibility" and "Togetherness, Cost-Consciousness, Respect."

Since the U.S. has a very diverse population with large variability in individual values, IKEA's solution was to sort through job applicants not for the best candidates, but for those candidates who best suited IKEA's core values. Job previews were provided as well, which led to candidates self-selecting out. The result was low turnover rates and successful business operations in the U.S.

Culture shock also presents itself with the introduction of South Asian software designers into the U.S. IT workforce. India has high "in-group collectivism," contrasting with the U.S. values of individual initiative and achievement. Research reveals the cultural conflicts which arise when introducing people from a culture which values group decisions, saving face, and fear of humiliation into American IT society, mostly male dominated. In a typical American IT world, members often work alone, are independent thinkers, may resist cooperation, and often have a "tech bro" attitude.

This culture adaptation would be a challenge for anyone breaking into the U.S. IT world. Many of these people have to be trained in basic communication skills, like courtesy, manners, and even hygiene. Since many IT people work into the night, their personal sleep, hygienic, and diet habits lend themselves to cultural stereotypes.

After working with all kinds of engineers over the years, I can attest to the challenges a new, fresh face from an inherently polite culture would encounter. The many Google memes about engineers portray the on-going narrative.

As could be expected in this "Bro" culture, newly immigrated Indian employees have great difficulty in the simple act of interaction with fellow American employees. Unable to respond to a greeting due to

language barriers or shyness, for instance, cause some American co-workers to regard a new South Asian immigrant as "rude and standoffish" when their aloof response is a simple miscommunication. As a recent article noted:

> "Historically, Indians have lived with thousands and thousands of years of subservience. Obedience is a deeply ingrained trait. Many Indian professionals will carry out orders to perfection but will rarely take the bull by the horns and make an independent decision. As a people, we are not used to the aggressive 'just do it' attitude that today's IT industry requires. Initiative is something that has to be [learned]."

Sources indicate that if an Indian employee is to be placed in any manner of authority, the extent of that authority has to be clearly delineated. The role must be explicitly defined, or the Indian worker will believe that the authority has not been given. Indians rank as moderate in valuing group cohesion more than individualism, while Americans rank low, clearly suggestive of conflict when placing an Indian in a position with decision-making power. In the United States' more competitive culture, true group cohesiveness may only exist in our military, because American culture places higher value on individualism, not groups.

Another example: native Nigerian companies display massive hierarchical tendencies. For example, CEOs tend to be authoritarian in their management style. It's not unusual for a Nigerian CEO to blame a junior employee for a decision gone wrong. An interesting post from Medium tells the story:

> "A CEO heard their competitor's radio jingle on his way to work. When the CEO arrives to his office, he asks a junior employee about airing their company jingle on that specific

station by the end of the week, The junior employee explains to the CEO the demographic of that radio station is totally opposite of their company's youthful market (14–30). Furthermore, the cost to run the jingle on the station is five times the cost of the station that their youthful audience typically listens to, but the CEO insists. Ultimately, the junior person is overruled, and the radio ads are placed anyway. The ads do not generate the expected sales conversions. The CEO instead of admitting he didn't quite get it right, blames the junior employee for not creating the right messaging, even though the CEO himself had approved the content that was aired."

While the hierarchical system works in Nigeria, a striking contrast on the same continent exists at its very southernmost tip. Because of its racially charged history, in South Africa, "Ethnic and racial divisions can make it difficult to build teams which cross these boundaries." Even though Apartheid has been illegal for over 30 years in South Africa, remnants of it still exist. You may be surprised to know, the population in South Africa still lives separately and neighborhoods are still segregated. Generations of living in a racist society have left the scourge of intolerance in its wake. It's ingrained into the culture. The social structure in South Africa is much the same as it has always been, consisting of many ethnicities and races, with the majority of people employed at large, global enterprises.

The South African typical work structure is quite 20th century, top down. So, if you need a decision made quickly, and you didn't deal with the boss initially, don't expect a quick answer. In my research, I learned that globalization trends have recently started influencing the hierarchical structure of South Africa, flattening

that hierarchy. However, even though Apartheid was banned over 30 years ago, people find it hard to break old habits. It seems South Africans are more comfortable when working within their own ethnic group.

Not surprisingly, most businesses are still divided along racial lines, and that includes pay inequity. Thanks to a new world of globalization, this outdated practice has been gradually phasing out. Another left-over Apartheid practice is overtly identifying race; it is not considered rude when people refer to themselves as black or white. So, don't take offense if you're doing business in South Africa and you hear comments that sound racist to you.

Innovation and talent from South Africa have made a huge impact on the world. Elon Musk, and Charlize Theron are among many South African natives who have become household names. And let us not forget Trevor Noah. The bi-racial South African comedian and host of *The Daily Show*, grew up in South Africa during the Apartheid era. He soared over the strict ethnic and racial divisions by pointing out how ludicrous they were. He turned to comedy to identify society's unjust systems and practices. Thanks to leveraging his greatest talent, his sense of humor, he's now a successful stand-up comedian and TV host, still making jokes about the foolishness of politics and current events.

My research revealed something about the Finns that I never knew. The Finns seem to have a very lateral working culture. Supervisors do not check on employees, and it's important that employees' voices are included in all decision making. Agreement is critical to the Finns. Once a decision is agreed upon by the group, it's adhered to. In Finnish culture, it's unthinkable to violate any agreement. Flexible hours are also part of the Finnish work culture. People are free to take time off to take care of personal and family matters,

and once the flex schedule is agreed upon, it is left to the employee to observe the agreement. Obviously, honesty is held in high esteem and is an intrinsic part of the culture. Finns also are not shy about speaking out. And unlike some other cultures, it's not considered impolite to do so. Finns say what they mean, there's no obfuscation in their conversations.

> **Countries around the world could benefit from adopting Finland's values**

It's easy to see Finns value fairness and equality. Men and women are treated equally in all aspects of life. Contrary to many cultures, both men and women are considered responsible for raising children.

Furthermore, Finland's high level of autonomy and low level of bureaucracy add to the smoothness of communication among employees and top management. Time is not wasted waiting for approvals, and, in contrast to some old guard American organizations, ideas from all levels are seriously considered. As I read this research, it almost sounded too good to be true. But here it was in black and white. My thought was, "Countries around the world could benefit from adopting Finland's values. The world would be a better place."

I expect just these few stories could save a novice businessperson from wrong assumptions and gaffes in dealing in global cultures.

Culture and your brand

Carelessness and ignorance of cultural finer points can create insulting language and make the a company look foolish in the eyes of global consumers. *Inc. Magazine* published an intriguing list of twenty egregious mistakes companies made when they didn't

bother to consider cultural details when presenting their brands globally. Some of the more interesting faux pas include: "Colgate launched toothpaste in France named 'Cue' without realizing that it's also the name of a French pornographic magazine. Coors translated its slogan, 'Turn It Loose,' into Spanish, where it is a colloquial term for having diarrhea, Coca-Cola's brand name, when first marketed in China, was sometimes translated as 'Bite The Wax Tadpole.'"

The executives in charge of these projects didn't check first to determine whether or not their catchy American tag lines translated well into the language of their targeted market. These errors are often career ending. A slight overlook led to a marketing disaster, costing their companies millions.

Whether we like it or not, the world of business is a flat landscape, but even so, we still know the sun doesn't rotate around the earth. Our instantaneous communication, web meetings, and improved travel make the entire earth accessible to doing business globally. There are no more excuses to avoid learning the culture of our clients and suppliers. The concept of social harmony, prosperity for all, collectivism, loyalty, and respect towards authority are among the values we need to learn, that other cultures value.

As you think of growing your career, consider an international assignment as part of your leadership development plan. Once you have the assignment, ensure you and your family members embrace the customs, traditions and work culture of the country that may be your home for a long time.

When my husband and I lived in Australia for a year, we were delighted to be introduced to so many different cultures, from Indian, Mexican, Japanese, Chinese, and anywhere else you can imagine. Even as Americanized as Australia seemed to be at first blush, there were distinctly Australian customs.

205

Stores closed at 3:00 P.M. on Sundays. The work culture was far more flexible. They started later and left work early. Lunch was at 1:00 P.M., not 11:30 or 12:00. Socialized medicine is in place, so doctor's visits were much cheaper. The cities had nearly zero homeless. Australians liked to party late, with parties ending at 2:00 A.M. – or going all night long.

Studying global cultures and living and travelling to other countries has taught me to appreciate what's different and new. I've learned to take off my shoes in a Japanese household, find a way to drown out the noise of partying Australians, draw out the personalities of shy Indian IT workers, and accept gifts from Malaysian consultants. Culture shock is real and we need to patient and tolerant of newcomers to this country. Just think how loud, rude and complaining, we seem to people uninitiated to American way of life.

When in Australia, American employees and families had to acculturate ourselves because we were the foreigners. We went to Australia knowing almost nothing about the country, assuming it was pretty much like home. After a few weeks of living there, we embraced that we were experiencing a whole new world. As a result of his overseas experience, my husband was promoted to Director of Global Satellite Sales at his company. And after that amazing year abroad, it's still shocking to our fellow Americans that we travelled so far for so long and returned with so much more knowledge and understanding of other cultures.

Prepare yourself for overseas work. Embrace a new culture and learn from it. Do your research. And that incredible, successful career move could be yours, too.

Chapter 21

How Values Help Overcome the Generational Crisis

*"That which seems the height of absurdity
for one generation, often becomes the
height of wisdom in another."*

— Adlai Stevenson

GROWING WORLDWIDE INFLUENCE in business causes a need for understanding cultural differences. In fact, cultural differences exist within countries, within regions, and surely within organizations. Having lived in five different states, traveled to two different countries, and worked at three different companies, I've noticed a jarring difference among cultures.

New England is very different from other regions in the US, and they are not shy about letting you know if you didn't come there via the Mayflower. Some companies hire for specific talent; others expect employees to fit like slots in their roles.

Yet, aside from these long-standing disparities, leaders face even greater challenges to organizational cultures, with the oncoming *generational* sea change.

And in America, we're facing a generational crisis.

Out with the old, in with the ... younger?

In the next decade about 60% of the workforce, Baby Boomers, is set to retire. Many older workers have devoted their lives to their careers, and some are not ready to give it up any time soon. Some Boomers do have retirement in their sights and intend to leave work and career in the rear-view mirror. Because this generation has dominated workplaces for so long, the loss of technical skills and industry knowledge could create a talent-void organizations will struggle to fill.

Industry leaders know they have to prepare for the eventual turnover in generations to ensure the future of precious intellectual capital. In certain organizations, more and more young faces are integrated every week. These organizations welcome Generation X, Millennials, and the Gen Ys and Zs, young people emerging as the next great hope for business continuity and talent retention. The hope is that the Boomers hang around long enough to mentor and teach the treasure trove of knowledge they've possessed for years.

But at the onset, before the real work of sharing knowledge and serving intergenerational talent, showy displays of welcome blossom. Throughout industry, the new hires are celebrated. They arrive on their first day with a large reception and a group picture, summarily flashed across large plasma screens shown throughout all worksites. HR parades them around the sites with special personal tours followed by white tablecloth lunches with company executives, assuring their worth to the company.

While this important recognition is admirable and makes the new hires feel good, many Boomers consider it just style over substance. They watch

with their experienced eyes, gazes brushing past the newcomers, remembering what their first day was like, and give a desultory shrug. It's just another touchy-feely HR stunt, they think to themselves. Just easy superficial improvements in business culture and one way HR assumes it might solidify the company's future.

The question on the Boomers' mind is always, "Are these young people going to add value? And how will they make positive lasting contributions?"

And so, as the cultural differences begin to surface, the entrenched Boomers begin to question the value of these new, younger people. The cultural divide between Boomers and younger generations grows as wide as the ocean. While company leaders plan for the future, integrating generations from Baby Boomers to younger generations may not always work out as the HR department or the recruiters planned.

While the need to bring in younger employees is generated by retirements and voluntary layoffs, and by a need to maintain a viable talent funnel, some older employees wonder if their needs are now being sufficiently considered. Just as company leadership had to approach global hiring with an eye on cultural differences, they now must address the inevitable tensions arising due to conflicting levels of experiences, values, expectations, work habits, and communication styles, as well as perceived favoritism or even nepotism when hiring a new generation.

Each generation has its own culture

So introducing these younger workers into a company populated with Boomers creates the need for a cultural shift, regardless of notions of superiority or longevity.

As a Boomer encountering Millennials or Gen Ys in a work setting, I used to dread the experience. I immediately reacted in one of three ways: I thought, "How bad a slacker is he/she? Who actually does his/ her work?"

Or, if luck prevails, and he/she is the son or daughter of another employee, "Will he or she perform well as a matter of family pride and tradition, so as not to embarrass the parent?" I wondered if they'd be up to the task and if they could adapt to the culture of a 100-year-old company. Even experienced professionals had to learn to adapt. Was it likely these youngsters would like it enough to actually stay? The company went all out in its recruiting efforts, would that effort eventually fail if these new, younger employees failed?

Tensions definitely arise when some younger workers seemingly take advantage of this unique situation: lots of Boomers clearly looking to retire, lots of future empty slots. The cultural divide widens again when Boomers wonder, "Do you really think you can take our place? What have you proven you can do?" Boomers feel a level of resentment because we scrambled for jobs as we reached working age. There were millions of Boomers, but our generation didn't produce the same number of offspring as our parents did. The new generations will find many open slots and lots more opportunity than Boomers did years ago.

Bridging the divide

So, how to reconcile these differences and smooth over prideful feelings? How to overcome stereotyping and pigeonholing our fellow employees?

One study offers solutions that speak to reconciling generational conflict, suggesting that when common,

cross-generational values and behaviors are applied, it's easier to look past stereotypes and labels. The seven-year study found these ten values shared across all generations:

- Family
- Integrity
- Achievement
- Love
- Competence
- Happiness
- Self-respect
- Wisdom
- Balance
- Responsibility

Moreover, when properly applied, these ten shared values can remind a business to keep its moral compass by appointing leadership across multiple generations to mitigate the inevitable inter-generational conflicts.

However, unless top leadership clearly defines the principles and values to all generations, discord may remain. Younger workers could resent Boomers telling them what to do. Most are more comfortable with a more collaborative environment. Boomers might decide to assign the younger folks menial work, like running errands, filing, or even fetching coffee. Where's the fun in that?

I've heard of a case where a young engineer was hired, given a desk, computer and phone, and rarely saw his boss again. He was being totally ignored. After about three months, he quit the company, and why would he stay, doing absolutely nothing all day long? In such an adverse cultural environment, careers stall out, and discouraged young talent makes their exit. Companies now know, they can't

afford to continue ignoring the potential future of their organizations.

So, again, it's up to leadership to set the tone and guide harmony across generations. Help break down barriers caused by resentment and chagrin. Smooth over the bumps in the road as if your future depends upon it. Because it does.

It's up to leadership to set the tone

Leaders have to step up and do more to integrate younger workers. They need to go beyond the white table-cloth luncheons and the polished company tours. Focus on what these generations hold as true, their common value system.

Years ago, when I first came to work at GE as a new, young employee, I felt valued. People reached out to me. I had mentors. I made personal sacrifices to work late into the night because I felt like family there. They wanted me to succeed, so they appealed to our cross-generational values. While there was a modicum of resentment, by some, overall, the experience was my introduction to industry and the core values it's capable of reflecting.

Leadership set the tone there, and I responded. It made me love my job, my industry and my company and I stayed in that industry for 30 years.

Isn't it ironic that "love" is the key to loyalty and longevity? Maybe if leaders put "love" as their number one value, generational differences and cultural divides might vanish.

Chapter 22

When Failure is Not an Option

"Common sense tells us that nobody needs a leader to take the path that's intuitive; people would do that on their own. Therefore, since the leader recommends a path that is seemingly illogical to the 'average' person, we can conclude that a leader must be either: 1. So smart that nobody can share the vision or 2. A nitwit."

— Scott Adams

WHO HAS NOT KNOWN a leader similar to Scott Adams' description? Everybody has seen this movie before; the pointy haired boss who just doesn't get it. The one who makes the already nonsensical rules of organizations even more ridiculous, rules like adhering to the CEO's "on time is early" dictum, and then locking the conference room door a half an hour before the meeting even starts. You would think Harvard, Stanford, and the Wharton School had never published or taught a word about leadership.

When you browse the business section of a big bookstore, or scan leadership titles on Amazon, you'll notice an overabundance of leadership books. These books are all full of advice by famous gurus and professors from the top business schools in the world. So how is it that leaders seem to lack the qualities needed to be effective? How do they end up being "The Leader You Don't Want to Be"?

I worked at GE for a few years and I learned the ropes of how leaders were developed. CEO from 1981 to 2001, Jack Welch has written several books on leadership and while he's widely admired, there are only a handful of people who can emulate him.

In the early 1990's, Welch gathered 20 of his brightest executives to capture best practices of what made them successful. These individuals were the future senior leaders of GE.

This group spent weeks planning a seminar to be presented to GE'S global management team, inspire the next generation of leaders, and impart the learning and experiences of Welch's top people. Welch and his team evolved the objective: teaching the high potential (hi-pot) managers "The GE Way".

Among the topics discussed was "Why Senior Executives Fail in GE." As a one-time GE employee, myself, these simple guidelines seemed so self-evident. But as is often demonstrated and included in this book as true accounts, this wisdom has not made it to the C-Suites at many other organizations. For many ex-GE employees, realizing the glaring contrasts between the once envious leadership principles at GE and their current employers was a cleansing and cathartic experience.

The wisdom was captured in one presentation slide which many former GE employees once had hanging on their cubicle walls.

Why Senior Executives Fail at GE

- Bad Actor- Behavior Contrary to Corporate Culture Values
- Flawed Organizational Concept – Unnecessary layer ... Drastically Under-resourced ... Inherently conflicting Expectations.

- Bad Selection – Missing Necessary IQ Points ... Lacking Threshold Experience Skills or Behaviors
- Insufficiently Heroic Objectives ... Fails to Communicate and Inspire Around a Simple, Energizing Stretch Vision
- Bad Beginning – Starts Behind and Never Catches Up
- Bad Adapter – Skills Which Once Drove Success Begin to Drive Failure ... Not Open to Legitimate Criticism ... Unable to Fix Fatal Flaws
- Can't Pull the Trigger- Talks a Good Game ... Great Analysis but Doesn't Get it done
- Out of Focus-Misses the Real Leverage Points ... Inability to Process Multiple inputs
- Bad Instincts-Can't Run with Scanty Data or makes Wrong Conclusions off Insufficient Data
- Self-Importance-Overly Critical and Sometimes Disdainful of Subordinates ... Lays off Blame ... Soon Lacks Supporters.
- Pace-Moves at the Different Rate of Speed from Rest of Organization ... Time Management Issue ... Lacks Urgency

A group of cohorts read his book, *Winning*, and immediately set up informal discussion groups. We were experiencing cognitive dissonance. It was time to realize we were no longer in the Emerald City. We had stop glorifying our past life and play the cards we were dealt. GE had sold off our part of the business and the culture shock of the new company was jarring.

Employees recognized three glaring contrasts reminding us we were not in "Oz" anymore.

"Bad Actor: Behavior contrary to corporate culture/values, etc."

Many organizations, U.S. and international, place great emphasis on living the company values. "People" are often noted as the number one value. The message every employee may wear on his "values" badge card proclaims, "You're important to us." Yet, recently, in at one large organization a VP lacking theses important people skills had been promoted from director, where he acted with common courtesy and manners.

Once promoted, this VP seldom stepped out of the executive suite and didn't acknowledge employees by name in any setting, meetings, all hands events, or even casual encounters. One manager was heard to comment, "He only talks to 14 'chosen' people." This select group included a handful of direct reports and the company president.

This VP was known to shout his demands during meetings, without concern for others around him. In one case, he requested his secretary bring him a bottle of water saying, "Hey, lady. Get me water!" at the top of his voice. To add insult to injury, this request was made in a roomful of people, and not one other person was offered water or any other type of refreshment.

In another case, the VP toured the manufacturing area, where a strict no food or drink policy existed. The VP entered the area with an open cup of coffee. When this was pointed out, he rejoined: "No coffee, no Me," leaving employees in stunned silence. Inopportunely, this VP had a two-year contract with the company and according to highly placed, reliable sources, he wasn't leaving anytime soon.

Flawed Organizational Concept:
Unnecessary Layer ...

In this organization, if you were a friend of the company president, you were pretty much guaranteed employment for life. In the case of one man, failure as a business area leader gave him entry into the world of business development, despite the fact that he had little business development (BD) experience.

This person had a reputation as a great engineering manager and was recruited by the president himself. However, as a business area director, his innate lack of business acumen and the distractions created by continuous interruptions by family phone calls, damaged his ability to focus on the business. With few options open to him, his career was salvaged by his friend, the company president, who created a spot for him in Business Development. Since he was originally hired at the director level, the company president decreed that he would become the "Deputy" Director of BD for a particular customer-based business. (Interestingly, none of the other businesses in this company had a "Deputy" BD Director.)

Rather than spending his time with customers and watching competitors, he followed his engineering background and went way overboard perfecting his chart making skills. He created charts for BD process, new business investment funding, and the five-year plan. He also successfully coordinated a corporate loss analysis, ironically, conducted on one of his own major business failures. It was well known he had aspirations to the "real" BD director's job.

But the company president was a savvy man. He'd been around the industry for years and knew a lot of key players at the board level and with top

customers. In a less partial world, this extra layer would be eliminated and he would be returned to the bosom of the engineering department, where apparently, he was quite a star.

Can't Pull the Trigger | Talks a Good Game | Great Analysis but Doesn't Get It Done

Another manager I knew in that same organization, and in the same time frame, was in charge of business development operations for many years. As such, he conducted multiple studies, analyses, and led several projects investigating the reasons for poor overall performance. The company wasn't winning much new business. Time after time, the results of these many efforts showed that there was really nothing wrong with the current, existing processes, procedures, and policies. They were all intact, accessible, and aligned with industry standards across the board.

The manager ruminated over these results, called many meetings, and created even more presentations on the topic. He even attached himself to a company wide study, led by several experts, to dig further into this apparent conundrum. Each time, the results were fashioned into PowerPoint and some even found their way to the hands of senior management.

Over and over again, the problem was traced to the same root cause: in that particular company, there were absolutely no consequences attached to not following policies, or to ignoring process and procedures. Bonuses were not based on following these rules, so no one felt compelled to do so.

I participated in a few of these exercises and recall making the suggestion that if we connected following the processes to dollar figures to achieve

the next process step, we might see better results in process adherence. While the manager agreed with me, he could never bring himself to enact that policy. I had been with the company for eight years at the time, and the company still suffered from a lack of process adherence as well as a dire lack of upcoming new business. Common sense would say marrying the required processes with rewards would have been tangible enough evidence to convince him to go higher with his findings. But somehow, fear and cowardice overtook him, and he just couldn't make the move.

Welch's philosophy took hold at GE while he was still in charge. Back in the good old 1990s, when employees greatly benefited from Welch's business savvy and the GE stock split and then doubled within a few years.

> **Jack Welch tied executive and company performance to faithfulness and adherence to GE values**

The unfortunate conclusion is, although much of Jack Welch's management philosophy has been published and studied by hundreds of executives in the business world, there are still companies led by those who are satisfied to make rules up as they go along, and experience their orders, sales, profit and cash slide downward: mostly due to bad actors, flawed organization concepts and those who "can't pull the trigger."

Jack Welch clearly tied executive and company performance to faithfulness and adherence to GE values and saw certain doom for those who could not incorporate those values into their work performance. GE's brightest minds gathered to clarify what good leadership is about; the power point slide addressing

why executives fail makes clear what leadership is not. This is why that slide is still hanging on the wall in many offices today.

The takeaway: If you are self-aware enough to know you demonstrate more than one of these characteristics, now is the time to rid yourself of this management "style." If your boss or senior executives show more than one of these traits, now is the time to start exploring your options.

Characteristics to watch out for:

1. Bad Actor: Behavior contrary to corporate culture/values,

2. Flawed Organizational Concept: Unnecessary Layers

3. Can't Pull the Trigger: Talks a Good Game ... Great Analysis but Doesn't Get It Done.

Chapter 23

"Bring Me a Rock" and Other Leadership Failures

"In sports and in business, the greatest leaders are those who make the best decisions in the most crucial of situations. They are the ones who focus their energy on turning tough decisions into winning decisions."

— Don Yaeger

WHAT GIVES an institution its purpose? What binds an organization together? What is the uniting force of an organization with its members? And how do its leaders ensure that bond is protected and safe?

It's up to the chosen leaders to model the organization's reason for being by leading with its established mission, vision, values, and goals in mind. Every person connected to the organization needs to be aligned with those standards. Without the existence of common purpose, the organization will fail to move ahead.

Most importantly, how are the mission visions, values, and goals created?

Mission

The origin of the U.S. Constitution is a good example of establishing purpose, in this case, the purpose of bringing forth a new nation. The Age of Enlightenment had a profound effect on the creators of the U.S. constitution, with many concepts of Enlightenment thinkers present in its fundamentals. The idea of people choosing their own leaders, separation of powers, and checks and balances, direct democracy, as well as the concept of religious freedom, are all present and still functioning as major American tenets. The purpose of the new nation is rooted in the men of the Enlightenment.

From our Founders, it's easy to see how their mission evolved. Following that model, today's organizational mission is also based on the "why." Why do we exist as a company or why are we in business? What is our purpose as an organization? The U.S. Army's mission statement clearly states why they exist; to fight wars on land.

"To deploy, fight and win our nation's wars by providing ready, prompt and sustained land dominance by Army forces across the full spectrum of conflict ..."

A mission statement defines what we do as an organization. The mission helps the organization stay within its core competencies. If your core competency is manufacturing products for the U.S. Navy, you may not be agile enough to start manufacturing voting machines. Voting machines are not aligned to the core mission of serving the U.S. Navy. Resources pulled away from the Core Business waste a lot of time and money on fruitless efforts like this.

In one such experiment, the flashy facility created for a similar "adjacent" or additional market, closed down within a matter of months.

222

Too much human and hard capital was shifted from the company's core mission of serving the U.S. Navy, and instead, focused on the business of teaming with voting machine companies, right after the contested election of 2000. (Remember "hanging chads?") The company understood the Navy's mission very well. But they had not done their homework on the voting machine experiment. They didn't have a clue that voting was managed on a municipal level and they had no experience with local governments who ran elections and were in need of better voting machines.

Now that we know why we exist; we have to set a course to move forward. That's when we need a vision to guide us to imagine our future.

Vision

What keeps us going? Why do we get up every day and do what we do?

A vision statement is future oriented, we state where we want to be in the next five to ten years. The company vision is an inspiration to employees, customers, and all other stakeholders. Amazon's vision unambiguously states where it wants to be: "to be Earth's most customer-centric company, where customers can find and discover anything they might want to buy online." Simply put, Amazon wants customers all over the world to get what they want, when they want it, without ever leaving their homes. And isn't that the reason we all love Amazon?

Companies that create clear vision statements base their entire business strategy on fulfilling that vision. The infrastructure, talent, and facility planning are all determined by the company vision. However, what violation of the vision would cause

harm to a company as big as Amazon? If their vision relies heavily on an exquisitely designed logistical system tied to a supply chain with the delicate "just-in-time" balance of the famous Chinese Acrobats, any glitch in that smooth-running machine can cause disaster. During the 2020 COVID-19 outbreak, Amazon's fragile supply chain dried up, and with so much essential product manufacturing off-shore (like masks and toilet paper), Amazon could not keep up with demand. It only took one major asymmetrical event to throw out of whack the genius of Jeff Bezos.

What should the ramifications be after such a disaster? Following historical protocols, serious and dramatic change usually follows a world-wide catastrophe. We now know that the 2020 pandemic caused major changes in the way business is conducted. Amazon's deep pocket advertising budget has helped restore their on-time delivery reputation. But behind the scenes, much in that company, as well as others, has changed. Remote work and reduced social interactions are only a few results of the 2020 pandemic.

Values

One of the key components of an organization's function is its set of core values. Values support the organization's vision and set the standard for organizational culture and accepted behaviors. One leader I knew told me that "we can't teach values, but we can teach behavior." Meaning, if an employee does not hold honesty, for instance, as a core value, the company can hold him or her accountable for behaviors that do not represent honesty. In cases where we notice managers not upholding the values of honesty and transparency, we can question the behavior. In one instance I know of, a money-losing program was not reported as such. An employee

challenged this misrepresentation of facts but bringing this up was not career enhancing for that employee.

If we examine the Values of Apple, it's easy to see a reflection of their distinct culture and standards. As stated by Tim Cook, the Apple Values are:

"We believe that we're on the face of the Earth to make great products. We believe in the simple, not the complex. We believe that we need to own and control the primary technologies behind the products we make. We participate only in markets where we can make a significant contribution. We believe in saying no to thousands of projects so that we can really focus on the few that are truly important and meaningful to us. We believe in deep collaboration and cross-pollination of our groups, which allow us to innovate in a way that others cannot. We don't settle for anything less than excellence in every group in the company, and we have the self-honesty to admit when we're wrong and the courage to change."

Simply put, Tim Cook's values for the company are that Apple will make great, simple to use products, and they will never sell their technologies. Their sales strategy is simple, too. They'll only sell in markets where they can make a difference. Internally, it's all about collaboration and innovation: people won't stray out of their "swim lanes" so collaboration can flourish, while avoiding siloes, which stimy innovation. And they expect excellence, honesty, and courage to be an integral part of their culture.

What might happen if, somehow, Apple's technology was secretly sold to Samsung? We can safely guess that the root of the problem would be uncovered, and appropriate steps would be taken, like multiple legal suits, a possible shut down of manufacturing, and firing or jailing some key Samsung executives!

Goals

Goals help the company move in the direction established by the creed of the mission, vision, and values. In the case of Microsoft, their goals relate to accountability, performance, integrity and use of resources: "Establish and preserve management accountability to Microsoft's owners by appropriately distributing rights and responsibilities among Microsoft Board members, managers, and shareholders. Provide a structure through which management and the Board set objectives and monitor performance. Strengthen and safeguard our culture of business integrity and responsible business practices. Encourage the efficient use of resources, and to require accountability for stewardship of those resources."

These goals seemed to be designed to shape behavior, for instance, culturally, leaving lights on would contradict the company goal of "accountability for stewardship." Same, if an employee lied to a customer about a product's performance. Even forgetting timely performance reviews would be a departure from company goals.

Colossal Leadership Failures

So, what happens when a long-time, maybe even venerated employee can't behave in a manner that exemplifies what the organization stands for? Often in some places, nothing. Bad behavior is allowed to persist, because the offender has someone covering for him or her. The overall impact is a decrease in morale, employee engagement, productivity, and even the bottom line.

What happens when a manager has an employee who is untrustworthy, slows down the workflow, or worse, makes the boss look bad?

226

What happens when an entire organization exhibits a catastrophic failure of leadership? Consider the sex abuse crisis of the Catholic Church. What allowed this predatory behavior to go on for so long?

In each case, the leader could not make a tough call. I often fall back on the Jack Welch comment, "Being in a position of power isn't always fun, and sometimes it means you'll be put into positions that are very tough to navigate. You'll need to fire people. Hire people. And make some very tough calls that can make or break an entire organization."

Yes, with power comes the responsibility of dealing with the ugly parts of the job and having the fortitude to take action, otherwise, the entire organization can suffer. No matter even if the person involved is a friend, creates a profitable product, or is the smartest person in the room. Being a leader means having an objective view of the issue at hand and dealing with it.

But why is making a tough call so difficult? Recent research has shown three major reasons leaders avoid making tough calls.

1. The leader is afraid to alienate those they lead. They have an image to maintain, and they don't want to disappoint people. In the case of one manager with an obstreperous employee, the manager was afraid of being perceived as a "bad guy." When asked how long he'd been putting up with the behavior, he said for five years. He then began to slowly realize by tolerating the person for that long, he, in fact, made himself appear weak, and as a result he, himself, wasn't being promoted.

2. The leader over analyzes every aspect of the problem before addressing it. A typical failure of leadership is hiding behind analysis, always needing more data. One long-time employee with behavior issues wasn't given any notice that his job was on the line. He expected an annual review at a specific time, and instead, was blindsided by a scathing warning from HR only months before his annual review.

 What happened behind the scenes? HR had been collecting data for over six months, without his or his boss's knowledge. The employee then had to decide whether he was willing to work on his weaknesses or quit.

3. And there is the case of "bring me a rock." Before making any decision, a leader wants one more piece of data. The "rock" never seems right, another "rock" is always required. A manager is told to create a business plan and assigns the effort to his direct reports. The manager calls a meeting to review the data he requested. When each individual contributor presents his/her findings, the manager rejects each piece of information, whether it be schedule, deliverables, requirements, specs, hiring plans, test plans, etc. The manager may have something in mind or not, in any event, what he's presented is never exactly what he thinks he wants. He continues to ask for another "rock," therefore never reaching a decision.

4. The leader can't face the truth and can't make the right decision. In the case of the abuse scandal in the Catholic Church, leaders for many years hid the horrific behavior of its

prelates and other clergy. Offenders were simply reassigned or sent to rehabilitation centers. Some of the leaders themselves were, ironically, also abusers. The truth was kept quiet and the issue was never dealt with legally.

Victims and their families were always too afraid to challenge the Church authorities. In some cases, the truth was swept under the carpet with settlements. Now after many years, these injured families are speaking up, notifying police and legal authorities. Offenders are going to jail. And what has been the impact on the Church?

Pope Francis has set up a committee to review all abuse cases. However, the church has no provisions to involve any legal system outside the Church itself to help with the reviews. Church attendance has declined. Many Catholics are taking matters into their own hands and directly reporting abuse to the police.

The Church has still not fully faced the truth of the matter. It's a colossal failure of leadership.

Making better possible

By staying true to the company mission, vision, values, and goals, with courage, confidence, and truth, leaders step up to reality and make the tough calls necessary to guide their organizations into the future. Without these qualities, and the ability to make hard decisions, the organization and its people will not, cannot, thrive.

Good leaders *model* the behavior of the company as expressed in the organization's mission, vision,

values, and goals. If the modeling is not reflected at every level, the company creed is an empty set of words. Existing talent needs to embrace the creed, and new employees need to learn the culture. How is that possible if everyone lives by his or her own set of rules?

If we consider the mission, vision, values and goals of our Founders, those principles have stood fast for over 200 years. Inspired by the great thinkers of the Enlightenment, the Founders proposed the system of government that Americans live by to this day. It's unimaginable that anyone would behave in a manner to violate those principles, because these are American principles.

> **If the modeling is not reflected at every level, the company creed is an empty set of words**

And how can they call themselves Americans if they don't live by the vision, mission, values and goals conceived and codified by Thomas Jefferson, John Adams, Benjamin Franklin, Alexander Hamilton, John Jay, James Madison, and George Washington?

What gut instinct could be operating in that case?

Chapter 24

Leaders Follow Their Instinct

"Leaders need to have good instincts.
They learn to trust their gut."

— Anonymous

WHO COULD FORGET the gutsy actions of Capt. Chesley (Sully) Sullenberg on January 15, 2009, when a bird strike forced him to land his 737 in the middle of the Hudson River? All 155 people aboard survived, and Sullenberger himself was the last one off the plane.

In those precious minutes before his plane hit the water, the Captain had decisions to make. Would he return to the airport or find another one nearby? His thought process went into high gear. He relied on his gut instinct and skill to make the decision that the safest and quickest way to get out of the air with two dead engines was to land in the frigid river directly below him. With that quick decision-making ability, he managed to save all those lives as his plane floated helplessly in the icy January waters.

Can you imagine what could have happened if Sullenberg couldn't make a decision? What could have happened if he became paralyzed thinking of too many choices? One hundred and fifty-five souls survived because of Sullenberg's resolution, level-headedness, and grit.

But you don't have to be a highly skilled airline pilot to be decisive. You just have to learn to trust your instinct and follow your gut.

You may never be a hero, but you can save yourself time and alleviate the frustration of those around you if you break loose of the mistaken belief that all the calculous has to work out perfectly. This mindset throws people into a cycle of overthinking, and lack of action.

How can you tell if you are an overthinker?

Do you try to work out every possibility in your mind, proposing endless "what if" scenarios? Do you get a feeling that something's missing in your "if, then, therefore" logic? Do you sweat every last detail of a decision, from how many towels to bring to the beach, to gaining the courage to apply for a promotion?

If this sounds like you, you have what is known as "analysis paralysis." That means that you spend so much time imagining what might be a potential outcome in endless possible scenarios. It means you never take that first step and nothing you thought of in your analysis, none of your scenarios, ever play out in reality, because you're so busy thinking about them there isn't time for them to come to fruition.

It's common knowledge that hemming and hawing makes us feel and appear ineffective. Leadership development programs for years emphasized that when you finally achieve that leadership position, you need to appear strong and decisive, resolute, and demonstrate some grit. In fact, some weak leaders trick themselves into thinking they are protecting themselves by doing nothing. Or, to distract from a problematic issue, to keep people's attention away from an embarrassing question, like why there's a new VP ensconced every six months. These leaders

make the conscious decision to do nothing because they don't have the backbone to make anything happen and worry endlessly about every decision that comes their way. If you've had a boss like that, you know the frustration of waiting for her decision to materialize on funding for a new project or reviewing upcoming promotions, including yours.

Teddy Roosevelt said, "In any moment of decision, the best thing you can do is the right thing. The worst thing you can do is nothing." You wouldn't want to be derided for all of history for not stepping up where action is called for. Janus, the Roman god with two faces, one side facing front and the other facing back symbolizes the struggle between making a decision or not. A side has to be chosen, a side picked, a decision made.

Throughout history, indecisiveness has brought calamity and misfortune on nations. Neville Chamberlain's indecisiveness after failing to "appease" the Nazis plunged the UK into war. Chamberlain was considered a failure because the Nazis broke their word. Soon after the "appeasement" meeting, the Nazis savaged Poland. That success encouraged them to invade most of the rest of Europe.

During the U.S. Civil War, General George B. McClellan was ordered to take aggressive military action against the South, but his overly cautious nature led to his demise. He overestimated the size of his opponent's forces and did not follow logic or President Lincoln's orders. His hesitancy to attack led to his removal from command.

Neither of these historical figures could muster the confidence and instinct to make good decisions, leaving history to wonder, what were they thinking? Let's explore what happens when your swirling mind blocks out your gift of intuition, or instinct. One idea

piles up on top of another, thus avoiding making the tough call (the right call, as Roosevelt said). You don't know which choice to make and you don't want to make a mistake or let anyone down.

When a colleague asks about making a new hire, you say you'll get back to them; then you fret that you can't find the right fit for that important slot. You review again the many resumes piled up on your desk, you see so many great potentials, it's too hard to choose. You consult your HR recruiter again, and she has two strong recommendations., You thank her, take her recommendations, and stare out your picture window. Your phone rings and you see it's the headhunter you hired, you let the call go to voice mail. You wish the last person in that position had never left – he got a better offer while waiting for you to counter-offer, but you just couldn't make up your mind. At lunch time, you close your shades and jump on your exercise bike. Maybe you'll get some ideas after your exercise, in your private executive shower.

Now you can easily see how the indecisive CEO's desk becomes a swirling cyclonic edge of a black hole. This is where time passes far slower than elsewhere in the universe. The CEO's desk is the "singularity," the sucking point of time and space. (According to NASA, a black hole's gravity is so powerful that it is able to pull in nearby material and "eat" it.)

Think of yourself as this CEO: What if you stepped back, gave yourself a break, and just let your mind rest? Maybe another voice within you could be heard, a feeling could overcome you?

If you listen, you might hear the sound of your gut instinct telling you to act

For Jack Welch, following instincts was as important as quarterly reviews. He expected his

234

leaders to take "scanty data" and make sense out of it. He also expected people to do their research, and not make snap decisions. Welch realized that developing the confidence to go with gut instinct can take years to mature. He expected his leaders to take "intelligent" risks. In fact, Jack Welch rewarded risk taking. To encourage innovative thinking, he firmly believed that intelligent risk taking should not be punished. In fact, when one of his teams was tasked with creating an energy efficient light bulb, they succeeded, however, the light bulb's price was over $10.00. because their current manufacturing methods were too expensive. Welch's comment? "We were ahead of our time." All 120 of his team members were rewarded with cash, trips and more.

We all have the ability to use our gut when making decisions, we just let our "monkey mind" get in the way. Monkey mind is not a made-up term. It is, in reality, a term from Buddhism meaning "unsettled; restless; capricious; whimsical; fanciful; inconstant; confused; indecisive; uncontrollable."

To be effective, we have to mentally sort through the available data and make educated guesses, especially under pressure. As Welch recognized, it takes time to develop "street smarts," it's not exactly an overnight process.

You'll notice that in war conditions, soldiers are able to sense when something isn't going right and predict enemy movements. After several months or years in battle, instinct kicks in and can save lives. There is no time for over thinking in combat. Similarly, police are well known for following their instincts, they get a feeling about a suspect, witness or case. More times than not, hunches turn out to be facts. If you've been working in organizations for a number of years, you see CEOs, VPs, and

others come and go. You become highly educated in the politics needed to survive and how to position yourself to avoid landmines. You develop a savviness, a sixth sense, you can tell how long someone will last or what the next steps in the organization will be. You'll even learn what battles to pick and when you need to use "hand to hand combat."

For instance, let's take Sarah, an executive director at a major university. Sarah was facing a crossroads in her career. She had many ideas about her future but could not decide on just one. She discussed numerous scenarios; moving thousands of miles away, applying for local opportunities, maybe changing careers completely, and many other "what ifs." Each conversation surrounded some new venture that interested her, and there were so many, it was hard to keep track. All involved some level of risk taking. Her indecision was causing tension on her job, she hesitated to make important connections, and dithered rather than acted to bring her closer to a goal, any goal.

The constant spinning in her mind distracted her from her everyday duties, including staffing, preparation for the coming semester's work, and important departmental decisions. She was distracted at home as well. Her domestic life became strained, as she changed her mind daily about the family's future; would they move, sell the house, where could the husband find work, would they homeschool the kids? The anxiety she was creating both at work and home was affecting her marriage as well. Her husband became more apprehensive about her lack of decision and concerned about when she would definitively settle on something, anything.

Finally, after several months of almost maddening vacillation, she came to some conclusions. She decided that she and her husband did not want to

move. Then she decided, surprisingly, that she did not want to stay in an academic setting. By chance, she stumbled upon a private sector job very similar to the one she held at the university.

How did Sarah become so sure about her need to make a big move, to seek an alternative plan? After a lot of thinking, she decided to sit with herself in a quiet setting over a long vacation and focus on her gut. She stopped the monkey mind, and in her quiet time, away from distractions, she listened to her inner self. Her instinct told her what she didn't want to hear all along, and finally helped her decide what she truly wanted to do.

All leaders don't have the luxury of vacillating for weeks at a time, like Sarah, but after avoiding her truth for many months, this leader finally learned how to follow her gut. And once this skill was learned and practiced, all her decisions fell into place.

The consequences of leaders who couldn't make decisions and didn't follow their gut are all around us. Think about the lasting reputation of some former leaders who vacillated. The problem often was not that they were weak, but that they were indecisive and did not believe or follow their instincts.

In Japan in 2010, a very popular and handsome Prime Minister swept into power on big promises that he eventually couldn't deliver. He was known to have "snatched defeat from the jaws of victory." Because over time, he couldn't live up to his initial promises, and he quickly fell out of favor. His "flip-flop" on very important decisions facing the country, rendered him ineffective. His continued reversal of some of his earlier decisions was perceived by all as indecisive. Elected in September of 2009, by June of 2010, he was out. But maybe this indecisiveness was not entirely his fault.

The Japanese culture was once a feudal society, where collectivism was a social norm. Decisions weren't made quickly and depended on the approval of the leader. Apparently, the new Prime Minister experienced cultural barriers to performing his duties as a leader. His own inability to make a decision was based in acting in a subordinate's role. Therefore, the root of his failed tenure as Prime Minister grew from old cultural norms and beliefs. He didn't make room in his repertoire of gifts for using his gut instincts to run the country. What would his political career have looked like if he trusted himself, stepped up and took power as expected?

Bill Walsh, who coached the San Francisco 49ers to three Super Bowls states his leadership philosophy as "committing to a plan of attack, executing it, and then instinctively reacting to the results." It's a philosophy that applies not just to NFL coaches, but also to startup founders, managers, and team leaders.

It's a philosophy that can help you, as an individual, succeed in decision making when confronted with the daily choices that we are all challenged to make.

"Breaking an old business model is always
going to require leaders to follow their instincts
... But if you only do what worked in the past,
you will wake up one day and find
that you've been passed by."

— Clayton Christensen,
Harvard Business School Professor

Chapter 25

Going Through the Motions of Being Normal

"When there's nothing better to do,
we go through the motions."

— Trudi Pacter

WHILE THIS BOOK was being written, the world experienced a run-away pandemic, and you've read a bit about it in earlier chapters. The effects of the pandemic were wide-spread and varied. Most notable, people were heard (or seen, via their social media posts) saying, "I just want to get back to normal." Since the pandemic stretched out over many long months, some people, trapped at home all that time, forgot what "real" normal looked like. When states slowly crept back to "normalcy," with warmer weather and strict health policies in place, people felt incredible relief. Even for a while, they could escape the confines of the house, and take a break from binge-watching TV.

With the public cooped up at home, businesses felt the pain. The pandemic caused multiple setbacks in American businesses. Without clients or customers, retailers, barber shops, hotels, and restaurants (among others) careened toward failure. Business couldn't survive with shoppers under orders to stay home.

However, after self-isolating for a number of weeks Americans began to learn the new meanings

of "pivot" and "shift". Kids, dogs, husbands or wives, were all together, quarantining at home all day, and even the chore of cooking took over our lives; we now had to prepare our meals from scratch, no more fast food. So, the pandemic brought on a trend in home cooking, which entailed more time in the kitchen. Newly initiated home cooks deployed their crock pots, pressure cookers, and food processors, once forgotten and neglected. Baking bread from scratch became all the rage causing shortages of flour and yeast. Everywhere we looked, TV, radio, news blurbs and newspapers, paraded out some wide eyed-optimist doling out coping advice, and the main message we heard was "be productive," learn something new, read more books, get more sleep, exercise, eat healthy, write your book, be upbeat and optimistic, and attend your religious services via the TV, instead of incessantly watching the nerve-wracking news.

In short, America, off balance for the first time since World War Two, sought guidance, answers. We wanted to know when we could have "normal" back again. The messaging from the top did nothing to help. It was confusing and contradictory, nothing seemed to make sense. Worse, each state governor devised their own brand of rules. We looked for direction for wisdom and found none. We could only rely on our own research to sort fact from fiction; to decode the perplexing stories and rules about COVID-19.

Americans had other issues on our minds, too. I suspect some of you were among those not focused on working in your daily yoga practice or cleaning baseboards the old-fashioned way. I know I wasn't. The all too realistic and ever-present worry over how long the quarantine would last and whether or not we would have money coming in loomed large in all our minds. We wondered where the promised unemployment checks were – many of us never even

received one. When we put our heads on our pillows at night, we worried about how we'd survive in the long run. What would happen to our businesses? What would happen to our employers? Would our jobs even exist after the quarantine?

No one could escape these feelings, regardless of the bright face we put on. Despite countless "experts" who urgently shared their "wisdom" about stress relief and working from home, many of us became paralyzed with confusion and fear. A depressing fog descended upon the nation.

Why bring up the universal craziness of the 2020 pandemic in a leadership book? Because everyone from average people to business owners and entrepreneurs needed leadership in that moment. In a national crisis, how could leadership fail? We hoped for a modern Winston Churchill to materialize, but instead, we were handed a modern Nero, who fiddled while Rome burned. Mismanaged messaging, ignoring opposing points of view, and lack of expertise are only a few failures in the top leadership structure of the United States during the 2020 pandemic.

While absorbing the shock of this failed leadership, we all forgot what we were supposed to do. There was a generalized feeling of emptiness. We were missing something, but we just couldn't define what it was.

We tried to stay as "normal" as we could. But the numerous Zoom, Skype, WebEx meetings left everyone drained. And all the "don't worry, be happy" talk didn't fill the void, even when we heard Bobby McFerrin himself singing that tune, a kind of pandemic "anthem." What we really felt like was "Paint it Black," by the Rolling Stones.

While the world was whirling in uncertainty, our leaders were scrambling for answers. Apparently,

we lacked a business continuity plan for worldwide pandemics. We had plans for floods, hurricanes, fires, and tornadoes, but none for a highly contagious, deadly disease. What were company executives thinking in their "tabletop" disaster sessions? Everyone knew where to go if the building caught fire, but an asymmetrical attack by a deadly virus was absent from the organizational survival blueprint.

No wonder so many of us felt like we were living in an alternative reality. No one from the top down knew what they were doing. As the months dragged on, what action did our business leaders take?

Small business owners came up with creative ideas to keep going; curbside pick-up, touchless delivery, remote classes, and new apps were among them. Independent business leaders could not afford to allow the status quo to dominate them They had to innovate to survive.

What happened in the big organizations? After the two-week mandatory lock down, many larger businesses insisted employees physically return to work. Going back to the office generated a whole constellation of other challenges for people. Who would help kids with schoolwork, since so many schools were closed, some even for the entire school year! Other leaders made allowances and were more generous, offering flex time and remote work indefinitely. And what about our health? What were the leaders doing to protect employees from the virus at work? There was no rule book in HR or the corner office to refer to.

However, company core values actually seemed to guide many leaders' behavior. Many companies publicly stated how their values aligned with their pandemic business plan and took action to do so. For example, at a Washington, D.C. pizza chain known as "&pizza," the founders delivered free pizzas to

healthcare workers, as part of their core philosophy of "doing good while being good". And it wasn't only the food industry which stepped up. How employees were treated during this time did not go unnoticed. In a recent MIT survey, Lockheed Martin, The Hartford, Marriott, among others were major companies whose employees felt had lived up to their core values during the pandemic. Employees rated their firms as "leaders" in transparency of communication and keeping integrity during COVID-19.

But as grateful as we were for displays of intact core values, most people still pined for the day when things would finally be back to "normal" again. But normal was a long way off for us in 2020.

As if we dreamed it, we were becoming like those pups in Pavlov's famous "classical conditioning" experiment. The Nobel Prize winner trained dogs to anticipate the reward of food when presented with a circle. When presented with an oval, however, the dogs were penalized. Pavlov began to slowly change the shape of the circle until it became an oval. The less the two shapes looked alike, the more the dogs became confused and anxious, and the more their behavior become more erratic and unpredictable. This phenomenon is called "cognitive dissonance."

In the "new normal" of 2020, humans acted a lot like our furry friends in Pavlov's experiment. Many of us were still stuck in place, not sure what was coming next, our collective behavior began to show all the signs of "cognitive dissonance." People intellectually knew the store shelves were empty, that shortages of essentials existed, that schools, theaters, shops, gyms, barber shops, and other normal venues were shut down. Driving past these now eerily empty places, a sense of bewilderment set in. What happened? Once bustling commerce now slowed to a shadow of its former self.

For those who may not recall, anti-quarantine protesters wanted it all to end immediately. Others cocooned in their homes with no plans to venture out. Still others ventured out with masks, but only for what was absolutely necessary, groceries or gas. Even with our local small businesses and restaurants testing innovative ways to get us moving, we were still only going through the motions. Who would break the spell? No guidance came from national leadership, so we turned to our state and local officials for direction. They didn't have all the answers, but they became the guideposts along the long, narrow, and twisty trail.

In psychology, there is a theory that engaging in some familiar activity may help heal a state of confusion and overwhelm. Maybe some trips in masks and gloves to the grocery store; walking the dog; visiting relatives on opposite ends of the porch; all of these and other activities" became the substitute for achieving something more "normal" in our lives.

"Working from home" (WFH, as HR refers to it) became the new normal for so many of us, as mentioned earlier in this chapter with its own set of challenges. Many were on furlough without any idea of what that meant. Businesses didn't know how to predict headcount. People were furloughed two weeks on, two weeks off, without any clear indication of a definite return date. Very difficult for employees and employers both. Without a pandemic business continuity plan, company leaders lacked the tools and information to provide solid answers. Many didn't know if they'd ever open up again.

Moreover, a survey of company employees revealed that employees questioned their leaders' ability to manage a crisis. Most felt their leaders prioritized profit over people, 69% believed that CEOs

and other C-Suite Leaders did a poor job performing crisis related duties during the pandemic.

Other companies ignored the seriousness of the pandemic. Carnival Cruise Lines knew in advance about infections on their ship, Diamond Princess. Its failure of leadership and lack of decisive action led to infections among 700 passengers and crew. Employees felt completely abandoned by their leaders.

Inaction, on any level, is never an option in a crisis. In crisis mode, leaders can't conduct busines as usual, because there is no usual. Leaders must seek out all relevant information without being overwhelmed by it. Form a strategy. Act like your career – and your company – depend on it.

It seemed, during the long months of the pandemic, company leaders were busy steadying themselves and figuring out ways to stay in business, while employees were feeling the mental stress of not knowing if their jobs were secure, or if the company would still be there since there was no end in sight. No cure, a vaccine solution far in the future, no solid public health policies.

While not new, the pandemic enabled psychologists to reintroduce the idea that people who experience a shock to the system – being furloughed, quarantined, health concerns, and worse – need to develop the ability of "going through the motions of being normal" to survive, to manage, to get through, to cope.

> **First take an honest, unemotional assessment of your situation**

How does that work? To practice, people are first directed to take an honest, unemotional assessment of their situation. This means allowing themselves to turn off the noise, step away from the chaos,

settle down the mind and break away from anything urgent, through yoga, meditation, experiencing nature, or relaxing in a comfortable chair.

Once awareness set in, people were then able to make decisions about what was most important and develop the ability to put things in perspective.

The idea is to come to terms with what we *can* control, what's realistic for us, and what's sustainable.

Setting priorities is the secret regardless of the background. Though so many of us felt too overly burdened to do what we needed to do, we did it anyway. Because in truth, no one else was going to do it for us. The dishes wouldn't do themselves, our pets still needed our love and attention, and the kids always needed clean clothes.

It was in learning how to re-assemble the fragments of our daily reality, slowly, that we began to remember what "normal" looked like and to bring some of it back into this new way of being. And even if we are only "going through the motions," it's a new normalcy we can cope with. It relieves the "cognitive dissonance."

"Even going through the motions is a way of establishing a new relationship with our inner life that is care and tender, versus one that is judging, distancing, or ignoring. This is the beginning of being capable of intimacy with others."

— Tara Brach

Conclusion

The Leader You Don't Want to Be

"You manage things, you lead people."

— Rear Admiral Grace Murray Hopper

DEAR READER, we've reached the conclusion of our leadership journey. If you are reading this conclusion first, I don't blame you, I would do the same. Don't we always want to know our outcomes first? We want the answers, the mysteries solved, the resolution to the plot.

But our question is, what did we learn along the way? Learning about what leadership behavior looks like advances your organization. It creates more engaged workers, happier workers. And study after study has shown that productivity increases when workers are happy.

When productivity increases, your bottom line also increases. There is now a proven and direct correlation between employee engagement and their experiences at work and increased profitability. How leaders act in general, what tone they set, and how they live their company values, speaks volumes about the organization and how it functions.

What are the guidelines for leadership behavior? We know about feudalism and tribalism, these ancient and ruthless systems to coalesce people into competitive, protective circles. This system forms around an influential leader and exists inside some of our most distinguished institutions. It's

counter to the idea of "seamlessness" and teamwork. Impenetrable silos are formed, and cooperation among these groups ends. What action can leaders take to break down the silos and defeat the tribes and fiefdoms? What's the guiding principle to bring the organization back into balance?

As discussed throughout this book, the answer is easily found when leaders begin to initiate a cultural change. Culture change happens when leaders step up and begin modeling the corporate values. Think back to how Jack Welch got his way with instituting Six Sigma. He insisted that all his "best" people be trained in Six Sigma Black Belt processes. But his VPs did not choose the "best." When bonus time came, the Black Belts received the bonuses, and the VPs "best" workers did not. Why? Because these VPs did not believe in the Six Sigma culture. Welch used the bonus system at GE to advance the culture. He modeled the behavior he wanted to see in the organization.

Through these chapters, we've learned that in a crisis, people expect values such as transparency and integrity. When clear messages are broadcast and truth telling takes precedence over a hidden agenda, the company gains credibility and the opportunity for scandal lessens. Our high expectations for the behavior of British Petroleum's leadership evaporated with the 2010 crisis bungling of the Deepwater Horizon oil spill. The callousness of the CEO's response to the calamity was, "I just want to get my life back." If only it were that simple.

Overall, what we notice in this book about leaders is that the more human they act, the better the entire organization thrives. Leaders easily get overwhelmed doing their jobs, and in robotically functioning every day, they can forget that their companies are comprised of people, and that people are the most important assets.

Now we know, it's the leader's job to think in terms of being "human." They deal with human capital, human resources and human-machine interface, but as we've learned, leaders must go beyond terms and remember that humans are sentient beings, not just "slots". When leaders think in terms of "slots" the humanity in their organizations becomes a fuzzy concept. They know the names and faces, but do they know the daily impact on these humans?

You've read the story of how leaders can become detached from the way humans are being treated. When you sit in the corner office, it's easy to forget there's a person somewhere being screamed at, sworn at, belittled or harassed. And are leaders aware that people fear reporting these events because of the potential of retaliation? How hard it is for the harassed to receive justice from the company or the Human Resources Department? We know it's the leader's job to take action, to walk the talk, and to live the values. We conclude that it's the leader's responsibility to ensure the values are not violated, that, like Jack Welch with Six Sigma, there will be dire consequences for bad behavior. But the leader has to be a person of character him/herself. When our leaders lack their own moral compass, they can't be expected to ensure the company lives by a moral code.

> **If you don't want to be the leader everyone silently dislikes or worse, act like a human**

So, if you've now skipped ahead to the last portion of this conclusion, you'll know what the message of this book is: If you don't want to be the leader everyone silently dislikes or worse, act like a human. Show your compassion, your concern for people, and live the cultural values your company

has established. Otherwise, you'll only last as long as the person who hired you. And when they go, you go.

Give up the tyrant act, you're not a medieval vassal.

Instead, create that aura of transformational visionary, be the one who advances your organization and its people into a leading innovator in industry. Be like 3M, Boeing, American Express, Ford, among others that have crossed the line from just good companies to great companies. As Jim Collins says in *Good to Great*, it takes "huge quantities of good old-fashioned hard work, dedication to improvement, and continually building for the future" to build a great company.

Dear Reader, I hope this book has advanced your learning about people, about comportment, about instinct, and how each is important to your growth as a leader. If nothing else, the stories might provide you with some interesting conversation starters at a corporate conference or even your next staff meeting. Why not offer some of the questions in this book as ice breakers, remedies to the hostage-like environment of a departmental gathering?

I will conclude this book with one more favorite leadership quote:

"Before you are a leader, success is all about growing yourself. When you become a leader, success is all about growing others."

— Jack Welch

Endnotes

All web references visited in the week of January 18, 2021

Ch. 2 - The Paradox of Women in Leadership

Page 26 –

"a woman he didn't consider his equal ..." – No specifics were named, but a case study about this incident was published by Liberty Packaging (now Liberty Intercept, a woman-owned business, https://www.libertypackaging. com/about-us). O'Sullivan, *Why Women Face Barriers to Leadership Roles*, https://rinewstoday.com/why-women-face-barriers-to-leadership-roles/

Page 27 –

"male-only social and religious groups ..." – Wall Street Journal, *How Men and Women See the Workplace Differently*, September 27, 2016

Page 28 –

"value of mingling with men ..." – Forbes, *New Study Reveals 6 Barriers Keeping Women From High-Power Networking*, June 26, 2019

Page 32 –

"The number one reason for delegating ..." – Kayla Sloan, *6 Reasons Delegating is Good for Your Business*, January 6, 2018, https://due.com/blog/delegating-good-business/; Jesse Sostrin, To Be a Great Leader, You Have to Learn How to Delegate Well, October 10, 2017, https://hbr.org/2017/10/to-be-a-great-leader-you-have-to-learn-how-to-delegate-well

Page 33 –

"chickenshit on your plate ..." – Charlotte Cowles, *How Women Really Say No at Work*, April 21, 2016, https:// mmlafleur.com/mdash/how-real-women-say-no-at-work; Megha Raizada, *How to Politely Say No to Extra Work at the Workplace*, August 21, 2017, https://www. classycareergirl.com/2017/08/say-no-extra-work-politely/

"self-deprecating words ..." – Tara Mohr, *How Women Undermine Themselves With Words*, https://goop. com/wellness/career-money/how-women-undermine-themselves-with-words/

Page 34 –

"she demanded the same pay ..." – Nellie Andreeva, *Julianna Margulies On Why She Didn't Reprise Her 'Good Wife' Role On 'The Good Fight': "CBS Wouldn't Pay Me,"* April 7, 2019, https://deadline.com/2019/04/julianna-margulies-the-good-fight-pay-good-wife-cbs-all-access-1202590243/

Page 35 –

"women are more uncivil to other women" – Shawn Andrews, *Why Women Don't Always Support Other Women*, January 21, 2020, https://www.forbes.com/sites/forbescoachescouncil/2020/01/21/why-women-dont-always-support-other-women/

Ch. 3 - The Role of Leadership in Creative Strategy and Problem Solving

Page 37 –

"Teresa Amabile's article ..." – Teresa Amabile, *How to Kill Creativity*, https://hbr.org/1998/09/how-to-kill-creativity

Page 38 –

"things that haven't been done before." – Lockheed Martin, *The Skunk Works® Legacy* website, https://www.lockheedmartin.com/en-us/who-we-are/business-areas/aeronautics/skunkworks/skunk-works-origin-story.html

Ch. 8 - Death by Meetings

Page 86 –

"Having food and drink around ..." – Chris Sherwood, *How Does Not Eating Affect the Brain?*, https://www.livestrong.com/article/482050-how-does-not-eating-affect-the-brain/

Ch. 9 - Down the Memory Hole We Go

Page 96 –

"wonderful definition of why words are important ..." – the quotation is from Johnny Lim, a main character in the novel by Tash Aw, *The Harmony Silk Factory*, 2005, https://www.amazon.com/Harmony-Silk-Factory-Tash-Aw/dp/1594481741

Ch. 12 - Let's Put Humanity Back Into HR

Page 120 –

"business school work ..." – Rebecca Knight, *The Right Way to Fire Someone*, February 5, 2016, https://hbr.org/2016/02/the-right-way-to-fire-someone; Knowledge@Wharton, *Leadership Lapses: When Is Firing the Right Response?*, September 12, 2017, https://knowledge.wharton.upenn.edu/article/ceos-wrong-firing-always-answer/; William Meehan III and Sheila Melvin, *Can Firing/Separation/Termination Be Anything But...Awful?*, 2019, https://www.gsb.stanford.edu/faculty-research/case-studies/can-firingseparationtermination-be-anything-butawful

Page 125 –

"CNN business report ..." – Kathryn Vasel, *The right way to fire an employee*, March 15, 2018, https://money.cnn.com/2018/03/15/pf/jobs/how-to-fire-employee/index.html

Page 125-126 –

"In a Dilbert cartoon ..." – Scott Adams, *Catbert: Evil HR Director*, January 22, 1997, https://dilbert.com/strip/1997-01-22

Page 127-128 –

"humans are happier and more productive ..." – Emiliana Simon-Thomas, *The Four Keys to Happiness at Work*, August 29, 2018, https://greatergood.berkeley.edu/article/item/the_four_keys_to_happiness_at_work

Page 128 –

"cowboy-style management ..." – Sylvia Ann Hewlett and Ripa Rashid, *Leading Across Cultures Is More Complicated for Women*, December 2, 2015, https://hbr.org/2015/12/leading-across-cultures-is-more-complicated-for-women; Ideas for Leaders, *Creating a High Integrity Corporate Culture*, https://www.ideasforleaders.com/ideas/creating-a-high-integrity-corporate-culture; Ideas for Leaders, *How a Culture of Integrity Boosts the Bottom Line*, https://www.ideasforleaders.com/ideas/how-a-culture-of-integrity-boosts-the-bottom-line;

"Organizations that trust ..." – Lindsay Harriss, *Six reasons it pays to trust your employees*, July 30, 2019, https://www.ciphr.com/features/six-reasons-trust-employees/

Page 130 –

"prefer 'happiness …'" – Jan-Emmanuel De Neve and George Ward, *Does Work Make You Happy? Evidence from the World Happiness Report*, March 20, 2017, https://hbr.org/2017/03/does-work-make-you-happy-evidence-from-the-world-happiness-report

Ch. 14 - A Modern Day Rasputin

Page 141 –

"'big rocks' to solve …" – Mark Nevins, *What Are Your Big Rocks?*, January 21, 2020, https://www.forbes.com/sites/hillennevins/2020/01/21/what-are-your-big-rocks/; Noel Tichy and GE, The Growth Institute, https://www.growthinstitute.com/faculty/noel-m-tichy/; Micheal Pacanowsky, *The Gore Culture as a Competitive Advantage*, December 11, 2013,https://michaelpacanowsky.com/2013/12/11/the-gore-culture-as-a-competitive-advantage/

Page 142 –

"a 'disturbance handler' …" – Henry Mintzberg, *The Manager's Job: Folklore and Fact*, March-April, 1990, https://hbr.org/1990/03/the-managers-job-folklore-and-fact

Ch. 15 - "Games People Play" Zen Principles

Page 151 –

"People like games." – Piers Steel, *Games People Play … at Work*, January 10, 2011, https://www.psychologytoday.com/us/blog/the-procrastination-equation/201101/games-people-play-work

Page 155 –

"Eric Berne's concept …" – Eric Berne, *Games People Play*, 1964, http://www.ericberne.com/games-people-play/

Page 159 –

"relinquish her child mentality …" – Eric McNulty, *Dealing with Your Childish Boss*, March 5, 2015, https://www.strategy-business.com/blog/Dealing-with-Your-Childish-Boss

Ch. 16 - A Decision Must be Made

Page 163 –

"high stakes games …" – Richard Connell, *The Most Dangerous Game*, short story published in 1924, now in the public domain (US), https://en.wikipedia.org/wiki/The_Most_Dangerous_Game

Page 164 –

"Research shows that judgment ..." – Andrew Likierman, *The Elements of Good Judgment*, January-February 2020, https://hbr.org/2020/01/the-elements-of-good-judgment

Page 167 –

"A survey of financial leaders ..." – Jacqueline Howe, et al., *The Relationship among Psychopathy, Emotional Intelligence, and Professional Success in Finance*, October 30, 2014, https://www.tandfonline.com/doi/abs/10.1080/14999013.2014.951103

Ch. 18 - A Year of Magical Thinking

Page 175 –

"Magical thinking, or denial ..." – Wendy Wisner, *How dangerous is denial?*, November 11, 2018, https://www.theladders.com/career-advice/how-dangerous-is-denial

Page 177 –

"from the Twin Towers attack ..." – Amy Edmondson, *How to Lead in a Crisis*, October 2020, https://www.ted.com/talks/amy_c_edmondson_how_to_lead_in_a_crisis

Page 178 –

"However comforting ..." – Joan Didion, *The Year of Magical Thinking*, 2005, http://knopfdoubleday.com/guide/9781400043149/the-year-of-magical-thinking/

Page 179 –

"slide into that Magical Thinking ..." – Good Therapy, *Magical Thinking*, https://www.goodtherapy.org/blog/psychpedia/magical-thinking

Page 182 –

"Bush stood atop the rubble ..." – Kenneth Walsh, *George W. Bush's 'Bullhorn' Moment*, April 25, 2013, https://www.usnews.com/news/blogs/ken-walshs-washington/2013/04/25/george-w-bushs-bullhorn-moment

Page 184 –

"I am a firm believer in the people." – Abraham Lincoln, via Brainy Quotes, *Abraham Lincoln Quotes*, without further source or date, https://www.brainyquote.com/quotes/abraham_lincoln_118732

Ch. 19 - Self-Actualization in Maslow's Hierarchy of Needs

Page 185 –

"The great psychological thinker ..." – Adrian Iliopoulos, *Self-Actualization – The End Goal or a Delusion?*, May 17, 2019, https://thequintessentialmind.com/self-actualization/

Ch. 20 - Understanding Cultural Differences

Page 195 –

"when in Rome ..." – https://www.gingersoftware.com/content/phrases/when-in-rome-do-as-the-romans-do/

Page 197 –

"Multi-national organizations ..." – I covered many of the cultural integration issues in this chapter in my earlier piece, with footnoted references, in *Take Off Your Shoes and Ask for Slippers*, October 6, 2019, https://www.encoreexecutivecoaching.com/take-off-your-shoes-and-ask-for-slippers/; see also *How Hofstede & Trompenaars Models Of Cultural Dimensions Apply To Global Leadership*, https://eurac.com/how-the-2-models-of-cultural-dimensions-hofstede-trompenaars-apply-to-global-leadership/

Page 200 –

"in this 'Bro' culture ..." – Erik Sherman, *5 Reasons the Tech Industry Has Got to Stop Being so Bro*, March 22, 2019, https://www.inc.com/erik-sherman/5-reasons-tech-industry-has-got-to-stop-being-so-bro.html

Page 201-203 –

"Another example ..." – OluwaTobi Banjoko, *The Culture of Work in Nigeria*, August 8, 2018, https://medium.com/@TobiBanjoko/the-culture-of-work-in-nigeria-768967bdfa3d; Alison Beard, *Life's Work: An Interview with Trevor Noah*, October 2018, https://hbr.org/2018/09/lifes-work-an-interview-with-trevor-noah; Trevor Noah, *Born a Crime: Stories From an African Childhood* (2016), details the "crime" his parents committed by marrying. Their bi-racial union violated South Africa's 1927 Immorality Act, since overturned

Page 203-204 –

"something about the Finns ..." – Keith Warburton, *Finland: Doing Business in Finland*, https://www.worldbusinessculture.com/country-profiles/finland/

Page 204-205 –

"Carelessness and ignorance ..." – Geoffrey James, *20 Epic Fails in Global Branding*, October 29, 2014, https://www.inc.com/geoffrey-james/the-20-worst-brand-translations-of-all-time.html

Ch. 21 - How Values Help Overcome the Generational Crisis

Page 211 –

"seven-year study found ..." – Center for Creative Leadership, *Tactics for Leading Across Generations*, https://www.ccl.org/articles/leading-effectively-articles/the-secret-to-working-with-millennials/

Ch. 22 - When Failure is Not an Option

Page 215 –

"We read his book ..." – Jack Welch, *Winning*, April 1, 2005, https://www.amazon.com/Winning-Jack-Welch/dp/0060753943/

Ch. 23 - "Bring Me a Rock" and Other Leadership Failures

Page 222 –

"The Age of Enlightenment had a profound effect ..." – *Enlightenment Influence on America, US Constitution*, https://sites.google.com/site/enlightenmentinfluenceamerica/us-constitution; see also A&E Television Networks, History Channel, *Enlightenment*, 2011, http://www.history.com/topics/enlightenment

Ch. 24 - Leaders Follow Their Instinct

Page 233 –

"During the US Civil War ..." – Michael Peck, The National Interest, *Commanders of Chaos: The 5 Worst Generals in U.S. History*, November 8, 2014, https://nationalinterest.org/feature/commanders-chaos-the-5-worst-generals-us-history-11630

Ch. 25 - Going Through the Motions of Being Normal

Page 242 –

"For example, the founders at &pizza ..." – Jenny Chatman and Francesca Gino, *Don't Let the Pandemic Sink Your Company Culture*, August 17, 2020, https://hbr.org/2020/08/dont-let-the-pandemic-sink-your-company-culture

Page 243 –

"Employees rated their firms ..." – Donald Sull and Charles Sull, *How Companies Are Winning on Culture During COVID-19*, October 28, 2020, https://sloanreview.mit.edu/article/how-companies-are-winning-on-culture-during-covid-19/

Page 244 –

"Moreover, a survey of company employees ..." – Nurhuda Syed, *COVID-19: Employees believe leaders are 'failing' to manage the crisis*, May 8, 2020, https://www.hcamag.com/us/specialization/leadership/covid-19-employees-believe-leaders-are-failing-to-manage-the-crisis/221937

Page 245 –

"Carnival Cruise Lines knew ..." – Jaclyn Jaeger, *Carnival CECO trying to right the ship amid 'two storms'*, May 19, 2020, https://www.complianceweek.com/ethics-and-culture/carnival-ceco-trying-to-right-the-ship-amid-two-storms/28944.article

About the Author

Mary O'Sullivan has over 30 years of experience in industry as well as in business functions such as business development and subcontract management. In each role she's been a change agent, moving teams and individuals from status quo to higher levels of performance, through offering solutions focused on positive behavior change and fostering growth.

Mary has a Master of Science in Organizational Leadership from Quinnipiac University. She is also an International Coaching Federation Professional Certified Coach, a Society of Human Resource Management Senior Certified Professional, and has a Graduate Certificate in Executive and Professional Coaching, from the University of Texas at Dallas. Her certifications include an EQi-2.0 and EQ 360 Emotional Intelligence test assessor and an Appreciative Inquiry Practitioner.

In her leadership and executive coaching, she focuses on improving the executive behaviors that slow down performance and lead to growth, such as soft skills, communication, micro-bias awareness, etc. She has successfully helped other professionals, such as attorneys, surgeons, pharmacists, engineers, and university professors, make career decisions to lead to success in their chosen careers. In addition, small business owners have sought Mary's services to bring their companies into greater alignment, working on their culture, vision, mission, values and goals as well as organizational structure.

Mary's executive coaching has been mainly with large organizations among them: Pfizer, Sofi, Cisco, Thermo Fisher Scientific, Liberty Mutual, State Street Bank, Biogen, Sanofi, Intel, Toray Plastics America, Hasbro, Raytheon Company, Lockheed Martin,

CVS Healthcare, Merck, Monster.com, Oracle, P&G, Sensata Technologies, Citizen's Bank, Ameriprise, BD Medical Devices, Naval Undersea Warfare Center, (Newport, R.I.), General Dynamics, University of Rhode Island, Community College of Rhode Island.

Mary has facilitated numerous workshops on a range of topics in leadership such as, emotional intelligence, appreciative inquiry, effective communication, leading in adversity, etc. She has also written extensively on similar topics.

Mary is a certified Six Sigma Specialist, Contract Specialist, IPT Leader, and certified in Essentials of Human Resource Management by the Society of Human Resources Development. Mary is also an ICF certified Appreciative Inquiry Practitioner, and a Certified Emotional Intelligence assessor and practitioner.

In addition, Mary holds a permanent teaching certificate in the State of New York for secondary education with Advanced Studies in Education from Montclair University, State University of New York at Oswego and Syracuse University. She is also a member Beta Gamma Sigma and the International Honor Society.

Mary dedicates herself to coaching good leaders to get even better through positive approaches to behavior change for performance improvement.

Connect with Mary today to talk about your leadership challenges:

Phone: 401-742-1965

mary@encoreexecutivecoaching.com

www.encoreexecutivecoaching.com

https://www.linkedin.com/in/marytosullivan/

Made in the USA
Monee, IL
16 June 2022

98097647R10151